Looking at Asian Art

University of Chicago
Center for the Art of East Asia Symposia

Between Han and Tang: Religious Art and Archaeology in a Transformative Period,
Between Han and Tang: Cultural and Artistic Interaction in a Transformative Period,
Between Han and Tang: Visual and Material Culture in a Transformative Period,
Volumes edited by Wu Hung,
Published by Cultural Relics Publishing House, Beijing, 2000-2003.

Body and Face in Chinese Visual Culture, edited by Wu Hung and Katherine R. Tsiang.
Published by Harvard University Asia Center, Cambridge Mass., 2005.

Looking Modern: East Asian Visual Culture from Treaty Ports to World War II,
edited by Jennifer Purtle and Hans Bjarne Thomsen.
Published by Art Media Resources, 2009.

Reinventing the Past: Archaism and Antiquarianism in Chinese Art and Visual Culture,
edited by Wu Hung.
Published by Art Media Resources, 2010.

Forthcoming publications with Art Media Resources:
Reinventing the Past: Archaism and Antiquarianism in Japanese and Korean
Art and Visual Culture

Tenth-Century China and Beyond: Art and Visual Culture in a Multi-centered Age,
edited by Wu Hung

Screens in East Asia and Beyond, edited by Ping Foong and Chelsea Foxwell

LOOKING AT ASIAN ART

Edited by
Katherine R. Tsiang
and
Martin J. Powers

The Center for the Art of East Asia, University of Chicago
Art Media Resources, Chicago

First published by The Center for the Art of East Asia, Department of Art History, University of Chicago and Art Media Resources, Inc.

Center for the Art of East Asia
Department of Art History
University of Chicago
5540 S. Greenwood Avenue
Chicago, IL 60637
http://caea.uchicago.edu

Co-published and distributed by
Art Media Resources, Inc.
1507 South Michigan Avenue
Chicago, IL 60605
www.artmediaresources.com

Design and layout by George Theen

ISBN:1-58886-113-9

Printed in China

Library of Congress Cataloging-in-Publication Data

Looking at Asian art / edited by Katherine R. Tsiang and Martin J. Powers.
 p. cm.
 "Developed from a symposium organized by the Center for the Art of East Asia in the Department of Art History at the University of Chicago in 2008 in memory of Professor Harrie A. Vanderstappen (1921-2007)"--Pref.
 Includes bibliographical references and index.
 ISBN 1-58886-113-9 (alk. paper)
 1. Art, East Asian--Congresses. I. Tsiang, Katherine R. II. Powers, Martin Joseph, 1949- III. University of Chicago. Center for the Art of East Asia.

N7337.L67 2012
709.5--dc23

 2012016334

Contents

Preface 7

INTRODUCTION
Katherine R. Tsiang and Martin J. Powers 9

I. VISUAL ANALYSIS AND INTERPRETATION
Robert Poor, **Looking At and Understanding Early East Asian Ceramics** 18

Martin J. Powers, **Looking at Ornament: The Red Lacquered Coffin from Mawangdui** 35

Amy McNair, **Looking at Chinese Calligraphy: The Anxiety of Anonymity and Calligraphy from the Periphery** 53

II. VIEWING AND READING
Ikumi Kaminishi, **Animated Rhythms of** *The Illustrated Scroll of Major Counselor Ban* 75

Sandy Kita, **Japanese Prints: Two Views of Ukiyo-e** 94

Jerome Silbergeld, **First Lines, Final Scenes: In Text, Handscroll, and Chinese Cinema** 114

III. VISUAL AND CULTURAL CONTEXTS
Katherine R. Tsiang, **Recontextualizing an Extraordinary Sixth-Century Chinese Bodhisattva** 134

Rob Linrothe, **Landscape Elements in Early Tibetan Painting** 159

Kathlyn Liscomb, **Looking for Common Culture in the Pictorial Décor of a Ming Cizhou-type Stoneware Jar** 178

Index 199
Authors 207

PREFACE

This volume of essays on looking at Asian art developed from a symposium organized by the Center for the Art of East Asia in the Department of Art History at the University of Chicago in 2008 in memory of Professor Harrie A. Vanderstappen (1921-2007). To study with Harrie Vanderstappen was to receive intensive training in visual analysis of the fundamental elements and materials of art production as well as the formal properties of design. It was this kind of analysis that would open up, for his students, windows for deeper research. He encouraged a sustained search for the inner logic informing works of art. The broad application of his teaching can be seen in the wide range of scholarly interests represented in this volume. He himself was an artist, actively interested in the crafting of objects, and was accomplished at woodworking, watch-repair, and other varieties of "tinkering." Students, colleagues, and friends share warm memories of visits to his home where lively conversation would be punctuated with viewings of his collections of old tools, Asian art, and flea market treasures. A Catholic priest in the Society of the Divine Word, he first went to Asia as a missionary and, as he himself once said, was "converted to art." He received his Ph.D. from the University of Chicago in 1955 under the direction of Ludwig Bachhofer, and began teaching there in 1959. He remained a priest throughout his life and so was called "Father Harrie," or "Father V," by students and colleagues alike.

The essays in this collection examine a broad spectrum of artwork, sharing secrets for "seeing" the arts of Asia as practiced by professional historians of Asian art. Here the novice and the scholar can find essays representing a range of regions and media written for the nonprofessional as well as for experts in other areas of research who use images, showing the reader how to look and ways of interpreting findings. For this reason, even though the volume covers many diverse aspects of Asian art through the centuries, every essay places works of art in frameworks that show how they were meaningful to the people who created, appreciated, and made use of them.

The publication of this volume is made possible with the generous support of Mr. and Mrs. Ralph Wanger, Elizabeth Plotnick, and Margaret R. Chung. The symposium was held with the assistance of the Japan and China Committees of the Center for East Asian Studies, University of Chicago, and of Dr. Mary Lawton. We thank our supporters and those whose interest sustains our activities.

Katherine R. Tsiang

INTRODUCTION

Katherine R. Tsiang and Martin J. Powers

Strategies for the visual analysis of art are of many types. The vocabulary of art criticism in China was early on designed to identify visual properties characteristic of different artists and historical styles. In Europe the writings of GiorgioVasari (1511-1574) likewise attributed different qualities to the styles of different artists, but the systematic analysis of the visual properties of art, as we know it today, first developed in Germany during the nineteenth century. Initially an important aim of visual or formalist analysis was the identification of historical progressions that were thought to reveal the development of national characteristics as understood in the philosophy of Hegel and other nineteenth-century German writers. In this approach, the styles of artworks were understood to represent qualities reflecting the spirit of the "folk" or of the age that produced them. This entailed a search for the inner logic of artistic forms, the latter being understood as a system that followed logical trajectories of development. Few if any historians today would subscribe to Hegelian notions of national character, but this tradition survives in narratives of the formal development of styles within different national traditions.

This formalist approach contrasted with a more historical, sometimes archaeological approach that was principally concerned with the content and interpretation of art in its original context. The latter method was theorized under the rubrics of iconography and iconology. Both types of analysis sought to unravel the meaning of figures, images, symbols, and narratives in painting and sculpture relative to a body of written texts such as the Bible, Greek mythology, sermons, histories, and so on. During the 1970s and 1980s, many of the leading art historians began to explain both the formal and iconographic features of art in terms of their social function. Artworks were no longer understood as mere reflections of national character and belief systems, or illustrations of canonical texts. Instead, details of a work's appearance were explained in terms of rhetorical properties in relation to the social or political concerns of specific audiences and patrons. While each of these

strategies for viewing art can be, and has been, exercised independently, the work of most art historians today makes use of some combination of these three basic approaches.

Throughout the late nineteenth century, when the formative studies of Art History as a discipline were being written, the arts of Asia, Africa, and the Middle East were being viewed, collected, discussed, and exhibited by artists, scholars, and curators in Europe and America. In the twentieth century, articles on the arts of Asia could be found alongside those on European art in such major venues as *Burlington Magazine* or *Art Journal*, but these arts generally were not represented in major departments of art history. From the 1960s onward, the study of non-European arts became professionalized as fields in art history departments, mainly in the United States, but also in England and Europe. This development required the identification of a canon for each field. For the arts of East Asia, Western scholars mainly adopted the canons that had early on been established in the relevant countries. For South Asia, Africa, and the Middle East, canons were invented based upon works in Western collections that were regarded as being of high artistic quality, just as nineteenth-century scholars had done for Medieval European art.

During the second half of the last century this growth in the professional study of non-European arts eventually led to the "Canon Wars." These, in turn, stimulated a critical reexamination of the fundamental aims and premises of the discipline. As a result, the field of art history has expanded to include artistic production from many parts of the globe, not only works originally considered "high art" in their local context—such as paintings by Chinese or European masters—but also art produced more for religious functions or for members of an aristocratic elite rather than for the delectation of art collectors. As a consequence, art historical research now incorporates a wide range of historical, anthropological, psychological, literary, economic, and sociopolitical perspectives. In recent years, historians of art might even make use of scientific studies of the physiological or neurological dimensions of visual perception, cognitive processing, or the function of images in memory. All this has led the discipline of Art History—long considered an independent field of study—into a wider arena of interdisciplinary studies.

For the authors of this collection of essays, the visual examination of artworks and the study of their meaning in the history and cultures of the people who produced them do not constitute mutually exclusive approaches. The visual analysis of works of art serves as a prism through which a scholar may investigate a complex arena of cultural references, signs, expectations, ideas, and social practices. While everyone can appreciate visual qualities of art and design, there is no universal

language of art, and our distance in time and space from their creation presents obstacles and challenges to engagement and interpretation. Our authors draw on their knowledge of languages, literature, history, and religion, as well as a variety of analytical approaches and comparative strategies, to make these works of art live again for the reader.

This volume does not attempt to survey all of Asian art. Rather it presents a selection of important works of Asian art in different media—including painting, sculpture, prints, ceramics, lacquer, and film—from a variety of Asian cultures and historical periods. It acknowledges that our acquaintance with the history of art and visual culture in Asia is but a random and fragmentary selection of all that has been produced. These essays study examples of fine art, objects of everyday use, funerary artifacts, religious images, and popular art forms from the prehistoric to the contemporary period. Most of the essays focus on a single work of art or a small selection of closely related materials, disclosing in clear language their compositional features, technical construction, and modes of representation. Their descriptions invite close looking and appreciation of the visual qualities of art and provide as well insights into the production, function, reception, and interpretation of these works. In this way the authors are able also to address broader historical systems of social practices, belief systems, or commercial and political structures so as to offer insight and understanding on multiple levels.

Although each essay stands as an independent study by itself, most of the essays resonate in significant ways with others in the collection, so that teachers might wish to assign two or more essays together. For example, Robert Poor's study of Neolithic ceramics and Kathlyn Liscomb's article on early modern ceramic consumption and design complement one another.

The essays have been grouped into three sections—1) visual analysis and interpretation, 2) viewing and reading, and 3) visual and cultural contexts. This provides a useful framework for discussing the essays, although the essays are not limited to these categories. Indeed some take their visual analysis into transmedia territory.

Visual Analysis and Interpretation

Neolithic Ceramics

Analysis of the formal and material properties of objects naturally suggests questions concerning function, social roles, and reception. For instance, early pottery vessels of Neolithic cultures across the globe share much in common: all are

functional objects formed of clay and fired by people living in settled agricultural communities before the advent of the Bronze Age. However, they vary greatly in appearance and conception. A selection of vessels from widely separated geographical regions of China and Japan reveals vast differences in clay material and its shaping, surface treatment, and firing. Through the examination of shape, thickness, weight, texture, and ornament, Robert Poor discusses the various techniques employed in the formation of Neolithic pottery—coil building in sections, sculptural modeling, throwing on the potter's wheel, painting, and firing. He treats these features as clues to function and cultural significance and shows how a close inspection of ceramic vessels with consideration of archeological contexts can disclose vital information about the lives of these ancient peoples, including their dwellings, tools, and diet.

Chinese Ornament

Much of what we know about ancient cultures comes from objects found in archeological contexts, especially those preserved in tombs. One of the most important archeological finds of the last century in China is that of the second-century BCE burial of the Marquess of Dai in Changsha, Hunan. This lady's body was well-preserved in her richly furnished tomb where she was encased in three nested, ornamented lacquered wooden coffins. Lacquer, a natural tree sap with plastic properties, was used to make furniture and containers for food, drink, cosmetics, mirrors, and other personal effects through an extremely costly, labor-intensive, and hazardous process. Mixed with pigments and applied in thin layers that are dried between applications, the lacquer forms a durable shell on the surface of a wooden core that protects it from moisture, decay, and insects.

The painted motifs on early lacquered objects reveal sophisticated and ingenious combinations of figurative and abstract elements, including animal forms and geometric and scrolling patterns. Martin Power's case study of the lavishly decorated red lacquered coffin from the tomb analyzes its ornament. The essay begins by distinguishing four distinctive characteristics of ornament generally, including the fundamental ways in which ornament differs from pictures. Powers then surveys how the ornaments on the Mawangdui casket were made, as well as the meaning and significance of the imagery in the context of early Han dynasty aristocratic burials. The significance of the Mawangdui ornaments is then situated within the history of debates surrounding the use of ornament in China, including critiques of royal extravagance at the expense of social justice. Finally, the critique of ornament in China is compared more globally with similar critiques by European writers, both Medieval and Modern.

Chinese Calligraphy

Writing and literacy evolved early in China. As elsewhere in Eurasia, these tools were at first limited to the ruling elite, but in China they soon spread beyond the ranks of the nobility. Writing first on wood and bamboo slips and then on paper and silk, scribes, scholars, and bureaucrats developed a repertory of skills for the use of a flexible writing brush dipped in ink, giving rise to calligraphy as a recognized art form by the third century CE. Examples of this art, including the finest subtleties of a great calligrapher's brush, could be captured for the ages in stone by master carvers. Scholars of later centuries collected and studied rubbings of these stone inscriptions for their historical, epigraphic, and artistic value. Standardized script—along with government-sponsored schools, the invention of paper and, later, print technology—were key factors in the early development of popular literature, social criticism, and a centralized, post-feudal bureaucratic administration in China. All of these developments were essential to the ordering and administration of China's large cities and far-flung territories, the recording of history, and the dissemination and exchange of cultural information, including public debate. Amy McNair presents a close study of a rubbing made from an early fifth-century eulogy for Cuan Baozi carved in stone in Yunnan, in southwestern China, an area long considered to be on the periphery of Chinese high culture. It is a work with a rather hybrid style and unconventional character forms that has been interpreted in multiple and contradictory ways ever since it was rediscovered in the eighteenth century. From this essay, readers will learn about traditional standards of writing in China, their cultural and political implications, and how standards vary across different regions of the empire.

Viewing and Reading

Japanese Painting

The horizontal handscroll is a major format of East Asian painting, mounted on paper, attached to wooden rollers, and intended for viewing by unrolling one section at a time. The format is especially effective in the portrayal of a continuous narrative progression or movement in time and space. The unknown artist of the twelfth-century Japanese painting of "The Illustrated Story of Counselor Ban" (*Ban Dainogon ekotoba*) employed multiple and ingenious devices for representing temporal sequence, dramatic action, and personal emotion through gestures, imagery, or the placement of figures within architectural or other pictorial spaces. Through her analyses of poses, costumes, and figure arrangements, Ikumi Kaminishi

helps the reader to decode these devices and to appreciate their implicit meanings. She directs our attention to the use of different kinds of narrative progression, such as continuous, synoptic, and multidirectional. She compares the visual rhythms in the painting to tempos and movements in musical composition; the progression of scenes in Japanese handscrolls is also likened to the art of cinema with its narrative movement, shifting viewpoints, and pacing, and to Japanese animated films or *anime*.

Japanese Woodblock Prints

A single Japanese woodblock print by Utagawa Kuniyoshi (1797-1861) is the springboard for a far-reaching discussion of two interpretive art-historical "views" of Japanese *ukiyo-e*, an art form commonly translated as "Art of the Floating World." From this starting point, Sandy Kita guides the reader through all the technical details of print making, and surveys the themes and subject matter of prints within the sociopolitical context of the Edo period (1603-1868). He reveals how two fundamentally different assessments of *ukiyo-e* as an artistic genre resulted from competing premises defining separate groups of artists, artistic traditions, and artistic media. While one approach identified *ukiyo-e* through the medium of woodblock prints only, the second applied the term to both paintings and prints. He traces these premises to political constraints that developed during the mid-twentieth century, and shows how these alternate historiographical traditions have left their mark on Western scholarship. Through its analysis of the historiography of *ukiyo-e*, Kita's study alerts us to the ways that preconceptions can shape how we look at Asian art and, therefore, how we finally understand it.

Modern Chinese Cinema

Jerome Silbergeld's essay introduces a selection of contemporary Chinese films by focusing on their vivid, meaningful, or thought-provoking opening and final scenes, comparing them to the memorable opening and closing passages of great works of Western literature. Silbergeld's discussion also draws analogies between cinema and the compositional techniques employed in traditional Chinese narrative paintings, especially handscrolls, and points out the ways in which opening and closing scenes, as well as inscriptions at the right (beginning) and left (ending) sides bracket painting compositions. Through this approach, which is ideal for classroom discussion, he draws our attention to modern Chinese cinematic production and the ways in which these memorable fragments frame, and thereby open, windows onto entire films. He explores the various ways in which imagery and dialogue in a film will refer back to historical events in modern China. In doing so he reveals for the reader encoded messages about characters and their interrelationships, thus

clarifying the director's implied commentary about art, humanity, and politics. The symbolic strategies he examines include color signification, symbolic forms, references to literature and drama, and allusions to China's modernization that are culturally based. The themes exposed in this manner reference much larger social, cultural, and ecological themes as well as the larger repertory of modern Chinese films.

Visual and Cultural Contexts

Chinese Buddhist Sculpture

Buddhism was an important medium for the transmission of art forms across the Asian continent for two millennia, beginning with its introduction to China from India around the first century CE. The establishment of Buddhism as the predominant religion of medieval China precipitated a complex set of interactions with religious ideas, practices, texts, and imagery from beyond the borders of China. The excavation of Buddhist worship halls in solid stone cliffs began in India and spread across Asia into China. A fine stone sculpture of the bodhisattva Avalokiteśvara (Ch. Guanyin) that is the focus of Katherine Tsiang's essay was originally part of a group of carved figures and relief scenes in the sixth-century Buddhist cave temples of Xiangtangshan in northern China. These sculptures and fragments, some forcefully chiseled from the cave walls, found their way into the growing market for Chinese art that emerged in the early twentieth century. Like Christian sculptures from medieval churches displayed in museums as works of art, the sculpture described here is far removed from its original meaningful religious and social contexts. This essay systematically "views" this sculpture in multiple frames of reference, demonstrating how the use of visual analysis can provide cogent evidence linking the sculpture with a specific Buddhist cave site and belief system.

Tibetan Religious Painting and Landscapes

In Tibetan painting, Buddhist deities and saintly monks constitute the primary subject matter. While the representation of these figures suggests that they occupy a different plane of existence apart from this world, artists also frequently depicted them situated in the midst of stylized landscapes. Robert Linrothe surveys these landscape scenes in temple murals from the eleventh through the eighteen centuries. Some of the earliest examples of landscape scenes in western Tibet, a crossroads of Asian cultures, depict mountains that form the settings for narratives from Buddhist scriptures or the biographies of holy men. These landscapes skillfully lead the viewer to imagine those magical sites of remote isolation where Buddhist sages practiced spiritual cultivation, evoking an otherworldly quality. Linrothe's analysis

distinguishes the range of stylistic diversity among these paintings, noting differences between varieties of stylized mountain forms exhibiting rounded, angular, squared, and crystalline rock faces. The decorative forms and brilliant coloration of the mountains and surrounding areas appear to be based on established conventions of religious painting that have connections with Kashmiri, Nepalese, Indian, and Chinese traditions. Linrothe's close visual analysis demonstrates multiple ways to read Tibetan pictorial conventions, showing the reader how to decode their religious and cultural content.

<u>Early Modern Chinese Ceramics</u>

While Buddhism was a major source of ideas and images in Asian popular religious culture, secular culture in China was based on a shared history and literary tradition as transmitted through popular art forms. Ceramics were a mass-produced art form that can be traced in archeological materials from tombs and dwelling sites throughout China's long history. A large variety of examples can be seen in museums and private collections around the world. Despite their ubiquity, and perhaps because of it, very little was written about the ceramic material, its history, its functions, or its market. The development of fine, high-fired ceramic wares with beautiful glazes culminated in the Song dynasty (960-1279). Painted ornament on ceramics with transparent glaze on white ceramic bodies became popular in the centuries thereafter, such that many painters worked at kiln sites to produce the pictorial ornament.

Kathlyn Liscomb studies a painted wine jar of the sixteenth century, an example of Cizhou ware made for popular use in northern China. Liscomb identifies the three figures painted on a jar depicted in different states of inebriation. All were famous historical figures who lived from the fourth through eighth centuries, and were known primarily for their literary achievements, as well as for their love of wine. Liscomb introduces the reader to methods of historical investigation that illuminate how these historical figures could have been readily identifiable to patrons of popular drinking establishments in the sixteenth century. Her investigation uncovers evidence for the dissemination of high culture to a broad sector of society through popular media and commercial channels—including printed books, inexpensive ceramics and paintings, drama, and other popular forms of entertainment. Her close reading of this piece also demonstrates the value of careful observation and precise description.

Conclusion

Knowing how to look at works of art is a valuable skill for life in a world that bombards us with visual material intent on persuading, seducing, or delighting us with images that make use of many of the same methods that were employed by artists throughout history and across the globe. In this volume, the authors guide readers to look closely at art works from a variety of historical and cultural contexts ranging from ancient China, Japan and Tibet to the twentieth century. They demonstrate how scholars generate detailed descriptions, and show the reader how to recognize the effects of media, technique ,and motifs on meaning. Along the way the reader learns how important cultural and social issues can be visually encoded in works of art. The editors and authors of this volume hope that readers will come to better appreciate how historians of art develop their theories and make their arguments, how hidden premises can affect the development of historical interpretation, and how we are limited in what we can infer by the fragmentary nature of the evidence. Finally, by leaving readers with some appreciation of the complexities of learning about the arts of Asia, we hope that they will continue the enjoyable practice of just "looking" at Asian art.

I. VISUAL ANALYSIS AND INTERPRETATION

Looking At and Understanding
Early East Asian Ceramics

Robert Poor, University of Minnesota

Introduction[1]

The dry bones of prehistory cannot sing the songs of antiquity, recount the tales of early civilization, or declare the beliefs which governed people's lives in ancient China. For that we must turn to the ruins of their dwellings and to the cultural objects they created. Interestingly, much of this evidence has been recovered from gravesites. Since ancient Chinese customs focused heavily on ancestors as well as the afterlife, we trust that the images derived from burial goods are also valid representations of the life of those ancient times. Much of the early Chinese images and art that have survived consist of pottery.

In this essay I have paid special attention to the kind of wares that are readily seen in museums around the world. And although there are hundreds, if not thousands, of Neolithic sites scattered throughout China, and scores of different ceramic families, I have tried to be selective and chose those which are symptomatic of the general flow of ceramic history.

This is not a comprehensive academic account of the complete index of early ceramics but rather an introduction to the craft of seeing and interpreting this often underrated art. And in our exploration of these wonderful wares, we shall endeavor to learn the poetry and not just the prose of the story.

If, upon entering a museum or antique shop some day in the future, you are able to embrace a pot with a sense of heightened knowledge and understanding, then we shall have accomplished our purpose.

Production

Some of the fundamental problems which every potter in the Neolithic Period faced—e.g., how to shape a thing to serve a certain purpose and please the eye—had presumably already been resolved by the basket makers who preceded them. Still, in the workshop world of the ceramicist, certain basic design features always demand the attention of the potter, regardless of when or where a particular pot is made; every object has a shape and often it is decorated. These timeless elements of form—*shape*, *decoration*, and most importantly, the *relationship* of the décor to the finished object—provide a trio of entry points for looking at and achieving a better understanding of the complete work of the potter's art. There are of course other elements to be considered; the techniques of manufacturing, the meaning of decoration, the demands of patronage, etc., but these are best addressed after one has mastered the art of seeing, and developed an understanding of the form of the object itself, represented here by Chinese (and one Japanese) works dating from the late Neolithic Period of the Pre-historic era some five to seven thousand years ago.

Shape

Our perception of the shape of a thing differs if the object is held in the hand or just observed on a museum shelf or in a picture. In looking, without touching, we eliminate all that the hand teaches, the sense of weight or texture, while in the mind's eye we may reduce a shape to its abstract visual contour. This is a powerful tool of visualization. Hunters are trained to recognize birds from their printed silhouettes, and in a later adaptation the military learned to identify tanks, airplanes, and battleships using the same tool. Archeological publications regularly illustrate pottery types with profile drawings that ease their identification and encourage analysis in a way that a photograph does not. A drawing juxtaposed with a photograph of a water jar dating from the Prehistoric Era in China illustrates this abstraction[2] (Figs. 1, 2).

The vessel is of the kind unearthed at Banpo, the modern name for the seven-thousand-year-old site of a Neolithic-Era village. It is set on a terrace overlooking the Chan River, a subsidiary of the more powerful Wei River, one of many tributaries of the mighty Huanghe, or Yellow River, which flows from the rugged western mountains of China all the way to the eastern seaboard. Located in a nearby suburb of the modern city of Xi'an, the Banpo site was one of the earliest major excavations in the People's Republic of China and was given special care as a model endeavor and later as a tourist destination. The approach to the large hall that houses the well-preserved archaeological site at Banpo is marked by a greater-than-life-sized

Above: Figure 1. Pottery bottle, China, Neolithic Period, Yangshao culture. Unearthed at Banpo, 1955. Banpo Museum, Xi'an, Shaanxi Province.

Right: Figure 2. Reconstruction of a bottle from Banpo.

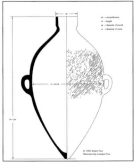

statue of a young kneeling woman pouring water from a jug into the lily pad basin of the courtyard fountain, like the one illustrated here.

The hydrodynamic form of the vessel is perfectly designed for collecting water. The jug could be lowered from the treacherous banks of the nearby river by a line attached to its handles and looped around its neck. Once submerged, the tapered mouth and bottom would align with the current—like a double-ender boat or canoe—and hold its course, allowing the heavier base to settle in the stream and the mouth to siphon clean water from the flowing current. For storage, the jar might be hung on an interior household post or set into one of the cone-shaped depressions of a household floor. As a serving vessel, it had a small mouth that retarded evaporation and directed the flow of liquid while the slightly roughened

upper portions of the vessel ensured a good grip. In this instance, utility and design merge in a form that suits the task and pleases the eye.

The simple-looking hand-built shape of the jug belies the complexity of its production. It was constructed in sections consisting of a cone-shaped lower body, a dome-shaped upper portion, a small mouth, and finally, two handles. Each segment was made separately and then set aside until it was firm enough to handle, after which the potter could reach inside the domed section to attach the mouth and then fuse the edges of the upper and lower body sections using a technique called luting, a method still in use for welding clay. Next the potter striated the domed upper part of the pot, providing a rudimentary sort of decoration that also disguised the seam between the domed-shaped shoulder of the vessel and its conical lower section. All that was left to do was to lute the handles to the body of the pot near its broadest point and fire the assemblage to give it permanence.

The anonymous potter who made this jug had to envision the completed shape of the vessel as well as the full sequence of the assembly process before his, or perhaps her, hands touched clay. In the process of production, the size of each section had to be exactly measured to correspond with its adjacent section. The necessary preoccupation with measurements, with the specific size of the matching parts, led naturally to a conscious consideration of the proportions of the finished piece. These vessels were shaped according to strict rules of proportions employing simple but effective formulas (Fig. 1).[3]

There were many variants in the formulas applied to the design of vessels at different times and places within the Neolithic Era in China, but all ceramic types commonly shared a commitment to the systematic application of the rules of proportion. The procedure for applying these rules could be accomplished by using a "ruler" of knotted cord or a notched piece of wood that sometimes mimicked the dimensions of the bones of the human hand. The length of a single fingerbone, or distance between knuckles, provided the basic module for proportional design— the "rule of thumb" that defined the precise dimensions of the Neolithic Era unit of measure, the *cun* (inch, or literally "thumb").[4]

The uncluttered shape of the jug from Banpo, the "mathematical" elegance of its proportions, recalls the Proto-Geometric Pottery of ancient Greece.[5] No dependence of the one upon the other is intended; the Greek ware was made thousands of years after the Chinese examples. Yet, in each case, we observe a rigorous attitude toward design that strove to produce a perfect, archetypal form, leaving unseen and unsought the individual hand of the potter who made the piece or any idea of personal performance, beyond the excellence of the execution. What

emerged from this shared disciplined ethos was a perfect closed form, pleasing in the way that geometry is pleasing, satisfying our need for order. There is nothing improvisational in these early Chinese works.

In the disciplined execution of a preconceived mental template, these works rival the regularity of an industrial product, which is of course what they were. The large-scale production of ceramics is always an industrial enterprise necessitating the discovery and mining of clay, the refining of the raw material to rid it of extraneous matter so that it might be properly worked in a variety of textures, the invention of some kind of firing chamber, and the provision of fuel to heat and harden the raw ware. All this required the development of an expert infrastructure and points toward the dedicated labor of specialists who often practiced their craft in an area set aside from the general domestic quarter. Yet, technology is not the exclusive factor in determining a design. Taste, the culturally imbedded preference for one style over another, may guide the potter's hand to make different visual choices under parallel circumstances. For instance, while the Banpo potters developed a style that stressed a commonality of type, their Neolithic counterparts in Jomon Period Japan (covering the long span from 10,000-200 BCE), who were working under the same general constraints as the Chinese Neolithic cultures, developed a very different approach to hand-built clay forms.

A tall container in the collection of the Minneapolis Institute of the Arts (dated by them to 2500-1500 BCE) comes as close to representing a typical example of Jomon Period pottery as one can find amongst wares that characteristically proclaim a unique individuality (Fig. 3).[6]

The lower part of the vessel resembles a flat-bottomed basket with outward-sloping sides. Beginning at the base, shallow incised lines set on a lightly picked background produce a decorative and perhaps figurative pattern that flows easily around the wall of the vessel that is now darkened by the cooking fire. The clay fabric at the neck of the piece is left unmarked, providing a smooth transition from the mildly textured body to the exuberant manipulation of its rim. There the flamboyant sculptural gesture (fire-flame pattern in Japanese) explodes with an unrestrained spirit that celebrates unexpected twists and turns, defying the very notion of a tightly defined standard. The sculptural decoration of the mouth of the Jomon Period cooking vessel so dominates the overall design that one may overlook the intriguing motifs incised in the clay of the body. These shallow incised motifs are of similar curvilinear design and were also significant in the overall composition.

The Jomon Period potter exploited the plastic potential of clay in a way untested by the maker of the jug from Banpo, and it takes only a quick glance at the respective

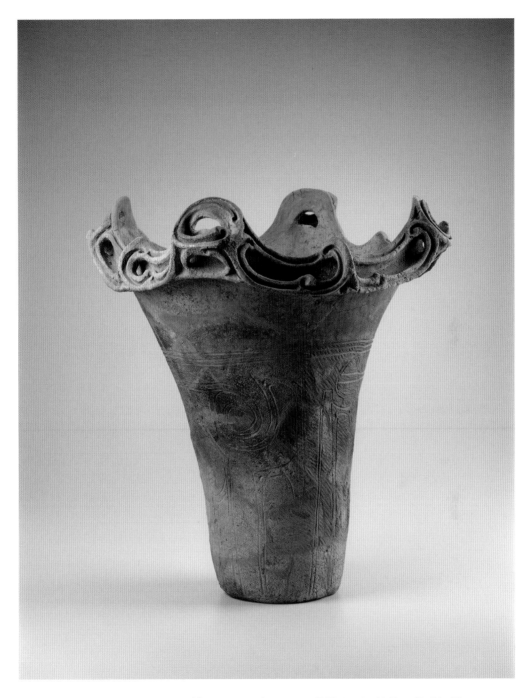

Figure 3. Earthenware Jar, Japan, Middle Jomon Period, 2500-1500 BCE. 53.98 x 55.88 cm (21.25 x 22 inches). The Minneapolis Institute of the Arts, The Ethel Morrison Van Derlip Fund. Accession Number: 82.9.1

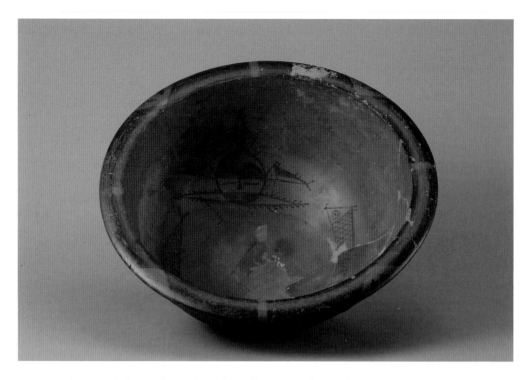

Figure 4. Basin with design of human face and fish. Chinese, Neolithic Period, Yangshao Culture. H. 16.5 cm. Excavated in 1955 at Banpo. Banpo Museum, Xi'an, Shaanxi.

profiles of the two vessels to distinguish one from another. The great differences in the style of the vessels, Jomon Period as against the Banpo representative of the Chinese Yangshao Culture, should not disguise their common bonds as products of comparable Neolithic cultures, each using stone tools, weaving fabrics of natural grasses, and cooking and eating out of clay pots.

Décor

Several flat-bottomed bowls from the Banpo site, contemporaneous with the plain jug, have exceptional images painted on their smooth curving inner sidewalls. The lead motif is a pair of opposing mask-like devices augmented by an intervening pair of fish or deer (Fig. 4).[7] The mask effect employs a familiar convention that exploits the symbolic potential of placing two slits and a dash within a circle to suggest the features of the human face. The resulting conceit, not unlike a "smile button," establishes a human presence. But this human presence is one that assumes a ritual significance from the addition of elaborate face paint, the suggestion of a special costume, and, most especially, by the appearance of prominent fish or antlers where

we would expect to see ears. The design may portray a shaman in full ritual regalia and makeup, the fish ears or antlers being the tokens of the specific goal of the moment. The heraldic composition of the design is a universal sign of symbolic procedure, the depiction of a timeless ritual performance in which the living face of the performer is enhanced by the transformative power of the mask. Yet as a seeming contradiction to the features of the mask we must note the difference between the stylized depiction of the small fish that appear on the shaman's mask and the keenly observed portrayal of the scaly slope-headed bottom-feeding carp that swim between them. The confronted symmetry of the two gigantic fish, each pointing toward an opposite mask, injects a lively rhythm into the design—a sense of immediacy—as though these prize catches were seen as related to the call of the shaman's chant. Other painted designs found on Neolithic pottery of the approximate age of the Banpo examples introduce similar animating notes like fish arranged in serial order swimming tail to tail around the outer or inner wall of a bowl, suggesting living creatures envisioned in real-time actions. Occasionally there is evidence of the accurate observation of different insect and reptilian forms from larval state to maturity.[8] But in every case, the pictures found exclusively on pots explore the relationship of human beings to animals, whether as prey, food, or clan sign.

It is hard to imagine that food ever marred the carefully prepared painted surfaces of these objects. Yet these painted bowls are first and foremost *food dishes*. The hieratic motifs so carefully formatted inside the shaman's bowl must have something to do with our daily sustenance. The complete motif, masked-being and fish (or deer with horns on the shaman's mask), surely refers to an act of sympathetic inducement—summoning the fish that were an important source of nutrition for these river dwellers, as were the deer from the neighboring countryside. As if to complement the spiritual intent of the design, the rims of these bowls are marked by eight evenly spaced alternating "V" designs or vertical bars reserved from the dark ground. As precisely arranged as the markers on a compass rose, the linear figures on the rim suggest a provocative comparison with the Eight Trigram symbols of later times the correct reading of which was believed to reveal the path to the successful completion of some task (like obtaining food). However one interprets the intriguing marks on the rim of the Banpo bowl, it is clear that they differ in an important way from the painted designs on the interior of the same piece; non-representational in nature, these provocative signs prosper in the realm of ornament. In fact, we see three different modes of imaging in these bowls, including the closely observed and recorded natural forms like the carp, highly

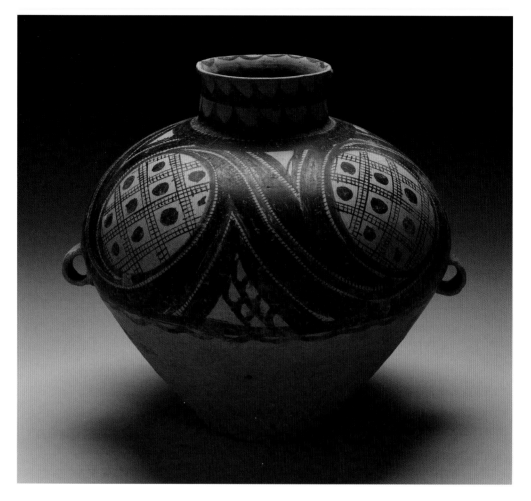

Figure 5. Funerary storage jar, ca. 2400 BCE. Pan Shan type, Earthenware with painted spiral decor. 37.15 x 40.01 cm (14.625 x 15.75 inches). The Minneapolis Institute of the Arts, The Ethel Morrison Van Derlip Fund. Accession Number: 89.9

stylized depictions like that of the mask (itself an abstract version of a face), and an ornamental treatment of the décor on the rims of these bowls.

Our interest in the "Shaman's Bowl," which is illustrated in every textbook dealing with this ancient art, may lead us to think it is a typical type. That is not the case at the Banpo site nor is it so within the broad context of Neolithic-Era ceramics in China. The overwhelming majority of excavated pieces are unpainted and often undistinguished in shape and manufacture. Amongst the rare painted wares, only a very few carry a representational image pointing to a specific creature or event. More typical are the wares found in the northwestern region of China. Made two millennia after the jug and bowl unearthed at Banpo, other pottery from Yangshao Culture sites are sometimes brilliantly decorated with intriguing designs

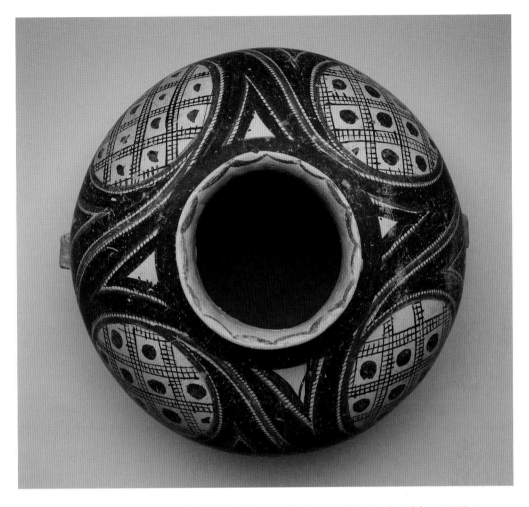

Figure 6. Funerary storage jar, ca. 2400 BCE. Pan Shan type, Earthenware with painted spiral decor. 37.15 x 40.01 cm (14.625 x 15.75 inches). The Minneapolis Institute of the Arts, The Ethel Morrison Van Derlip Fund. Accession Number: 89.9

made up of various geometric forms that have yet to be deciphered, if indeed a specific meaning was ever intended.

First discovered and then published by the noted amateur archeologist J. G. Andersson in the early twentieth century, vessels from the two Neolithic Period cemeteries at the Banshan and Machang locales, dating to about 2500 BCE, were greatly admired in European circles and soon became the mainstay of Neolithic exhibitions in dealer's shops and museums outside of China.[9] A vessel now in the collection of the Minneapolis Institute of the Arts illustrates a typical specimen of the Banshan type (Fig. 5).[10]

The broad-bellied amphora as illustrated here always has a flat base, a cone-shaped lower section, and a domed upper section; the Minneapolis pot has a short

stovepipe neck (others may have a broad open mouth). Though these vessels vary slightly in shape and were of different sizes, each was made according to a formula that set the ratio of height to width, and the relative size of foot, belly, and neck. In the instance of the Minneapolis jar, the diameter of the broadest part of the body (excluding the handles) is just twice that of its foot and mouth added together and the overall height is nearly the same as the width. These pots where hand-built in sections; nothing had changed in that regard during the several thousand years that separates Banshan pieces from the water jar from the Banpo site. The clay cone-shaped lower section of the pot was left untreated whereas the domed-shaped upper section was coated with fine slurry to provide a suitable ground for the painted decoration. The distribution of the décor on the vessels from these sites always ends at the midsection. The handles are attached at or near the broadest diameter of the body, where the contour shifts from the straight-walled cone of the lower body to the curving arch of the upper section. Thus, the natural bulge of the contour serves as the meeting ground of the handles, the décor field, and the shift in shape.

This tectonic composition perfectly balances our sense of structure and decoration, recalling some of the best work of the Proto-Attic potters of ancient Athens. The view of the pot from above—the angle that most closely approximates what one would have seen if seated on the floor of a Neolithic dwelling in this period before the introduction of the chair—reveals the harmonious complexity of the design (Fig. 6). In the most dynamic of the Banshan amphora, the brush-painted ornament resolves into a bold composition flowing rhythmically around the body of the vessel, a syncopated triumph of ornament in action.

Technology: Inside the fiery furnace

Despite their arm-filling size, many of the vessels from the Banshan site are surprisingly light. Though they were still fashioned from coils or slabs of clay, and may have been trimmed on a slow-moving turntable, there is no evidence of the use of the high-speed potter's wheel. Yet the thickness of the sidewalls of these vessels is quite regular and may be no more than a few millimeters, a feature that one would not anticipate in ware made in this elementary fashion. The firing station at the Banpo site was of the simplest sort: a ditch to bring in air, a tunnel to contain wood and pots, and an open exit. That was all that was needed to develop the heat necessary to harden a pot and give it a reasonable degree of permanence. In the process of firing, the color of the raw clay would shift to lighter or darker reddish tones depending on the chemical makeup of the raw material, and the painted designs (not glaze) would harden and become permanent. The pots from

the Banshan site were fired in a still-primitive but improved kiln with a hole in its roof to serve as a chimney and a flat rock to serve as the furnace door. That was enough to control the flow of oxygen—and thus the heat—needed to fire the raw vessels placed on a low shelf over the wood embers. The genesis of the modern kiln can be found in this modest arrangement.

By the late Neolithic Era, the discovery had been made that damping down the flow of air to the interior of the kiln by restricting the size of the door opening would reduce the flow of oxygen in the firing chamber, resulting in what is technically known as a reduction atmosphere. One immediate result of this procedure, which can be stimulated by the introduction of foreign matter, is the production of carbon that will be absorbed by the fired object and will turn the object black. The internationally admired black pottery of the native American potter Maria Martinez, made in the San Ildefonso Pueblo in New Mexico, was fired in this way, beginning over an open flame and, according to one local potter, finished under a pile of fresh horse dung "for the time that it took her husband to drink two cups of coffee" (fired in a normal way, the pots would be a terra cotta color). The most famous examples resulting from this technique in China are the black wares associated with the Longshan Culture (ca. 2500-1700 BCE) in Shandong Province in northeast China. A stem cup in the collection of the Minneapolis Institute of the Arts illustrates this type (Fig. 7).[11]

The firing of the Longshan pieces began in the usual way in an oxygen-rich atmosphere. At the appropriate moment, the supply of oxygen was reduced and foreign materials were added so that the fired object absorbed carbon particles. When the object had cooled, its surface was burnished to a lustrous matte finish. The clever exploitation of reduction firing presages the use of glaze. For the first time, a pot goes into the fire the color of the natural clay and comes out jet black—a near-magical transformation that occurs unseen and unwitnessed by the human eye. In learning to control this process, the fire masters were well on the way to establishing the technology that in later centuries led to the smelting and casting of metals and all other procedures that depend on the control of fire and heat generation. The dazzling technical achievement of the Longshan potters is appreciatively summed up in this frequently quoted but unattributed aphorism: "Thin as paper, as hard as china, voice like that of a stone chime when struck, and as bright as lacquer."

Indeed the most striking feature of the ceremonial Longshan wares is the eggshell thinness of the walls, although this can only be fully appreciated when one has a piece in hand. Thinner than the most fragile glass, the best examples of this lustrous black ware are feather light. Such delicate potting is only possible when

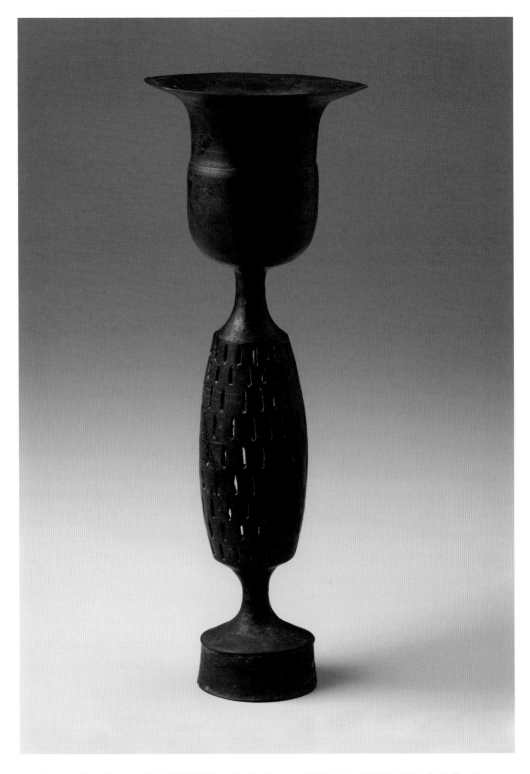

Figure 7. Stem Cup, ca. 2500-2000 BCE. Burnished earthenware. H. 88 x 3cm (18.94 x 3.31 inches). The Minneapolis Institute of the Arts, Gift of Ruth and Bruce Dayton. Accession Number: 2000.156.1.

highly refined clay is thrown on a high-speed potter's wheel, presumably trimmed, and fired at a high temperature in a reduction atmosphere. These features—refined clay, the use of the high-speed wheel, and total control of the kiln atmosphere—constitute the full arsenal of tools and techniques available in a modern pottery workshop. All that was lacking in the late Neolithic Period technical arsenal was modern fuels and electric power-driven equipment.

The best-made Longshan pieces are, as we might expect, food and drinking vessels, such as might grace a ceremonial banquet. They were the *ware deluxe* of their era, a world removed from the coarser black, grey, or red wares intended for everyday use. Although rare, or rather because of their rarity, they were suitable for deposit in the graves of the elite, as signs of rank and privilege.

Amongst the Longshan wares, the stem cup in particular offers the greatest array of visual surprises. The basic composition of this type is more or less the same: a cup with everted lip supported by a bulging stem set, in turn, on a smallish foot—very much like a champagne flute. And like a modern glass flute, the Longshan stem cups followed the age-old tradition of making an object in sections—tulip-shaped cup, stem, and foot—guided by the established mode of imagining, manufacturing, and finally assembling a series of parts—the same sectionalist approach that had been used to construct the earlier Neolithic wares. But in the Longshan examples, sectionalism was exploited to produce a shape that reveals itself as an assemblage and in that, Longshan pottery is very different from the more organic-looking wares of earlier eras. There is an engineered quality to the precarious construction of the Longshan stem cups, as though they were constructed from sheet metal and shaped on the anvil rather than the wheel. The possibility of the influence of an as-yet undocumented sheet metal technology in this early period is highly controversial. One might argue the reverse, that the thinly cast early bronze vessels which appear in the subsequent dynastic period were made in imitation of black pottery prototypes. However we understand the Longshan ceramic technology, we must recognize that this is a fundamentally new ware, drawing on the accumulated expertise of centuries of pottery-making, to produce an entirely original kind of ceramic unlike anything made in the earlier centuries of the Prehistoric Era.

The Longshan wares are precursors of things to come. The technology that underlies their production marks a major advancement in the control of heat, a skill that was essential to the casting of metals in the Bronze Age. Similarly, the extraordinary delicacy of the Longshan stem cup demonstrates the ability of the potters to manipulate clay in ways that made possible the construction of other vessels, including the crucibles that would contain molten ores and the molds that

would shape the fiery flux into vessels made of bronze. The kiln keepers of the Longshan culture already had one foot in the Bronze Age, for it was the descendants of these same masters who sculpted the clay models of bronze wares and carved the intricate patterns that embellished the surfaces of the ritual vessels, as they envisioned every stage of the process as a sequence of tasks governed by the rules of sectionalist procedures.

The ceramic craft tradition, if that is not a too modest a title, ran unbroken through several thousand years of pottery-making in the prehistoric period. Always evolving to a higher standard of sophistication, the tradition continued down to modern times, refining the art of pottery-making and, along the way, sharing the secrets learned by the potter-kiln masters with the masters of bronze-making and other arts.

Neolithic Pottery Then and Now

Throughout this essay, the reader has been provided with illustrations that purport to represent a pot in the clearest possible way. We should be cautious not to confuse the allure of a good illustration or dramatic exhibition with the reality of holding the object in our hands, or imagine that this is the way a Neolithic pot was seen or even thought about in antiquity. What would have been obvious to anyone using these objects would have been the weight, texture, size, and most especially the feel of the piece. The vast majority of excavated pottery is undecorated. Yet even in these utilitarian wares, we sense the focus on purpose: The clay used in the manufacture of the water jar from Banpo was carefully washed, allowing the potter to achieve a fine nonporous texture best suited to avoid evaporation. Food bowls from the same site were fashioned from less finely levigated clay, yet still have smooth surfaces that would not be displeasing to the touch of the hungry hand. Cooking vessels, on the other hand, are often of a coarser texture that facilitated the transmission of heat (here function influenced preparatory procedures) for efficient cooking.

Although decorated wares are in the minority of things discovered in the archaeological excavations, it is inevitable that they capture a disproportionate amount of our attention. Yet, any discussion of pictures or ornamental patterns, or the presumed meaning behind them, may distract us from recognizing a common sort of symbolism associated with all of the Chinese Neolithic wares: plain or otherwise, they all have to do with food.

Food is life. It sustains the body and nourishes the spirit. What we eat, meat raw or cooked, vegetables steamed or pickled, food that is spicy or mild, sweet or sour, is part of our cultural identity.

The nuance of preparing and serving food gives us our special sense of a particular self so that in the end we really are what, and how, we eat. The communal sharing of food is a trait around which we have created social institutions. Indeed, mealtime is the most dependable moment of family interaction. The more formal banquet presents an opportunity to bring together the extended family, the clan, tribe, or kingdom, as the circumstances require. In many religions, both ancient and modern, religious rites are centered on a shared meal made sacred by the ritual ceremonies that evoke a sense of communion between the living and the dead.[12]

We know the vessels discussed herein because they were deposited in tombs, which imparted a special symbolic function as grave offerings to these buried utensils. It is no different today. The cherished possession of a deceased loved one, placed tenderly in the coffin, is given special significance by the very act of pious remembrance. The placing of a food vessel in a grave initiated a shift in the meaning of the object from everyday utility to symbolic function and presumably signals a belief in an afterlife that required the same food and drink needed during life. Significantly, the burial of eating utensils acknowledges the social importance of the shared meal.

We are accustomed to seeing ancient Chinese and Japanese ceramics in a special setting, yet I doubt that even the most finely decorated piece was placed on a shelf for all to admire; if anything, it is more likely that the shaman's bowl, if I may call it such, was hidden from common view. These vessels were not the rarefied *objects d'art* that grace the display cases of museums but the vital utensils of everyday life and death. What is remarkable is that these robust pots stand as works of art for us today, many thousands of years after the anonymous potters who made them first put hand to clay.

Endnotes

1. Parts of this essay are excerpted from my forthcoming book *The Pottery of Ancient China*.

2. A photo of the vessel displayed at the Banpo Site museum; other vessels of this type are shown *in situ* in cone-shaped depressions in the floors of houses. The drawing reproduced in Fig. 1 is my own reconstruction originally published in Robert Poor, "The Circle and the Square: Measure and Ritual in Early China," in *Essays in Honor of Professor Harrie A. Vanderstappen, S.V.D., Monumenta Serica* (September 1995): 159-210. See especially p. 165 and Pl. V and Fig. 5, pp. 193-194.

3. Poor, "The Circle and the Square" illustrates my reconstructions of various Neolithic Period ceramics, and jades as well as early Dynastic bronze vessels.

4. *Ibid.*, 176ff. See also David Keightley, "Archaeology and Mentality: The Making of China," *Representations* 18 (Spring 1987): 91-128.

5. Discussed in well-illustrated detail in L. D. Caskey, *Geometry of Greek Vases, Attic Vases in the Museum of Fine Arts Analyzed According the Principles of Proportion Discovered by Jay Hambridge* (Boston: Museum of Fine Arts, 1922).

6. Earthenware jar, Japan, Middle Jomon Period. 2500-1500 BCE. Dimensions: 53.98 x 55.88 cm (21.25 x 22 inches). The Minneapolis Institute of the Arts, The Ethel Morrison Van Derlip Fund. Accession Number: 82.9.1.

7. Basin with design of human face and fish. Chinese, Neolithic Period. Yangshao Culture. H. 16.5 cm. Excavated in 1955 at Banpo. Banpo Museum, Xi'an, Shaanxi.

8. Xiaoneng Yang, *Reflections of Early China: Décor, Pictographs and Pictorial Inscriptions* (Kansas City and Seattle: The Nelson-Atkins Museum of Art and University of Washington Press, 2000), 49-51, offers a comprehensive collection of illustrations of these motifs; see especially Figs. 35, 42-43.

9. See J. Gunnar Andersson, *Children of the Yellow Earth; Studies in Prehistoric China*, trans. E. Classen (New York: Macmillan, 1934) for a popular account of his discoveries. Nils Palmgren, "Kansu Mortuary Urns of the Pan Shan and Ma Chang groups," *Paleontologia Sinica*, Series D, Vol. III, Fasc. 1, Geological Survey of China, Peiping (Peking) (1934) provides a comprehensive study of Andersson's finds.

10. Funerary storage jar, ca. 2400 BCE. Banshan type, earthenware with painted spiral decor. 37.15 x 40.01 cm (14.625 x 15.75 inches), The Minneapolis Institute of the Arts, The Ethel Morrison Van Derlip Fund. Accession Number: 89.9

11. Stem Cup, ca. 2500-2000 BCE. Burnished earthenware. Dimensions: 8 x 3 cm (8.94 x 3.31 inches). The Minneapolis Institute of the Arts, Gift of Ruth and Bruce Dayton. Accession Number: 2000.156.1.

12. This paragraph is excerpted from a syllabus for a seminar called "Food and Food Rituals in Ancient China" that I taught in 2001. The complete statement can be found at http://www.arthist. umn.edu/classes/AH8720/Spring2001/reading2.html.

Looking at Ornament:
The Red Lacquered Coffin from Mawangdui

Martin J. Powers

Possibly the most remarkable feature of ornament is its apparent universality. When the Jesuits began visiting China in the sixteenth century, they were unable to appreciate the expressionist brushwork of literati painting, but when it came to ornament, they had no difficulty discerning its general social import. In the late seventeenth century Louis Le Comte described the ornament of the imperial court as follows:

> These vast bases, with their balustrades made of white marble, and thus disposed amphitheater-wise, which when the sun shines seem covered with a palace glittering with gold and varnish, make, indeed, a glorious show, considering too, that they are thus placed in the midst of a spacious court, and surrounded by four stately rows of buildings: so that were its beauty enhanced by the ornaments of our modern architecture, and by that noble simplicity which is so much valued in our buildings, it would doubtless be as magnificent a throne as ever was raised by art.[1]

Despite its defensive tone, this passage specifies a good deal that could be applied to ornament in many times and places:
1. Material is at the heart of the matter: whether making use of gold, marble, or painted wood, ornament augments the material from which it's made with a dazzling display of periodic, jewel-like patterns (Figs. 1, 2).

Figure 1. Bronze belt buckle inlaid with gold and inset with jade. Art Institute of Chicago. Warring States Period.

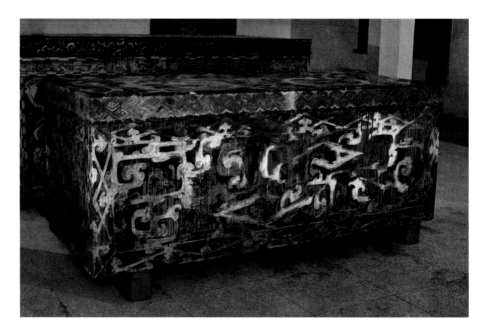

Figure 2. Red ground casket, Mawangdui Tomb #1, Hunan Provincial Museum, Hunan. Former Han dynasty, ca. 170 BCE.

2. Because it makes a glorious show of expensive material, ingenuity, or labor, ornament tends to have a large economic impact. For this reason the use of ornament is vulnerable to charges of extravagance, and so ornament frequently becomes the focus of contested social values. This is why Le Comte, anxious to cast a favorable light on Europe, contrasts the glorious show of Chinese architecture with that "noble simplicity" he attributes, somewhat incongruously, to the Baroque architecture of his native France!

3. Ornament signals group identity: it is immediately recognizable as belonging to China or France, a duke or a count, rich or poor, woman or man. This is why ornament was the favored medium for signifying the livery, insignia, and social rank of the nobility across Eurasia for much of human history.

4. Ornament is non-mimetic (not "realistic"), even when it is figurative. In this passage Le Comte doesn't mention the figures one typically sees on Chinese architecture. He may not have known what those dragons on the eaves signified and probably didn't care—the import of "the glorious show" was clear enough. Even when ornament consists mostly of figures, these figures often seem to emerge and disappear among the interstices of the design, as in Irish manuscripts. Ornament can achieve this effect precisely because it makes no claim to represent the ordinary world.

Let's have a closer look at these practices with the aid of an elaborately decorated coffin from classical China and dating to roughly 170 BCE.

The Lacquer Coffins from Mawangdui

The decorated wooden coffins or coffins made for the Marquess of Dai (Figs. 2, 3) show every kind of ornament from abstract patterns to lifelike monsters. The coffins were found at the center of a lavish tomb discovered at Mawangdui, Hunan Province. The occupant of this tomb is believed to have been the wife of Li Cang, the prime minister of the Kingdom of Changsha (appointed second century BCE), and the Marquis of Dai.[2]

The ornament on the coffins testifies in every way to Lady Dai's exalted status. The innermost coffin where she was laid to rest was the simplest, with nonfigurative designs only. The second and third coffins encasing that one were both generously decorated with figures of thin, feathered immortal spirits, as well as fantastic nature spirits, in addition to abstract designs. Both of these were first painted all over in one solid coat of lacquer paint—the third coffin in midnight black and the second in bright vermilion. At that time lacquerware was more expensive than vessels of

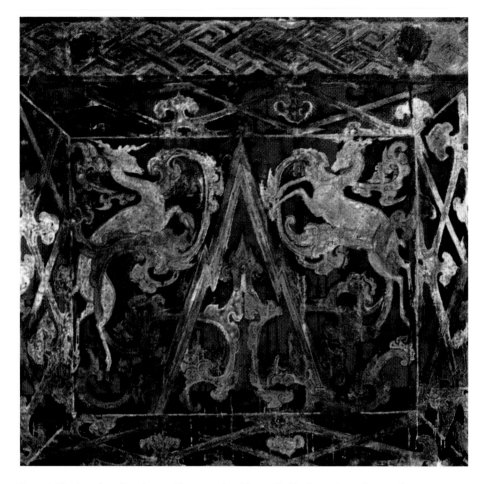

Figure 3. Head panel on the red ground lacquer casket, Mawangdui Tomb #1, Hunan Provincial Museum. Former Han dynasty, ca. 170 BCE.

bronze, so the base-layer lacquering alone gave the coffins a rich appearance. On top of this ground a drawing was made taking into account all the intercrossing patterns intended for the final design. The intricacy of the design naturally drew attention to the skill and ingenuity of the craftsmen. Then layers of thick lacquer stiffened with powder were applied where appropriate within the drawn contours (Fig. 4). Such lacquer is extremely difficult to manage and so this, too, served to display the artisan's dexterity. Additional coloring was added where necessary, as well as lines in ink detailing the form and texture of each figure. Finally, the outlines of cloud patterns were reinforced and elaborated with delicate but raised lines in stiff, heavy lacquer (Fig. 4). Considering that lacquer was so expensive, adding to its thickness gave the work an exceptionally luxurious tactile quality.

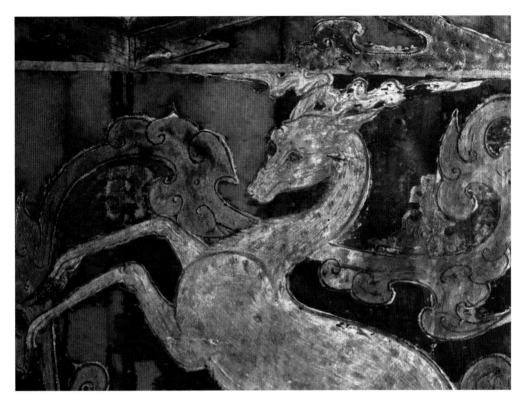

Figure 4. Immortal deer ascending the clouds. Detail of the head panel on the red ground lacquer casket, Mawangdui Tomb #1, Hunan Provincial Museum. Former Han dynasty, ca. 170 BCE.

Such luxury is hardly known elsewhere; how could even a marquess afford this level of extravagance?

It is unlikely that these coffins were the work of a single artist, nor is it necessarily the case that the artists worked in the shops attached to the court at Changsha. The imperial court supported several craft shops producing artifacts in bronze, lacquer, silk, and other precious materials.[3] These workshops operated under the auspices of the *Shaofu*, or "Privy Treasury." This treasury handled all funds and revenues relating to the emperor's personal use, as opposed to public monies derived from taxes, which were managed by the state. The court workshops produced artworks, clothing, and furnishings for the emperor, as well as gifts for dignitaries or officials. Among these was a workshop that specialized in funerary furnishings, and the emperor sometimes granted objects from this shop to important personages. At least some of the lacquer objects found in the tomb bear inscriptions identifying them as the work of imperial shops, so it is possible that some portion of Lady Dai's funeral and burial goods was arranged by imperial order.

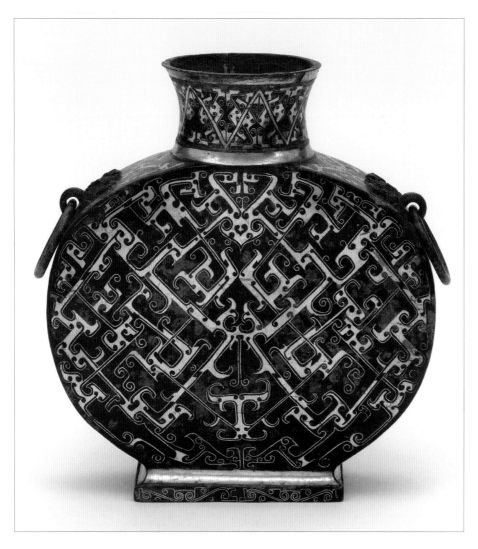

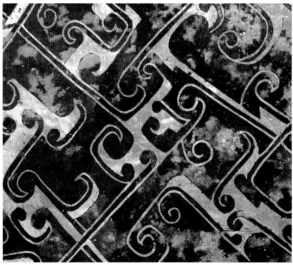

Above: Figure 5. Bronze bianhu wine vessel inlaid in silver. Freer/Sackler Galleries of Art, Washington, D.C. Warring States Period.

Left: Figure 6. Detail of the silver inlaid ornament on figure 5.

The Politics of Ornament

In classical China, artifacts were used to create material scales for ranking human dignity in a visible way. This is evident from a passage in *Sayings of the States*:

> (The appearance of) their attire and ceremonial vessels manifest their merit, and so the colors and ornaments were clear and distinct. The patterns and insignia resembled figures, and so their performance was in the proper order. As their appearance was beautified (with ornament),[4] levels of dignity were properly regulated.[5]

Similar methods were employed to distinguish social status in Medieval and Early Modern Europe. More often than not, on both ends of the Eurasian continent, the logic of the visual argument was fairly simple: more = "more." More material, more precious materials, or more elaborate ornamentation generally signified a higher level of prerogative. This was certainly true of the Mawangdui coffins. That Lady Dai was granted four coffins was a special mark of honor to which lesser ladies could not aspire. The level of ornamentation on the coffins was also commensurate with her status.

How would the luxurious appearance of Lady Dai's coffins have been appreciated at the time they were made? Would they have elicited universal awe? Or disgust? We know from other cultures that ornament is rarely neutral in effect. In Medieval Europe St. Bernard castigated those clerics who decorated their churches on the pretense that it glorified God. Likewise, William of St. Thierry observed that God loves humility and self-denial, so how could expensive ornament glorify Him?

> Banishing from ourselves and from our cells the pattern of poverty and the model of holy simplicity, the true beauty of God's house, bequeathed to us by our fathers, we build for ourselves by the hands of skilled craftsmen cells which are not so much eremitic as aromatic, each of them costing a hundred golden pieces. They are the delight of our eyes but they come from the alms of the poor.[6]

Of course exhortations such as these were not generally observed, particularly during the early modern period, but the association between ornament and excess remained a leitmotif over the centuries—Ruskin, for instance, considered Medieval ornament more "chaste" because it shunned the profusion of Baroque or Rococo ornament. Not long thereafter, on the very eve of the modern era, Adolf Loos

would declare ornament—quite literally—a crime. His argument, however, was not about impoverished people, but rather about impoverished culture. During the nineteenth century, in part due to the influence of Hegel, many Europeans came to believe that a nation's fate was determined by its national "spirit" or character, and that some national characters were more superior or more inferior. How could one tell? National character inevitably would be reflected in cultural production. As Loos declared: "The evolution of culture is synonymous with the removal of ornamentation from objects of daily use."[7] Since "primitive" people tend to favor ornament, Loos regarded the absence of ornament as the hallmark of the modern man:

> The evolution of culture is synonymous with the removal of ornament from the object of daily use.' Everything within the grasp of the Papuan is covered with ornament, from his face and body, to his bow and boat. However, today, tattoos are a sign of degeneration and only used by criminals and degenerate aristocrats. Contrary to the Papuan, the cultivated human thinks that an untattooed face is more beautiful than a tattooed one, even if the tattoos were made by Michelangelo or Kolo Moser themselves.[8]

This critique of excess resonates, faintly, with the tradition represented by Bernard and William de Thierry. But Loos, of course, was a product of his time; a close read of his essay reveals a Hegelian model in which art objects were regarded as an expression of their culture, and so: "In each case those objects were the expression of their culture and were produced by the master craftsman, in the same way as the farmer builds his house.[9]" For Loos, ornament still served as a scale against which to measure humanity, but it was a reversed scale. Modern—which is to say, civilized—artifacts would be recognized as modern precisely by the absence of ornament.

Despite their different scales of value, both William and Loos based their critiques on the argument that ornament is an adjunct, an excrescence, either unnecessary or wasteful in a world of practical needs. Comparable arguments would have been familiar to courtiers at the time Lady Dai's coffins were made. In fact, in China such critiques can be found throughout the period leading up to the Mawangdui coffins and for centuries beyond. One of the better-known arguments appears in the book of *Mozi* (see Fig. 1):

Therefore when wise rulers had their clothing made, it was to suit the needs of the body and that is all. It was not to bedazzle the eyes and ears or to befuddle the people with the pleasure of viewing beautiful artifacts. . . . Today's rulers are not at all like this when they have clothing made. Their clothing being already light and warm in winter and light and cool in summer, they must yet levy heavy taxes on the people, robbing the people's property in food and clothing so as to make brocades and embroideries for fine, decorated garments. They cast metal so as to make belt buckles and use jewels and jade to make belt ornaments. . . . This then causes the people to prize excessive and rare things, which makes them difficult to govern. At the same time their lord is self-indulgent and extravagant and unresponsive to criticism. If a self-indulgent and extravagant lord rules over people who desire excessive and rare things, and yet expects to avoid social disorder, he will surely fail.[10]

Mozi placed the expense for aristocratic ornament directly onto the backs of the people. In this view, the jewels and brocades adorning noble bodies bore witness to the theft of what rightfully belonged to the people. As if this weren't bad enough, the people would acquire a taste for ornament and so imitate the court's avarice. The people would wax greedy while the court wallowed in self-indulgence, unresponsive to social criticism. In classical Chinese political thought, a government unresponsive to criticism was sure to collapse. William's argument appealed to religious values while *Mozi's* argument was secular and political, but both laid the blame for poverty at the feet of an extravagant, privileged class.

But why blame those who merely owned beautiful ornaments? Why do most writers not blame the artisans who made them? The reason is that ornament tells us little about the artist, as a Chinese literati painting or a modern painting might; nor does it tell us much about the world "out there," as mimetic ("realistic") pictures do. The content that ornament conveys ultimately refers to the one who *owns* it. That is why ornament is so useful in marking a person's social role, status, or identity.

Ornament and Identity

Ornaments often make use of conventional designs, but any given design is conventional only in relation to a particular community. As Adolf Loos observed: "If I could dislodge all ornaments from our old and new houses, so that only naked walls remained, it would certainly be difficult to differentiate the house of the fifteenth century from that of the seventeenth. But any layman could pick out the houses of the nineteenth century at first sight."[11] In order to reliably duplicate those designs favored by a given community, each ornament is created according to a particular set of design *procedures*, rules of thumb that craftsmen learn and pass on to their apprentices. Granted that ornament thrives on theme and variation, the kinds of variation permitted will be limited by those procedural rules. It is periodic obedience to these rules that announce the ornamental nature of ornament.

Consider the red ground coffin at Mawangdui. The band along the border (Fig. 2) is of a type associated with Southern China. Objects bearing such designs often come from the region formerly belonging to the State of Chu (regions now occupied by provinces such as Hunan and Sichuan). A good example is the silver inlaid *bianhu* wine vessel housed in the Freer/Sackler Galleries in Washington, D.C. (Figs. 5, 6). Designs from this region tend to be aligned along a diagonal grid, visible in the top and bottom bands that border the coffin, and more clearly in Figure 3. The use of a diagonal grid works against partitioning the band, as would occur with a horizontal/vertical grid. On the contrary the use of diagonals permits the designer to integrate different elements of the design by interlocking all space and everything in it.

Another procedural rule evident in such patterns is the frequent interchange of figure and ground. This is accomplished by keeping the background area similar in size and shape to the figures painted upon it. In addition, the width of the bands that make up the design may change abruptly in width. As the bands grow thick or thin, what had been a figure on a ground suddenly turns into the ground for another figure (Figs. 5, 6). These two procedural "rules" have the effect of integrating the design into a seamless whole rather than breaking it up into discrete units. In Han times, these qualities, which tended to showcase the designer's ingenuity, were associated with the region of Chu.

How Ornaments Mean

What does this pattern tell us about the people of Chu? One can think of an ornament as a kind of demonstration, for a decorated artifact is a direct record of the thought, care, and labor required for its production. Because ornament may belong to a community, as when it decorates public architecture, it can encode a good deal about community practices and priorities. Is the ornament dense or sparse (profligate or frugal)? Is it applied evenly (with care) or capriciously? Is the design difficult (expensive; exclusive) or easy (inexpensive; accessible) to conceive and execute? Does it employ a variety of forms (a taste for novelty) or merely a few (a preference for the familiar)? All such properties in some sense establish a scale and thus are quantitative: one can distinguish degrees of complexity or evenness, for example. But each of these *quantities* could be interpreted as a material demonstration of human *qualities* such as effort/care, skill/knowledge, discipline/reverence, ingenuity/thought and so on. It follows that every ornament is a demonstration of a set of human qualities, and so a simple ornament can provide a "pattern" for social conduct. Whoever possesses the ornament, claims to possess those qualities. In this respect the ornament demonstrates a social pattern to which the owner implicitly subscribes.

There is another way in which ornaments can convey social value. Through a process much like metonymy, ornamental figures could stand for various desirable properties and these, in turn, would be attributed to the ornament's owner. For example, the royal robes in classical times often had figures of the sun, dragons, or mountains embroidered upon them. The *Record of Rites* explains: "[The significance of images of] the sun and moon derives from their brilliance; that of the mountain derives from its stability; that of the dragon derives from its flexibility."[12] Most likely these embroidered designs were not naturalistic; rather, they would have retained sufficient periodicity to announce themselves as a "pattern," an image that tells us something important about the bearer as opposed to the real world.

In the case of the borders decorating this lacquered coffin, the complexity of the design reveals a delight in mind-bending ingenuity. Unexpected twists and turns in form betray a taste for aesthetic surprise, and the quickly brushed-in strokes reveal a healthy disregard for finicky precision. These are qualities one can find in a wide range of ornaments associated with the State of Chu between the fourth and second centuries BCE. But the ornaments covering the central portions of each panel on this coffin have another story to tell. Those ornaments press the boundaries of what an ornament can be. Those ornaments virtually come to life before our eyes.

Figure 7. Jet stream clouds over Ann Arbor, September, 2010.

Ornament and Fantasy

The designs occupying the body of the red ground coffin are different in kind from those along the borders. These shapes seem to hover between ornament and animal, between fact and fancy: they are vivacious like living things yet remain obedient to the procedural rules of the craftsman's shop. Consider the cloud designs on the main panels of the coffin, as opposed to those in the narrow bands along the border (Fig. 4). Like jet stream clouds (Fig. 7), these designs billow up into puffy cusp-like forms and leave long streamers behind. But upon closer inspection we find that, despite their endless variety, each cloud unit has been constructed according to exactly the same procedural rules. Each and every unit of the design is made up of a long, shallow curve that expands and finally ends in a mass of cusp-like forms (Fig. 4).

This unit derives from the scroll and volute motif of earlier designs found on bronzes and lacquers from about the fourth century BCE (Fig. 6). Like earlier scrolls, it follows a rule of alternation, with new scrolls shooting out in alternate directions, now left, now right, now up, now down. It differs from earlier volutes because the cusps are highly irregular. Unlike the periodic shapes of earlier scrolls, these cusps can be modified to suggest natural shapes—not merely clouds but even body parts such as a shoulder, a claw, or a nose (Figs 8, 9). This same scroll and cusp unit appears throughout the design as "cloud" scroll, in which case the "cusps" mimic the structure of clouds curling back due to wind and turbulence (Figs. 4, 7). In other words, these cloud motifs function like ornaments that, as Max Loehr once observed, have somehow come to life. [13] How was this accomplished?

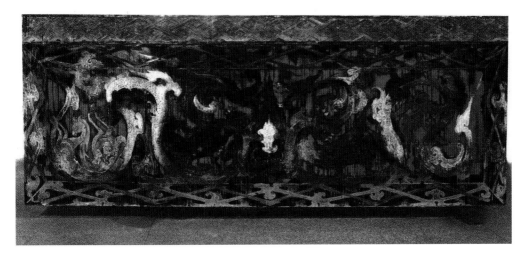

Figure 8. Dragon, phoenix, tiger, and deer like creature. Side panel on the red ground lacquer casket, Mawang-dui Tomb #1, Hunan Provincial Museum. Former Han dynasty, ca. 170 BCE.

Some of the earliest texts to describe ornament in China distinguish a special kind of ornament called *bixiang*, which is to say an ornament that "resembles a (recognizable) image." This can only mean that a conventional design was shaped in such a manner as to call to mind an object without actually attempting to represent it convincingly, for clearly *it retains its identity as an ornament*. The commentator Wei Zhao explains that *bixiang* means "to compare a pattern to the figure of something like a mountain, dragon, flowers, insects and so on."[14] Such an act of comparison requires the exercise of imagination: by its very nature it alerts the viewer that she is engaging in an act of fantasy, for the ornamental nature of the ornament is nowhere denied as it would be in more illusionistic art. This conscious act of fantasy harbored social connotations because, as noted above, what is significant about figures in ornament is the qualities they stand for by metonymy. It is these qualities that would be attributed to the owner.

Viewers of the red lacquer coffin at Mawangdui may have approached it with a similar set of expectations. On the side of that coffin we find a panel dominated by three animals: to the right is the Chinese phoenix, king of the birds, gorgeous and grand. The animal to the far left looks like a hornless deer with a beautiful, flowing mane (Fig. 8), while the animal beside it is a tiger. We should note that some of the bright vermillion ground of the coffin has oxidized and formed black streaks like dripping water behind the deer, and some of the cloud patterns have darkened. One should imagine that, except for the deer and the cloud patterns outlined in thick, raised lacquer, the entire ground was originally a smooth, glossy red.

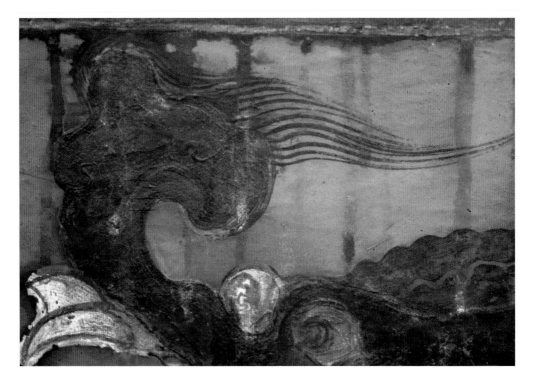

Figure 9. Dragon's head, featuring the nose. Detail of the side panel on the red ground lacquer casket, Mawang-dui Tomb #1, Hunan Provincial Museum. Former Han dynasty, ca. 170 BCE.

All three animals are shown floating among roiling patterns conventionally understood to represent swirling clouds. These three animals—the phoenix, the "white tiger," and the immortal deer—appear together with the dragon in a poem close in date to the Mawangdui coffins. The poem describes the imaginary tour of a man who has become an immortal spirit, or *xian*. In the narrative of the poem this adept takes flight in the company of these animals after first learning the secrets of immortality from the famous immortals Chi Song and Hang Qiao. Having acquired the power to command the forces of nature, he soars upward in the company of divine beasts:

> The White Tiger makes up my retinue.
> Floating on cloud and mist, we enter the blue;
> Riding the white deer, we sport and pleasure.
> On and on my soul speeds, seeking a lonely dwelling;
> Swiftly it goes forth, never again to return.
> Aloft and aloft we go, ever more distant,
> Till my mind is unsettled and my heart replies.
> The phoenix soars up into the azure clouds

Where the fowler's barbed cord can never reach him.
The dragon lies low in the swirling waters
Where he cannot be caught with nets.[15]

Flying high or low, beyond the reach of harm, soaring in the empyrean without restraint—this is a vivid description of the soul's freedom in the afterlife, paradise if ever there was one. But it isn't that the coffin illustrates the text, which may be somewhat later in date; rather, both are informed by a common mythological tradition reflected in any number of Han dynasty images of the immortal's paradise. One of the common features of that tradition is the sacred mountain that is often the site of the immortal's paradise. The mountain gives birth to clouds while the spirits ride the clouds to the empyrean. On the red coffin, the three-peaked triangles behind the deer may well allude to sacred mountains (Fig. 3).

In addition to a shared mythological tradition, both the poem cited above and the Mawangdui coffins share a common understanding of the curvilinear nature of atmospheric motion. That is why, in both media, these animals, and their spirit journey, could have aroused in ancient viewers dreams of free flight, a dream particularly suitable for sending a noble lady to eternal rest.

How was that dream of unbounded motion reimagined in visual form by the artisans who painted this coffin? First, the artist avoided the use of any stable spatial referent such as a ground line or horizon. Like the protagonists in the poem, the deer at the head of the coffin seem to float on roiling clouds, for there are no indications of any earth-bound setting. The deer on the right (Fig. 4), for example, straddles its way upwards through cloud patterns that seem to turn and wind in every direction. Some clouds twist and thrust their way between the hind legs, which hang in midair. Others curve in front of the forelegs as though to provide a foothold for the next leap toward the sky. In both cases the cloud patterns seem to move back and forth, in front and around in a way that implies complex and constantly shifting spatial relations.

The wide use of arabesques in scenes of spirits and immortals can be interpreted as a pictorial device for expressing that escape from space and time that immortals and other spirits enjoy. We find much the same device employed in the *Book of Master Huainan* written around the end of the second century BCE. Striving to convey the radical absence of boundary, this author imagined heavenly flight as curvilinear: "[These wise men] rode on a cloud carriage, entering the rainbow and floating on thin air and mist. They climbed into the wild, chaotic flow, rising in circling spirals like those of the ram's horn" (see the horns and clouds in Fig. 4).[16]

49

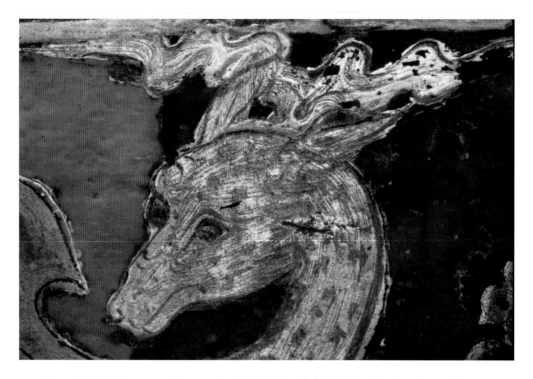

Figure 10. Head of the immortal deer ascending the clouds. Detail of the head panel on the red ground lacquer casket, Mawangdui Tomb #1, Hunan Provincial Museum. Former Han dynasty, ca. 170 BCE.

The imagery we find at Mawangdui allows us to reconstruct in some sense the awe that ancient people must have felt at the boundless expanse, the limitless freedom, and the mysterious rapidity of change to be seen in the skies and all the creatures who travel there. That this boundless potential should fix upon the metaphor of the curve in both literature and art is hardly surprising—flying things do move in curves, while earthbound things move from side to side.

As just noted, the alternate intercrossing of parts of the deer and the cloud patterns in Figure 4 helps to create a sense of area surrounding the deer. Although the space is shallow by the standards of a later age, the sense of volume created by the body of the deer itself should not be underestimated. In the detail in Figure 10 we can see that the head of the deer was conceived in three-quarter view. We might have thought that the white ground upon which it is drawn would have been laid on flat, awaiting the articulation of the final drawing to give it volume. But a close look at the brush marks in the ground shows that they were laid down in keeping with a conception of the three-dimensional head as it was intended to look. The strokes on the cheek, nose, and forehead of the deer create planes in space that give volume to the head as a whole.

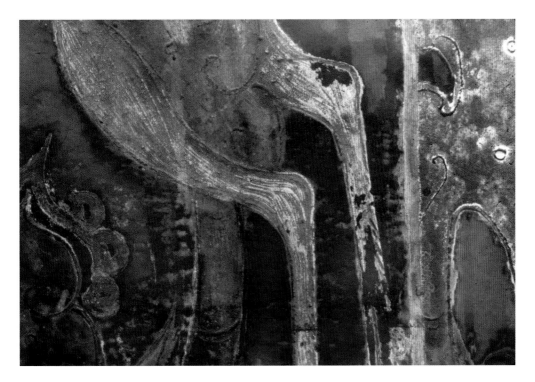

Figure 11. Hind legs of the immortal deer ascending the clouds. Detail of the head panel on the red ground lacquer casket, Mawangdui Tomb #1, Hunan Provincial Museum. Former Han dynasty, ca. 170 BCE.

Apart from the treatment of volume in the deer, subtle details also bear witness to focused observation on the part of the unknown painter. In the head, the straight ridge of the nose bone is carefully distinguished from the soft cartilaginous muzzle, which slopes roundly to a point (Fig. 10). In the feet also the several points above the cloven hoof are well delineated, as is the transition from flesh to bone at the "elbow" bend in the rear legs (Fig. 11). Needless to say, the artist could not have rendered things so convincingly had he or his master not spent considerable time studying how a deer's legs, in fact, join together.

This level of naturalistic detail might seem incongruous with the ornamental nature of the design. Is such a figure even an ornament? In fact there is no contradiction here. First, the bodies of all the animals represented on the coffin are organized like any cloud design, as flowing extensions in space which cross over, in front of, or behind other such extensions. What we actually see are no more than extensions and cusps, just as with any cloud design, even if those cusps have been exquisitely manipulated so as to "compare to," or "call to mind" the body parts of real animals. And precisely because these figures remain obedient to the procedural rules of ornament, in the end this painting's referent is not the world "out there,"

but rather the Marquess of Dai, no different from the insignia that may have been embroidered onto her shoes. We may conclude that the vigor, the beauty, and the unbounded freedom that these creatures embody, in the final analysis, was meant to have been enjoyed by the lady herself, in her newly transformed state.

Endnotes

1. Louis Le Comte, *Memoires and Observations. . . made in a late journey through the empire of China* (London: Printed for Benj. Tooke ..., and Sam. Buckley ..., 1697), 39.

2. Michael Loewe, *Ways to Paradise: the Chinese Quest for Immortality* (London: George Allen & Unwin, 1979), 17-34. For a discussion of the banner and its iconography, see Wu Hung, "Art in a Ritual Context: Rethinking Mawangdui," *Early China* 17 (1992): 111-144.

3. See Anthony J. Barbieri-Low, *Artisans in Early Imperial China* (Seattle: University of Washington Press, 2007), esp. Chapter 3.

4. "*Chong* 崇 literally means "lofty; sublime." The Han dynasty gloss, however, interprets it as "ornament." The underlying idea is that their dignity was displayed in the ornaments that determined their appearance.

5. *Guoyu* 國語, ed., *Shanghai Normal University Classical Texts Collation Group* (Shanghai: Shanghai gu ji chu ban she, 1978), 2B:65-66.

6. William of St. Thierry, *The Golden Epistle: a letter to brethren at Mont Dieu*, trans. Theodore Berkeley OSCO (Spencer, MA: Cistercian Publications, 1971), no. XXXVI.

7. Adolf Loos, *On Architecture*, selected and introduced by Adolf and Daniel Opel, trans., Michael Mitchell (Riverside: Ariadne Press, 2002), 104.

8. *Ibid.*, 31.

9. *Ibid.*, 105.

10. *Mozi jijie* 墨子集解, Edited by Zhang Chunyi 張純一. Reprint. Originally published: Shi jie shu ju, 1936. Taipei: Wenshizhe chubanshe, 1971), 1.52-3; translation adapted from Yi-pao Mei, trans., *The Works of Motse* (Taipei: Confucius Publishing Co., 1980), 46-48.

11. Loos, Architecture, 106.

12. *Liji jijie* 禮記集解 (The Book of Rites with collected annotations), ed. Sun Xidan 孫希旦 (Beijing: Zhonghua shuju, 1989), 31.855-31.856

13. Max Loehr, "The Fate of Ornament in Chinese Art," *Archives of Asian Art*, 21 (1967-1968): 12-13. For a general analysis of the style and iconography of Former Han works in this tradition see Wu Hung, "A Sanpan Shan Chariot Ornament and the Xiangrui Design in Western Han Art," *Archives of Asian Art* XXXVII (1984): 38-59.

14. For a discussion of these texts and this problem see Martin J. Powers, *Pattern and Person: Ornament, Society, and Self in Classical China* (Cambridge: Harvard University Asia Center, 2006), 75-78.

15. David Hawkes, trans., *Songs of the South: An Ancient Chinese Anthology of Poems by Qu Yuan and Other Poets*, (Oxford: Clarendon Press, 1959), 81-87.

16. *Huainan honglie jijie* 淮南 鴻烈集解 (the *Huainanzi*, with the assembled commentaries), edited by Liu Wendian 劉文典, annotated by Feng Yi 馮逸 and Qiao Hua 喬華, 2 vols. (Beijing: Zhonghua Shuju 1989), 1.5-1.6.

Looking at Chinese Calligraphy: The Anxiety of Anonymity and Calligraphy from the Periphery

Amy McNair

The appreciation of calligraphy goes back at least two thousand years in China and, quite likely, much farther than that. Although critical texts discussing calligraphic style date back only to the first century, it is hard to imagine that no one appreciated the design and execution of some of the earliest writing. Cast into a bronze ritual vessel from around 1200 BCE is the name of the royal consort for whom it was made, a woman called Fu Hao.[1] A comparison with the characters for her name written in a contemporaneous oracle bone inscription reveals that its elements have been duplicated and redistributed into a design that features mirror symmetry and a pyramidal stability (Fig. 1). The bronze design is intentionally beautiful, rather than immediately legible, which the oracle bone inscriptions, as historical documents, were meant to be. The intentionality and dominance of the design aspect of this calligraphy strongly suggests it was meant for the aesthetic appreciation of Fu Hao and her contemporaries. We do not know who wrote her name into the clay of the bronze mould; perhaps the lady herself did not, and if she cared about who the artist was, we will never know.

The rise of calligraphy criticism in the first century, however, was joined with the notion of graphology, or handwriting analysis, in which the viewer attempts to read aspects of the artist's character, demeanor, and physical appearance from the traces of his brush. The basis for the traditional passion for graphology is likely found in the first purpose for the collecting of calligraphy, which was as a memento of the writer.[2] Traditional critics and collectors believed that one could "see the man in his writing," so when they looked at a letter written by a friend, they "saw"

Figure 1. Left: *Fu Hao*, ca. 1200 BCE. Ink rubbing, from her square tripod ritual vessel, collection of the National Academy of Social Sciences. From *Zhongguo shufa quanji: 2: Shang Zhou jin wen* (Beijing: Rongbaozhai, 1993), pl. 2. Right: Drawing of oracle bone inscription, characters reading "Fu Hao." From Cao Dingyun, *Yinxu Fu Hao mu mingwen yanjiu* (Taibei: Wenjin chubanshe, 1993), 120.

Figure 2. *Cuan Baozi Stele*, detail. Ink rubbing, collection of the National Library of China. From *Zhongguo guojia tushuguan bei tie jing hua*, 8 v. (Beijing: Beijing tushuguan chubanshe, 2001), vol. 3.

the friend.[3] To see the trace of someone you know in his handwriting is largely an act of memory and association, but to take that "seeing" a degree farther, into the realm of graphology—that is, to see a man you never knew in his writing—that becomes an act of imagination. To support that act of imagination, unavoidably the critic will bring what he or she does know or can infer about the artist to the interpretation. As such, the critical judgment will reveal as much about the critic as about the artist. When the artist is unknown, however, critics must supply more from their own perspectives in order to make an assessment, and so the range of critical judgments on an anonymous work of calligraphy will be greater, and the critics' ideological convictions and cultural prejudices will stand out more vividly. An excellent case study in this phenomenon is the anonymous engraved stele inscription for Cuan Baozi (Fig. 2).

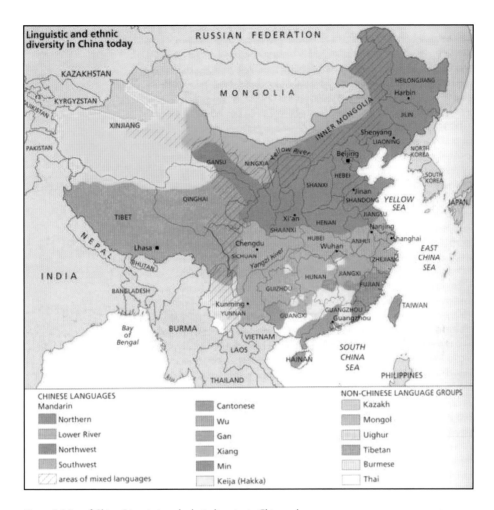

Figure 3. Map of China: Linguistic and ethnic diversity in China today.

After introducing the *Cuan Baozi Stele*, I will look closely at the formal qualities of the calligraphy. These should be examined as objectively as possible so that we can understand the various subjective interpretive strategies that have been brought to bear upon this work by twentieth-century scholars. Next, I will introduce some of the factors, having to do with the time and place in which this calligraphy was believed to have been written, that have made it open to various interpretations. Finally, having given the reader the range of information known to the scholars who have written about the *Stele for Cuan Baozi*, I will review some of their critical assessments. Hopefully this will allow us to understand how those scholars were informed by their convictions and motivations.

The inscription on the stele for Cuan Baozi is dated to the year 405, but the stone was lost to history until the year 1778, when it was excavated in the village of Yangqitian, 35 kilometers south of the modern city of Qujing, in Yunnan Province (Fig. 3). Yunnan Province is in far southwest China, bordering Myanmar, Laos, and Vietnam to the south and the Chinese provinces of Sichuan to the north and Guizhou to the east. Qujing is located northeast of Kunming, the modern capital of Yunnan. By 1852, when Deng Erheng arrived as governor of this area, the epigraphy studies movement had been under way among elite scholars throughout China for a few decades, so interest in early engraved inscriptions was considerable. Scholars of paleography and epigraphy were eager to collect and study any newly rediscovered work of calligraphy from antiquity, so travelers to Yunnan took ink rubbings from the stele to give as rare and elegant gifts to educated friends.[4] They were soon followed by professional sellers of ink rubbings. One of their unscrupulous practices was to take several ink rubbings from a stone engraving and then to damage it, in order to drive up the value and price of their ink rubbings. Perhaps to ward off such an event, Deng Erheng had the stele moved into the city of Qujing and set up in the Temple to Zhuge Liang.[5] He did this, he said, in order "to treasure this work for the people of this county."[6] In the twentieth century, the Temple to Zhuge Liang was converted into the No. 1 Middle School, and in 1961, the stele and the pavilion it stands in were designated an Important National Cultural Relic Protection unit.

The inscription has several parts, so we will look at them in the order in which they were intended to be read (Fig. 4). At the top is the heading, in larger characters, which reads: "Tomb of Commandery Governor Cuan, the late Awe-inspiring General and Governor of Jianning of the Jin Dynasty." Below this is the body of the text, which is a eulogy for the deceased, Cuan Baozi, who died at the age of twenty-three. The first section on the right is a biographical statement, written in the highly stylized "parallel prose," which contains the scant facts about the brief life of Cuan Baozi. This is followed to the left by a much longer eulogy in four-character lines of poetry, which extols his personality and character. On the extreme left edge, the line at the end gives the date as the fourth year of the Daheng era, which may be interpreted as the year 405.[7] Lastly, at the bottom of the stele are the names of thirteen local men, who have official titles and who may have been responsible for the setting up of this stele.

What is absent that would typically appear on such a monument is the name of the author and of the calligrapher. In other words, this is an anonymous work of art. Further, there is no other historical record concerning Cuan Baozi or any

Figure 4. *Cuan Baozi Stele*, complete, 1.9 m x 0.71 m. Left: ink rubbing, with 1852 inscription by Deng Erheng in lower left corner; right: ink rubbing, pre-1852. From *Cuan Baozi bei* (Beijing: Wenwu chubanshe, 2008), frontispiece.

of the other local men. This absence of biographical background created both a freedom and an anxiety for the traditional critics and connoisseurs. They were freed from the possible distortions of "seeing the man in his writing," and that freedom allowed some critics a more unmediated encounter with the content of the text, the orthography, and the calligraphy, yet the uncertainty of authorship also gave rise, in others, to anxiety and speculation about the ethnic and cultural background of the author and the calligrapher.

A good way to begin when looking at calligraphy is to categorize the script type. A single script type for this inscription is not easily identified, however, and connoisseurs see elements of both the old-fashioned clerical script, which was in widespread use in the Han dynasty (206 BCE-220 CE), and the modern regular script, which began to develop in the third century. Kang Youwei (1858-1927), the great statesman and epigrapher, was the first scholar to comment on the *Cuan Baozi Stele*, and it was his opinion that its script type lay "between clerical script and regular script."[8] The modern epigraphy scholar Ma Guoquan (1931-2002) said, "While some call this stele clerical script, and others call it regular script, from the perspective of its brushwork and character composition, it is more appropriately seen as regular script."[9] This is a more scientific statement, since if most of the characters in the *Cuan Baozi Stele* can be shown to have regular-script character compositions—referring to the number of individual strokes and how they are put

Right: Figure 5. *Cuan Baozi Stele*, detail. Above: *she*; below: *fang*.

Below: Figure 6. *Cuan Baozi Stele*, detail. *Jun*.

together—then the script type is appropriately identified as regular script, since it is the more evolved script type. Yet Ma does acknowledge the "lingering flavor" of clerical script and lists several features of the brushwork that belong to clerical script. These include diagonal strokes that end in rising, flared shapes and the so-called mouth element drawn as a square box instead of the trapezoidal shape common to regular script. The characters *she* and *fang*, for example, not only have the low, wide shape characteristic of clerical script, but also the flared, flipped endings to the final *fu* strokes at the lower right of each character (Fig. 5). The character *jun* shows both a flipped ending diagonal stroke on the lower left and the "mouth" element drawn as a square box (Fig. 6).

Another formal quality to examine in calligraphy is the relative size of the characters. In this, the *Cuan Baozi Stele* exhibits a remarkable variety. To modern eyes trained by reading the identical-sized characters in a printed book or even in a typical hand-written inscription, the variations in size of the characters in this calligraphy are rather striking. For example, the characters *zi* and *zhi* below

Figure 7. Left: *Cuan Baozi Stele*, detail. Right: *Epitaph for Tang Yao*, 528, 41.2 cm x 45.5 cm, collection of the Forest of Steles, Xi'an, detail. Ink rubbing reproduced from *Muzhi shufa jingxuan*, v. 1 (Beijing: Rongbaozhai, 1990), 17.

are quite small in comparison to the characters *fa* and *miao* above them (Fig. 7). By contrast, the *Epitaph for Tang Yao*, written in 528, shows a more "modern," regularizing impulse to write all the characters, even those with just a couple of strokes, so as to fill the same space.

Proportions of characters in the *Cuan Baozi Stele* inscription are not standard either. Not only are many characters not uniform in height, other characters are not uniform in width, as seen in the characters *su* (which looks too slender) and *gan* (which looks too wide) (Fig. 8). In addition to this, elements in many characters are structured or placed in ways that seem unbalanced compared to regular-script examples from around the same time. With *le*, for example, the standard way to form the lower part of the character is to use the four strokes to create a balanced support for the upper half of the character (Fig. 9). Yet in the same character in the *Cuan Baozi Stele*, the artist has flared out the strokes into upward-curving dots, effectively turning the lower half of the character into a smaller, hemispheric shape that seems to balance the whole character on a single point. Compare this to the same character in the *Epitaph for Xi Zhen*, dated to 523 (Fig. 9). Here the central stroke remains a vertical stroke, and the other two strokes balance themselves along a ground line. This is a modern way to write this character, which by contrast makes the Cuan Baozi version look awkward. The internal proportions of some characters

Figure 8. *Cuan Baozi Stele*, detail. Above: *su*; below: *gan*.

Figure 9. Above: standard printed character *le*. Left: *le, Cuan Baozi Stele*. Right: *le, Epitaph for Xi Zhen*, 523, 47.3 cm x 46 cm, collection of the Forest of Steles, Xi'an. Ink rubbing reproduced from *Muzhi shufa jingxuan*, v. 6 (Beijing: Rongbaozhai, 1992), 20.

Figure 10. Top: standard printed character *xing*. Below, left: *xing*, *Cuan Baozi Stele*. Right: *xing*, *Epitaph for Yuan Zhen*, 496, 66 cm x 66 cm, collection of the Forest of Steles, Xi'an. Ink rubbing reproduced from *Muzhi shufa jingxuan*, v. 6, 9.

Figure 11. Left: variant *yuan* characters. From Qin Gong, comp., *Bei bie zi xin bian* (Beijing: Wenwu chubanshe, 1985), 172. Right: *yuan*, *Cuan Baozi Stele*.

Figure 12. Above: standard printed character *yong*. Below, left: *yong*, *Cuan Baozi Stele*; below, right: *yong*, *Shi Chen Stele*, 169.

are also nonstandard and unbalanced. In the character *xing*, for example, the artist has shifted the lower *xiang* element over to the left side of the character (Fig. 10). Compare this to how it is centered in the same character from the *Epitaph for Yuan Zhen*, done in 496. These kinds of structural imbalances have been interpreted by some critics as evidence of archaism, normally an attractive quality, while others find it rustic or provincial, which is less so.

Lastly, in our discussion of the size and structure of the characters, we turn to the issue of orthography. By orthography is meant the degree of conformity of the arrangement and number of strokes and constituent elements in a character to a generally recognized standard, for any given script type. Since the eighth century, under the Tang dynasty (618-907), there has been general agreement on how individual regular-script characters should be written, and this has become the standard orthography.[10] Any character that does not accord with the standard version is termed a variant character. According to Ma Guoquan, the Cuan Baozi inscription has at least three categories of variant characters.[11] One category is characters that are written in variant forms seen only in this stele. A good example is the character *yuan*. As a page from a modern compilation of variant character forms reveals, there were many ways to write the character *yuan* in medieval times (Fig. 11). The way it is written in the *Cuan Baozi Stele*, however, is unique; that is, it is not found in any other writing.

Within a second category of variant characters are those that are also found in earlier stele inscriptions from the Han dynasty—about two hundred years before this stele. One example is the character *yong* (Fig. 12). Comparing *yong* in the *Cuan Baozi Stele* to *yong* from the stele set up at the Confucius Temple in Qufu in the year 169 by the official Shi Chen, even though the Shi Chen stele inscription was written in clerical script, we can see the nonstandard orthography is the same as in the *Cuan Baozi Stele*. The third category consists of variant characters also seen in inscriptions done in the late Northern Wei dynasty (386-534), around a hundred years after the *Cuan Baozi Stele*. The character *yin*, for example, is written in the same abbreviated fashion in the *Cuan Baozi Stele* as in the *Epitaph for Tang Yao*, which is dated to 528 (Fig. 13).

Beyond variant characters, there is the difficult issue of miswritten characters. One hesitates to declare something wrongly written, especially if it is legible, but certain characters in the *Cuan Baozi Stele* do call attention to themselves in this way. In looking at the character *cang*, the modern eye typically perceives as a mistake the way the left-hand diagonal *pie* stroke in the upper part of the character extends downward into the space between the three dots of the "water" radical (Fig. 14).

Figure 13. Above: standard printed character *yin*. Below, left: *yin, Cuan Baozi Stele*; below, right: *yin, Epitaph for Tang Yao*, 528.

Figure 14. Above: standard printed character *cang*. Below: *cang, Cuan Baozi Stele.*

Since the number and composition of the strokes in this character *cang* accord with the standard orthography, it cannot be termed a variant character. Rather, this character would be judged miswritten, since part of one element has intruded into the proper space for another.

One last formal element to examine, which in many cases is the most difficult to describe, is the style of the calligraphy. One aspect of the style of this inscription that many critics have considered its most striking aesthetic effect is the unusual and lively way that strokes flare or float upward at both ends. Many critics use similes evoking flight or scattering to describe it. Another extraordinary aspect of the style is the combination of what a traditional Chinese critic would call "square" and "round." Some of the brushwork is "square." The principal hallmarks of "square" writing are that the ends of the strokes are sharp and angular, and there

is a great deal of modulation (thickening and thinning) in the shape of individual strokes. Yet this writing also exhibits "round" brushwork. That is, many strokes have smooth, rounded ends, and the strokes themselves show little modulation, as though produced by a brush that was applied with even pressure throughout the stroke. Most calligraphers would not combine the two modes of "square" and "round" into the same work. To do so creates an uncommon visual tension. Lastly, something I particularly like about this work is the contrast between the organic quality of the upward curving ends of the brushstrokes and the squared, upright compositions of the characters and their four-square alignment along the vertical axis. See, for example, the character on the bottom left in Fig. 2.

To enjoy the visual tensions created by combining opposed modes is a modern undertaking, with which most traditional critics would not have agreed. The Japanese scholar Hibino Takeo (1914-2007), for example, wrote in *Shodō zenshū*, an authoritative survey of the history of calligraphy, this comment on the Cuan Baozi inscription:

> Even though it was written after the fluid style of Wang Xizhi was fully developed, this calligraphy from the border area of Yunnan still retains the old style of the earlier Western Jin dynasty [265-317] and carries an unpolished air.[12]

Of another Yunnan inscription of 458, the *Stele for Cuan Longyan*, he wrote, "Any stele set up in the southwest border region naturally has a rustic quality, which it cannot avoid."[13] The use of terms like "unpolished" and "rustic" seems to ally Hibino's opinion with a traditional view of center-periphery relations by positioning the Cuan steles as 'backward' in comparison to the style of Wang Xizhi (ca. 303-ca. 361) as the sophisticated, metropolitan standard. The hallmarks of the Wang style are horizontal strokes tilted upward from lower left to upper right, a fanning movement outward from left to right, variety and intricacy in the shaping of strokes, and a uniform fluidity and gracefulness of movement (Fig. 15). Although none of these qualities appear in the *Cuan Baozi Stele*, why necessarily condemn it? Let us examine what was believed about the circumstances of this inscription to find what might have influenced Hibino's and other opinions about the stele.

In the year 405, the Cuan clan ruled over not only the eastern part of modern Yunnan province, but also the southern part of Sichuan and the western portion of modern Guizhou province, an area then called Nanzhong. They gained control following the destruction of the Western Jin dynasty in the early fourth century,

Figure 15. Wang Xizhi, copy after, detail. *Huang ting jing*, ink rubbing from Ming-dynasty engraving, Palace Museum, Beijing. From *Jin Wang Xizhi Wang Xianzhi xiao kai shu xuan* (Beijing: Zijincheng chubanshe, 1985), 4.

when the central Chinese government that had nominally controlled the area could no longer hold its own capitals in Luoyang and Xi'an, in north-central China, much less the huge areas it had colonized in the southwest. In the early fourth century, there were three powerful native clans in Nanzhong: the Meng, the Huo, and the Cuan.[14] In 339, the Meng and the Huo destroyed each other in battle, and the Cuan were left to reap the spoils. After Huan Wen (312-373) occupied Sichuan for the Eastern Jin (317-420) in 347, successive southern Chinese dynasties claimed control of the Nanzhong area and continually appointed men to serve as governor of Jianning or Ningzhou, the official names of this area within the Chinese scheme of jurisdiction.

In reality, however, most of these appointed officials never went to Nanzhong. The Cuan clan was actually in control. They, too, employed the official Chinese bureaucratic titles of governor of Jianning and governor of Ningzhou, but as hereditary titles for their own chieftains. This practice is very obvious in the titles credited to Cuan Baozi. His epitaph claims that he held the posts of assistant magistrate, assistant governor, and administrative aide to the head of the commandery, and that by the end of his career, he held the position of governor of the entire commandery. Yet he was only twenty-three at the time of his death. That he could have attained these posts through service in so few years on earth seems unbelievable. Indeed, the eulogy does not specify any great projects or bureaucratic successes under his governance. More believable is that he inherited these titles. Inheriting bureaucratic titles was not official Chinese practice, but was commonly done by the ethnic minorities on the borders of the Chinese empire.

Were the Cuan Han Chinese or an ethnic minority? Information about them is found in a half-dozen epitaphs that have survived from the fifth century.[15] According to the *Stele for Cuan Longyan*, the Cuan were descendants of Ziwen, the prime minister of the state of Chu during the Spring and Autumn Period (722-481 BCE), who received the surname Ban. At the end of the Eastern Han dynasty, in the first or second century, they were granted land at some place called Cuan, which was perhaps in Shanxi Province, in northern China, from which they took a new surname.[16] If this story is true, then the Cuan may have been ethnic Han Chinese who migrated to Nanzhong after the native Dian Kingdom came under the control of the Chinese in 109 BCE. They then established themselves as a powerful local "Great Clan" and became "barbarized"; that is, they adapted to local ways. Conversely, however, even though we might be tempted to see a stone-carved epitaph as an accurate record written from the perspective of the Cuan, not Han Chinese historians, this genealogy could be fiction. The ethnicity of the Cuan is a matter of dispute. Some modern scholars say they belonged to the ethnic group who in ancient times were called the "Cuan Man" (*man* meaning "southern barbarians") and were the ancestors of the present-day Yi minority nationality.[17]

Though the ethnicity of the Cuan is open to discussion today, it would appear to have been a settled issue to the calligraphy critics of the twentieth century. As we will see, they believed the stele was produced in a border area of the Chinese empire, one that was only nominally under the control of any central Chinese government, and that the Cuan clan, which the inscription honors, was either originally Man, or "barbarian," or were Han Chinese people who had lived in Yunnan so long as to become "barbarized." In other words, the stele was produced by people who were, either ethnically or culturally, not fully Chinese in a place that was never fully a part of China. The anxiety provoked by its anonymity and its location in a peripheral cultural area seems to have encouraged a range of partisan interpretations. We have already heard the essentialist point of view, from Hibino, who called the Cuan steles "unavoidably" "unpolished" and "rustic."

Taking the style of Wang Xizhi as the gold standard in calligraphy is an old-fashioned practice that predates the fashion for studying and imitating epigraphic writing that began in the mid-1700s in China. Newer attitudes have formed with the rise of the epigraphy movement, which continues in force today, and with the advent of the People's Republic of China in 1949, which has promoted popularization of the "elite" art of calligraphy, created policies that intentionally embrace "minority" cultures within a "unified China," and advocated critical support for previously ignored or denigrated types of writing as "calligraphy of the people."

Taking four twentieth-century Chinese critics as examples, we can sketch a range of attitudes toward the *Cuan Baozi Stele*. Kang Youwei was the first of the epigraphy enthusiasts to comment on the aesthetic qualities of the *Cuan Baozi Stele*, and it is obvious he believed it was written by a non-Chinese person. He wrote:

> Among the extant steles from the south, the two Cuan (inscriptions) emerged from the Man of Dian and some dedicatory inscription(s) came from Sichuan. Like the engraved writings of the ancient cities of Goguryeo (37 BCE-668 CE) and the stele about the hunting expedition from Silla (57 BCE-935 CE), though they were created by distant barbarians, and they came from foreign countries, still their lofty beauty crowns ancient and modern.[18]

This is fairly strong praise, even though it is couched within the segregated category of calligraphy by "distant barbarians": artists from the southwest borders of China and the early kingdoms of Korea.

In other comments, Kang said the Cuan Baozi inscription's calligraphy was "simple, weighty, antique and beautiful; its marvelous gestures make it stand out from the crowd."[19] This suggests he liked the extraordinary sense of movement in the strokes, as well as its unaffected freedom from the self-conscious aesthetic effects of the Wang style. In another short essay, in which he characterized a number of early works in anthropomorphic terms, he said of the *Cuan Baozi Stele* that "its grave simplicity is like the face of an ancient Buddha image," meaning, perhaps, that it was worthy of veneration for its seeming lack of artifice, in contrast to the Wang style, which was typically criticized by epigraphy enthusiasts as "mannered" or "artificial."[20] It may be fair to say that Kang was a great enthusiast for anything surviving from antiquity, and for that alone, the *Cuan Baozi Stele* was quite exciting. Since the Jin dynasty proscribed the setting up of engraved steles, there was little other original epigraphy surviving from that time (more works are known today thanks to a number of recent archeological finds), so the mere fact that this stele boasted an Eastern Jin date would be enough to excite any historian's interest. In addition, Kang considered the script type to sit somewhere between clerical script and regular script, which meant it was pre-modern in script type, while the high percentage of variant characters also reinforced its feeling of antiquity and remoteness from the present day in terms of its orthography.

As a university educator, the famous calligrapher Sha Menghai (1900-1992) was focused on guiding young people in the study of calligraphy. Since the evidence

of the use of the brush is not obvious in engraved works of calligraphy, it is difficult for beginners to copy them using brush and ink, and as a result, Sha was critical of the current fashion for using ink rubbings of epigraphical works as models for calligraphy students. He also subscribed to the belief that the calligraphy on many engraved works had been altered or distorted by the engravers when it was carved. Sha had a particularly low regard for the *Cuan Baozi Stele*. He wrote:

> There are some works that have good calligraphy and are well engraved . . . others have good calligraphy and the engraving was not done well . . . but some have poor calligraphy and were poorly engraved, such as the *Guangwu General Stele*, the *Governor of Zhiyang Stele*, the *Cuan Baozi Stele*, and the *Zheng Changyou Inscription*.[21]

Sha Menghai's dislike of the *Cuan Baozi Stele* was so pronounced that he looked for a reason why so eminent a connoisseur as Kang Youwei would value it. In the end, he attributed it to Kang's love of the unusual and his urgent desire to break away from the stereotyped, flaccid "Academy Style" of the late Qing dynasty (1644-1911). Concerning Kang's praise for other fifth- and sixth-century engraved works of calligraphy, Sha wrote:

> When Kang Youwei praised the calligraphy of the *Inscription for the Stone Gate*, the *Essay Mourning Bigan*, the *Stele for Zhang Menglong*, the *Stele for Zheng Wengong*, and the *Eulogy for the Burial of a Crane*, no one challenged that.[22] Yet, at the same time he was so fond of the novel and the strange that he also praised the *Cuan Baozi Stele*, the *Cuan Longyan Stele*, the *Reverse of the Lingmiao Stele*, the *Stele for the Governor of Zhiyang*, and the *Dedicatory Inscription of Zheng Changyou* . . . he even put the *Cuan Longyan Stele* into the 'Divine Work No. 1 class,' which was really going too far and has misled later students of calligraphy.[23]

Another critic with a different point of view was Ma Guoquan, the eminent epigraphy scholar quoted above. As a student of ancient scripts, he considered every form of variation to be positive and interesting. In addition to extolling the variations in character forms and sizes within the Cuan Baozi inscription, Ma Guoquan also felt that the rising and slanting in the brushwork created a tremendous feeling of

liveliness throughout the calligraphy. He considered it a wonderful illustration of the description of characters by the Song-dynasty poet Jiang Kui (ca. 1155-1235):

> Dots are the eyebrows and eyes of a character. They depend entirely on the spirit of eye contact. Some face each other; some are back to back. Their shape varies from character to character. Horizontal and vertical lines are the flesh and bones of a character. They should be strong and straight, even and clean . . . *Pie* and *fu* are the hands and feet of a character. Their expansions and contractions are different in each case, with many variations, like the fins of fish and the wings of birds moving happily and contentedly.[24]

Although Ma Guoquan held the view that the Cuan were ancestors of the Yi nationality ethnic minority, he appeared to be unencumbered by concerns about ethnicity adversely affecting calligraphic style. In line with the other Chinese scholars who have continued the epigraphy studies movement into the twentieth century, he eagerly accepted all types of variant characters, as well as variant calligraphy styles. In political terms, this echoes the attitudes of the Manchu rulers of the last dynasty, who were eager to be inclusive of all ethnic types, while it also agrees with the current attitude of the Chinese Communist Party, which is that although minority peoples may have distinctive customs, they still find a comfortable place within the larger domain of Han Chinese culture and political control.

The most recent new point of view is that of a present-day native of Yunnan, Chen Xiaoning, an education official and a well-known artist, who wrote a provocative essay on the *Cuan Baozi Stele* for a collected volume of scholarly writings on the medieval Cuan culture, published in 1991.[25] Chen seems to adopt a post-colonial, "writing to the center" strategy in his argument, taking the most derogatory terms applied to the style of the *Cuan Baozi Stele* and turning them into words of praise. To summarize his argument here, he first disagrees with Kang Youwei's assessment of the Cuan Baozi style as "grave and simple," and he laments the fact that most other critics have followed Kang's judgment unthinkingly. In place of this facile view, Chen proposes we think of the qualities of the *Cuan Baozi Stele* as *ye*, meaning "rustic," *man*, meaning something like "barbaric, southern, from a border region," and *guai*, which we might translate as "strange, unusual." These terms, which would ordinarily be understood as undesirable in calligraphy, as well as insulting and derogatory toward people of the southern ethnic minorities,

Chen inverts to represent categories of admirable qualities.

The first quality, "rustic," is the same term that Hibino used in his comparison of the Cuan calligraphy to the Wang style. Chen, however, defines "rustic" as "lacking method." How could this possibly be seen as a good quality? Chen argues:

> In the history of calligraphy, particular stress has been laid on method (*fa*), order (*li*) and proportion (*du*). This is seen in Qin-dynasty seal script, Han-dynasty clerical script and Tang-dynasty regular script. Wang Xizhi and Ouyang Xun (557-641), for example, advocated balance and regularity, and so generation after generation of calligraphers have worn the chains of method, been bound by the ropes of order and been constrained by the rules of proportion.

By contrast, Chen claims that the Cuan Baozi calligraphy

> Pays no heed to method, order or proportion, but expresses its own unique spirit. It is something inexplicable and heaven-sent, and the elevation of its rustic, barbaric and strange style onto the high altar of calligraphy has astonished the cultural elite.

As to concrete examples of "lacking in method," Chen points to the compositions of characters that are unorthodox in their proportions and structures. We have seen an example of this already, in the character *xing*, where the lower *xiang* element is shifted off the central axis to the left (Fig. 10). *Man*, meaning "barbaric, southern, from a border region," Chen defines as "lacking order." This includes a variety of practices that Chen identifies as "an anti-traditional method of writing." Some are matters of orthography, while some are matters of calligraphic style. Concrete examples of an admirably "barbaric" lack of order in orthography include characters with an abbreviated number of strokes, such as *bin*, *yin*, or *ma*, where what should be a row of four dots is condensed into a horizontal stroke (Fig. 16).[26] In terms of calligraphic style, Chen notes the example of the character *cai*, in which the artist reversed the normal direction of the last *pie* stroke, and Chen also points out how the artist typically turned vertical strokes into hooked strokes, as seen in the characters *ban* and *wei* (Fig. 17).

Chen defines *guai*, meaning "strange" or "unusual," as "lacking proportion." Incongruous sizes of certain strokes are seen in *fa* and *gan* (Fig. 18), both of which

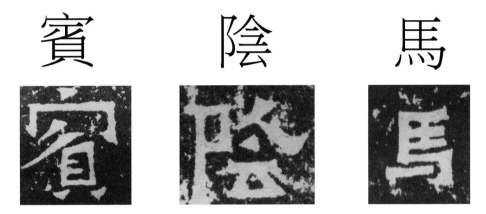

Figure 16. *Cuan Baozi Stele*, detail: from the left: *bin, yin, ma*.

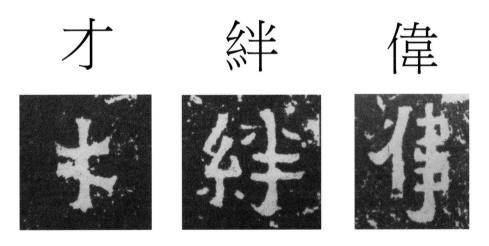

Figure 17. *Cuan Baozi Stele*, detail: from the left: *cai, ban, wei*.

Figure 18. *Cuan Baozi Stele*, detail: from the left: *fa, gan, cang*.

show disproportionately large diagonal strokes with swooping hooks at the ends. He borrows Jiang Kui's phrase to describe the extension of these *pie* and *fu* strokes as "spreading out like the fins of a fish or tail of a bird." In addition, he points out the most commonly cited example of the strangeness of this inscription: the upper *pie* stroke in *cang* that breaks through the three dots of the "water" radical on the left (Fig. 18).

In the end, Chen makes a grand claim for the style of the *Cuan Baozi Stele* that makes his postcolonial emphasis on ethnicity explicit and his assumption that the inscription's calligrapher was not Han Chinese clear: he praises hybridity as a virtue. He does this by personifying calligraphic styles in gendered terms, calling the calligraphic style of the Wangs "a dancing girl with flowers stuck in her hair." This in itself is nothing new in the history of calligraphy criticism, and several critics have characterized the Wang style as feminine.[27] But Chen goes further to personify the Cuan style as masculine, calling it "a young lad of the plains, who though slow and crude of speech, has a great vitality beneath a silent exterior. His is not the beauty of powder and perfume."[28] Chen claims that the mixture of the robust customs of native ways with Chinese culture worked like fresh blood in the anemic body of Han Chinese civilization and made the calligraphic art of Yunnan different aesthetically from the style of the Wangs used in the Chinese capital. It is this hybridity that allows the *Cuan Baozi Stele* calligraphy to manifest an aesthetic that is admirably "primitive, unruly, and fierce." Such a style could never have been produced in the realm of the Eastern Jin dynasty, so deeply mired in Chinese tradition, but only in a land under Cuan control.[29]

Endnotes

1. Though her name is conventionally read "Fu Hao," Fu is likely an official title meaning "royal consort," while the name Hao has been interpreted variously. Li Xueqin holds that Hao was her personal name, while Ding Shan and Tang Lan contend that the two elements in the character "hao" should be read separately, as "daughter" of the "Zi" family. Qiu Xigui believes Hao was a clan name. See Cao Dingyun, *Yinxu Fu Hao mu mingwen yanjiu* (Taibei: Wenjin chubanshe, 1993), 79-80.
2. See Lothar Ledderose, *Mi Fu and the Classical Tradition of Chinese Calligraphy* (Princeton: Princeton University Press, 1979), 30.
3. The earliest expression of this notion is the famous phrase of Yang Xiong (53 BCE-18 CE), "Writing is the delineation of the mind." Yang Xiong, *Fayan, Sibu beiyao* edition (Shanghai: Zhonghua shuju, 1936), ch. 5, 3b. A well-known later statement specific to calligraphy is the comment by Su Shi (1037-1101) about the calligraphy of Yan Zhenqing (709-785): "When I look at his calligraphy, I know what kind of person he was." Su Shi, "Colophon to a Letter by Yan Lugong," in *Dongpo tiba* (Taibei: Shijie shuju, 1962), 76.

4. See Ma Guoquan, "*Cuan Baozi bei* yanjiu," in *Xiandai shufa lunwenxuan* (Shanghai: Shanghai shuhua chubanshe, 1980), 241.

5. The stele is 1.9 meters tall, 0.71 meters wide and 21 cm thick. Each character is about 3 cm across.

6. Deng Erheng's inscription, engraved on the lower left corner of the stele, is transcribed in Xu Facang, ed., *Qujing shike* (Kunming: Yunnan minzu chubanshe, 1999), 8.

7. There was no fourth year of the Daheng reign period. It lasted only a few months in the year of 402, when Huan Xuan (369-404) elevated himself to prime minister. He quickly discarded this title when he usurped the throne and declared a new dynasty. This date is an interesting mystery, which I will explore in an article in the journal *Early Medieval China*.

8. Kang Youwei, *Guang Yizhou shuangji zhu*, ed. by Cui Erping (Shanghai: Shanghai shuhua chubanshe, 1981), 82.

9. Ma, "*Cuan Baozi bei* yanjiu," 237.

10. See Amy McNair, "Public Values in Calligraphy and Orthography in the Tang Dynasty," *Monumenta Serica* 43 (1995): 263-278.

11. Ma, "*Cuan Baozi bei* yanjiu," 235-236.

12. Hibino Takeo, *Shodō zenshū*, Vol. 4 (Tokyo: Heibonsha, 1954-1968), 199.

13. Hibino Takeo, *Shodō zenshū*, Vol. 5, 138.

14. See Lin Quan, "Cuan wenhua de lishi tedian," in *Cuan wenhua lun*, ed. Fan Jianhua (Kunming: Yunnan daxue chubanshe, 1991), 72.

15. These are the steles for Cuan Longyan, Cuan Shen, Cuan Longxiang, Cuan Baozi, and Cuan Yun. See Fang Guoyu, ed., *Yunnan shiliao congkan*, Vol. 1 (Kunming: Yunnan daxue chubanshe, 1999), 232-246

16. Xu, ed., *Qujing shike*, 12 and n. 36-38.

17. Ma, "*Cuan Baozi bei* yanjiu," 235.

18. Kang, *Guang Yizhou shuangji zhu*, 133.

19. *Ibid.*, 131.

20. *Ibid.*, 181.

21. Sha Menghai, "Shufa shi shang de ruogan wenti," in *Sha Menghai lun shu cong gao* (Shanghai: Shanghai shuhua chubanshe, 1987), 183. The *Guangwu General Stele*, dateable to 368, was excavated in the Qianlong period (1736-1795) and is now in the collection of the Forest of Steles, Xi'an. The *Governor of Zhiyang Stele* refers to the *Spirit Road Inscription for the Governor of Zhiyang*, dated 399, excavated in Baxian, Sichuan. The *Zheng Changyou Inscription*, dated to 501, is one of the "Twenty Works of Longmen" and is located adjacent to the Buddhist shrines donated by this aristocrat and his family on the south wall of Guyang Grotto, Longmen Grottoes, Henan.

22. On the Stone Gate inscriptions and the Zheng Wengong inscriptions, see Robert E. Harrist, Jr., *The Landscape of Words : Stone Inscriptions from Early and Medieval China* (Seattle: University of Washington, 2008), ch. 1-2. On the *Eulogy for the Burial of a Crane* (*Yiheming*), see Lei Xue, "The Elusive Crane: Memory, Metaphor, and a Stone Monument from Sixth Century China," PhD dissertation, Columbia University, 2009.

23. Sha, "Shufa shi shang de ruogan wenti," 183, ellipsis in the original. The *Reverse of the Lingmiao Stele* refers to the inscription on the back of the 456 *Highest Spirit of the Central Marchmount Song Temple Stele*, in the Central Marchmount Temple, Dengfeng County, Henan.

24. Ma, "*Cuan Baozi bei* yanjiu," 240. The translation is taken from Chang Ch'ung-ho and Hans H. Frankel, trans., *Two Chinese Treatises on Calligraphy* (New Haven and London: Yale University Press, 1995), 18-19.

25. Chen Xiaoning, "Shilun *Cuan Baozi bei* de meixue tezheng," in *Cuan wenhua lun*, 302-308.

26. To alert the reader to the highly polemical nature of Chen's view, however, I will add that other scholars have different explanations for some of these phenomena. Lu Mingjun states that the abbreviation in *bin* is simply a stroke missed by the engraver, while the abbreviation of the four dots in *ma* is a borrowing of that practice from cursive script. Lu Mingjun, *Wei Jin Nanbeichao bei bie zi yanjiu* (Beijing: Wenhua yishu chubanshe, 2009), 240, 59.

27. See Eugene Y. Wang, "The Taming of the Shrew: Wang Hsi-chih (303-361) and Calligraphic Gentrification in the Seventh Century," in *Character and Context in Chinese Calligraphy* (Princeton: Princeton University Press, 1999), 132-173, esp. 146.

28. Chen, "Shilun *Cuan Baozi bei*," 304.

29. *Ibid.*, 306.

II. VIEWING AND READING

Animated Rhythms of the
Illustrated Scroll of Major Counselor Ban

Ikumi Kaminishi

The *Illustrated scroll of Major Counselor Ban* (*Ban Dainagon ekotoba*, ca. 1177) depicts the 866 burning of the Oten Gate in the Heian (Kyoto) imperial palace. The production of this illustrated handscroll (emakimono) is attributed to the court painter Tokiwa Mitsunaga (act. twelfth century) who worked on commission by the retired emperor Goshirakawa (1127-1192, r. 1155-1158).[1] The painting showcases Mitsunaga's deft brushwork with lively lines, which reveals this aristocratic artist's arts education not only in calligraphy but also in poetry, music, and painting. This essay explores the senses of rhythm, tempo, and animation in the painting, to make a case study for looking at a Japanese illustrated handscroll from a perspective other than the conventional analyses of images as illustrations for narratives."

Prelude: Heian Court Culture and Art

Music and poetry represent two of the foremost art forms for members of the aristocracy to acquire and excel in during the Heian period (794-1185). In the chapter "A Picture Contest" of *The Tale of Genji*, the viceroy prince reminds his stepbrother, Genji, of their extensive arts education under their father (Emperor Kiritsubo) who placed particular emphasis on the study of poetry and music, but less on painting. "In every art worth mastering," says the viceroy prince to Genji, "the evidences of effort are apparent in the results. There are two mysterious exceptions,

painting and the game of Go, in which natural ability seems to be the only thing that really counts."[2] The experience gave the viceroy prince the impression that painting belonged to the playfully "mysterious"—if not innate—artistic talent that Genji possessed, as seen at the royal Picture Contest. The contest occasioned the painting collection contest between two imperial consorts, Akikonomu and Kokiden. Both factions submitted equally fine paintings, ranging from paintings of four seasons to somewhat more abstract drawings, making it difficult for the viceroy prince to decide on a winner.

Visual art appreciation involves discernment of the rhythmic power of calligraphic brushwork. The audience at the Picture Contest described the works by old masters as having "uncommon power, fluency, and grace, and a rather wonderful sense of unity," and some contemporary painters as exhibiting "their telling points in the dexterity and ingenuity of the strokes and in a certain impressionism (*kokoro ni tsukuritate*)."[3] The deciding painting that delivered victory to Akikonomu was an illustrated diary in Genji's own hand that he kept during exile. His despondent songs and paintings of nameless inlets between the bleak beaches of Suma poetically reflected his crestfallen state of despair. Genji, a man of culture, could do no wrong in the arts of painting, poetry, or music, regardless of difficult circumstances.

A way to understand the artistic unity of power, fluency, and grace in Heian aristocratic art is to examine the artistic practices that produced these dexterous strokes and the ingenious sense of movement in these scrolls. Seeing rhythmic artistry in pictorial art is essential, and musical readings of illustrated handscrolls are fitting, in that both media are experienced over time: Picture scrolls require not only pictorial space but also narrative time, just as a song, or a story, moves from beginning to end. The use of musical analogies in the study of Asian brush paintings had been effective in the past, but they tend to be marginal to most main theses in recent times and now have fallen out of practice in Japanese art history. Yet they still help us to understand something about visual order and culture of the period. Professor Harrie Vanderstappen frequently borrowed musical idioms to examine visual material during his lectures; he would sometimes point to certain images and talk of the effect of "staccato" patterns as though his point was completely transparent, and then move on to the next image. "Syncopation," "tonality," and "concordance" were other favorite idiomatic references to music. His use of these terms connoted the idea of rhythmic harmonies in visual images that some early twentieth-century Western art historians such as Laurence Binyon and Roger Fry proposed. Binyon wrote on the rhythmic character of the brushstroke:

> In the art of the T'ang there was a conscious effort to unite
> calligraphy with painting. By this we must understand that
> painters strove for expression through brush-work which had at
> once the life-communicating power of the lines that suggest the
> living forms of reality and the rhythmical beauty inherent in the
> modulated sweep of a masterly writer; for to write the Chinese
> characters beautifully is to have a command of the brush such as
> any painter might envy.[4]

Binyon's attention to rhythmical elements observes the first principle of the *Six Laws of Chinese Painting* by the fifth-century Chinese art critic Xie He, with the conviction that rhythm is the vital essence of painting.

Scholars have not only debated the meaning of the six laws but also applied the laws in their examinations of Chinese and Japanese paintings.[5] Japanese art historian Ichimatsu Tanaka considers the hermeneutics of the first principle (put in a four-word phrase, *qi yun sheng dong,* which may be translated as "spirit resonance and animation") in terms of the historical evolution of the Japanese ink painting tradition. He reads it as a reference to the development from the older tradition of painting with controlled contour lines, to a more expressive painterly use of calligraphic lines. Tanaka's modernistic theory has to be read cautiously, but his examination of premodern paintings offers us technical explanations for brushstrokes.[6] Supple calligraphic strokes used in the famous first two scrolls of "Frolicking Animals and People" (*Chōju giga,* twelfth century; Kōzanji, Kyoto), for example, are a sheer virtuoso display of brushwork. Quick and expressive brushstrokes generate the lively antics of animals engaged in human activities, much like our contemporary animated film (*anime*).

Recent academic interest in *anime* has resulted in exhibitions that point out the debt of contemporary Japanese animated film to images from traditional art.[7] Following the study of rhythmic brush strokes, I further investigate the artist's flexible and innovative vantage points in producing the *Major Counselor Ban* scroll, which feature *anime* camerawork-like perspectives. The artist captured scenes as though he used a viewfinder much as a modern film director manipulates. I explore the techniques of framing and the visual organization of horizontal scrolls, which were the "motion pictures" of their time.

Historical Background

The *Illustrated scroll of Major Counselor Ban* visually recounts the historical event of the Oten Gate Fire, the alleged arson of the main gate of the Kyoto imperial palace in the third month of 866. A criminal investigation had just begun when the senior counselor of the court, Tomo no Yoshio (811-868), reported to the authorities that his superior, Minamoto no Makoto, the minister of the Left, had set the fire. Tomo accused Minamoto of destroying Oten Gate out of envy, for it stood as a symbolic structure that Tomo's eminent ancestors (the Otomo clan) had consecrated. No sooner was the arrest order for Minamoto issued, however, than the charge was dropped, thanks to the Regent Fujiwara no Yoshifusa (804-872) who appealed directly to Emperor Seiwa (r. 858-876) to intervene on the grounds of insufficient evidence.

The case remained unsolved for five months, until the authorities took seriously the rumors spread by a petty official and were convinced that Tomo no Yoshio and his family members were involved. Tomo was then arrested and later found guilty. Art historian Komatsu Shigemi has researched various historical documents that recounted the circumstances surrounding the fire, which can be summed up as follows.[8] One of the most frequently referenced sources is the *Nihon sandai jitsuroku* ("True history of three reigns of Japan," an imperial chronicle of the events at court between 858 and 887 compiled by Fujiwara no Tokihira), which includes an entry dated nearly five months after the date of the fire—the third day of the eighth month in 866. According to the document, a low-ranked official named Oyake Takatori informed the court of the names of the arsonists—Tomo no Yoshio and his son. Subsequently the police interrogated Tomo but he denied the allegation. Three weeks later the police arrested Tomo's son on a separate charge that he had ordered his manservant to murder the informant's daughter. The authorities reckoned that the homicide was retaliatory and proof enough of the Tomo clan's culpability.

The revelation of the true arsonists in the Illustrated Scroll of Major Counselor Ban, however, is told differently, which suggest an unofficial version of this incident. *Major Counselor Ban* scrolls and its contemporaneous literary compilation (entitled *Uji shūi monogatari* or the "Collection of Tales from Uji," early thirteenth century) tell us of an innocuous fight between two boys that led to the eventual arrest of Tomo no Yoshio. Nevertheless, historical sources agree that the so-called "Oten Gate Incident" culminated with Tomo's exile to the distant Izu Province, where he died two years later. Tomo maintained his innocence throughout, and the truth of the fire still remains a mystery.

The political intrigue surrounding the three highest ranked courtiers keeps our interest in this incident. Rumor had it that Tomo planned to assume a higher

position. With the removal of Minamoto no Makoto from the post of Minister of the Left, the incumbent Minister of the Right, Fujiwara no Yoshisuke (Yoshifusa's younger brother), would move up, which would then promote Tomo to the rank of the Minister of Right. Curiously, however, the official history does not record that Tomo ever brought any allegations against Minamoto. Can it be mere coincidence that the chief compiler of the imperial chronicle was Fujiwara no Tokihira, a grandson of Yoshifusa? When we consider that Yoshifusa was the founding father of Fujiwara regents over subsequent generations, this incident can be seen as one of many strategic occasions in which the Fujiwara clan systematically removed rival clans from power.

The *Major Counselor Ban* scrolls visually recount events from the fire at Oten Gate up to the arrest of Tomo no Yoshio. The scrolls currently consist of a set of three long scrolls (each measuring nearly 350 inches long and about 12 inches high) but at least until the mid-fifteenth century, they were known to have existed as a single scroll, which would have been an impressive eighty-five feet in length. According to art historian Komatsu Shigemi, Prince Sadanari (1372-1456) of the Fushimi imperial line had a chance to see this scroll in 1441.[9] The prince found the painting old but exquisite, and attributes it to the legendary artist Kose no Kanaoka (active late ninth century).[10] However, current scholars agree that Tokiwa Mitsunaga painted the scroll. By the mid-seventeenth century, the painting was in the collection of Lord Sakai of Musashi Province in the triple set of handscrolls, which the Idemitsu Museum of Arts, Tokyo, purchased in 1983.

The Illustrated Story of Counselor Ban

The *Major Counselor Ban* scrolls narrate a simple story yet engage scores of figures as though it were an epic tale.[11] The first scroll (Fig. 1) opens with an action-packed scene in a quick tempo without a verbal prelude. A pack of soldiers dashes pell-mell into view from the right, visibly agitated, if not confused, charged with tense energy (Fig. 2). Two men in red robes carry a torch and lead eighteen soldiers, who are armed with either bows and arrows or swords; some are mounted, others are on foot. These men represent two units of firefighters (ten in each unit, according to the custom of the time).[12] Ahead of the firefighters, more people run in a straight line. A frantic courtier on horseback leads his scurrying servants on foot. A bald-headed Buddhist monk runs along at full speed with his robe fluttering sideways. All the men sprint toward the vermilion-colored main gate of Kyoto Imperial Palace. Beyond the red gate, a large crowd moves about under a rising cloud of

Figure 1. *Ban Dainagon ekotoba*, scroll 1. Attributed to Tokiwa Mitsunaga. Second half of twelfth century. Handscroll, ink and color on paper. Idemitsu Museum of Arts, Tokyo.

Figure 2. "Fire brigade rushing to the burning gate," detail from *Ban Dainagon ekotoba*, scroll 1, showing firefighters rushing to the Oten Gate. Attributed to Tokiwa Mitsunaga. Second half of twelfth century. Handscroll, ink and color on paper. Idemitsu Museum of Arts, Tokyo.

Figure 3. "Fire at Oten Gate and gathering crowd," detail from *Ban Dainagon ekotoba,* scroll 1. Attributed to Tokiwa Mitsunaga. Second half of the twelfth century. Handscroll, ink and color on paper. Idemitsu Museum of Arts, Tokyo.

Figure 4. "Courtiers watching the burning Oten Gate," detail from *Ban Dainagon ekotoba*, scroll 1. Attributed to Tokiwa Mitsunaga. Second half of twelfth century. Handscroll, ink and color on paper. Idemitsu Museum of Arts, Tokyo.

Figure 5. "Emperor Seiwa and Fujiwara no Yoshifusa," detail from *Ban Dainagon ekotoba*, scroll 1. Attributed to Tokiwa Mitsunaga. Second half of twelfth century. Handscroll, ink and color on paper. Idemitsu Museum of Arts, Tokyo.

Figure 6. *Ban Dainagon ekotoba,* scroll 2. Attributed to Tokiwa Mitsunaga. Second half of twelfth century. Hand-scroll, ink and color on paper. Idemitsu Museum of Arts, Tokyo.

black smoke from a raging fire that consumes the gabled roofs of the gate (Fig. 3). Yet another large group of spectators congregates on the other side of the burning gate (Fig. 4).

The first scroll lacks narrative text, but a contemporaneous literary source, the *Collection of Tales from Uji,* provides the corresponding narrative. The story begins with this sentence: "Once upon a time during the reign of Mizuno'o (Emperor Seiwa, r. 858-876), the Oten Gate was burned down."[13] Astonishingly, about eighty percent of this first handscroll is devoted to illustrating just this one sentence. The artist allotted some two hundred figures and four-fifths of the picture space to this single, headline-like sentence. The result conveys an effect that the incident caused sensation and excitement among many Kyoto residents.

In contrast, the subsequent scene, after some blank space, features just four men. The distinguished portrayals of these four men also mark their social status: they are the top three courtiers in the government—Tomo no Yoshio (known as Ban Dainagon who held the senior counselor position), Fujiwara no Yoshisuke (minister of the Right), Fujiwara no Yoshifusa (the regent)—and Emperor Seiwa (Fig. 5). The only standing man in this section is Tomo, shown from behind, presumably walking away after reporting Minamoto's crime to the court.[14] Yoshisuke kneels by

Figure 7. *Ban Dainagon ekotoba*, scroll 3. Attributed to Tokiwa Mitsunaga. Second half of twelfth century. Hand-scroll, ink and color on paper. Idemitsu Museum of Arts, Tokyo.

the door. The final scene reveals a private conference when Fujiwara no Yoshifusa petitioned the emperor to intervene in the arrest of Minamoto no Makoto.

The second scroll (Fig. 6) illustrates two scenes, each preceded by an explanatory text. The first scene depicts the imperial messengers' arrival at Minamoto no Makoto's house with the news of the dropped charges. Minamoto is in the yard, praying to heaven—obviously he has not yet heard the news of his exoneration. The following interior view highlights the household women's emotional rollercoaster from despair to joyous relief. The scene following the long text shows a series of events with an unexpected turn: a street fight between two boys in which one of their fathers unfairly intervenes. The vexed father of the second boy began spreading his long-kept secret that he knew the true identity of the Oten Gate arsonist, implicating the other father's involvement. A seemingly innocuous fight between two boys unfolds, leading to the eventual arrest of Ban, the senior counselor, in the third scroll.

The third scroll (Fig. 7) also consists of two scenes. The first scene depicts the authorities apprehending the father of the ill-treated boy and bringing him to the court for hearing. The man confessed that he happened to witness three men—Tomo no Yoshio, his son, and their steward—emerging from the darkness behind the main gate only an instant before the fire broke out. After a short narration, the

second scene (taking three-quarters of the scroll length) closes the story with the tragic drama of the police arriving to arrest Tomo no Yoshio at his home. Tomo's servants and maids are left in sorrow. At the gate of his house, the armed officers assemble, and a messenger advances to greet the manservant of the Tomo residence. The interior scene portrays the grief-stricken maids weeping in despair. The police escort of Tomo no Yoshio brings the story to an end. The armed officers surround the arrested Tomo and escort him away in an oxcart. The cart's curtain is left open, exposing the left shoulder and lower half of Tomo no Yoshio's body. It was customary to position an arrested person backward, so as to heighten the public humiliation of the criminal. The indifferent expressions of the officers behind the oxcart add to the sense of the downfall of the once powerful courtier.

Quick Tempos and Visual Staccato: Black Caps

Musical rhythm is, of course, something that one experiences aurally, but it is also possible to understand it through visual patterns. Among the patterns that provide rhythm for the illustration of the Ban story are the omnipresent black caps of the male figures. During this period, regardless of differences in age and social rank, every adult male wore a cap. The historian Amino Yoshihiko explains that the cap signified male adulthood and symbolized courtesy among men in society: Greeting someone without a cap either in private or public was considered rude.[15] Men would even have slept wearing a formal cap. Consequently, the loss of your cap meant humiliation and disgrace, so much so that it could be used as a form of criminal punishment. The only men exempt from this social code were Buddhist monks, mendicants, adult men associated with certain trades (such as packhorse-men), and adolescents. Thus nearly two hundred caps fill the opening section, but the artist carefully placed them so as not to overlap with any adjacent figures.

The rhythmic distribution of repeated caps gives a staccato effect that pulses in a steady counterpoint. The drama of the fire scene is built up by the sequential movement from syncopated staccato-like clusters of caps. From the exterior of the first gate, the firefighters approach the scene. Inside, a larger group of men gather with their densely swirling black caps that swarm together like tadpoles. Here the composition cleverly depicts the effect of wind direction by differentiating the responses of the gathering crowd. The group that gathers downwind of the fire exhibits a more agitated movement; some duck down low to avoid falling sparks, and some are backing in retreat to escape from harm. The crowd that stands upwind collects more densely, observing the great fire from the safer side.

The differentiated manners of comportment are not only dramatic in effect, but also manifest social distinctions between nobleman and commoner, as understood in this period. The artist conveys vividly both the confused and controlled movements of a multitude in a moment of panic. Those in the group upwind of the burning gate wear courtly attire, which indicates they have emerged from the inner palace to see the spectacle. They look at the fire from a safe position, their more dignified comportment implying a class-based contrast to the men running helter-skelter away from falling sparks. Unlike the confused spiral of commoners below, the courtiers' hats form a tighter and more orderly elongated N-shape group.

The artist creates the sense of progression in space and time by visually organizing and varying the density of the men's caps, much like the dynamic contrasts in tempo and articulation in a musical movement. Just as does the first scroll, the second and third scrolls employ the rhythmic patterning of black caps as well as the flowing movement of women's hair. The second scroll begins with only few figures, slowly measuring the space to lead into the populated household. The third scroll also alternates groups of people with empty space, but at a much faster pace, as if to build to the climax. The painting comes to a close similarly to the pack of marching officers in the opening. The built-up momentum comes to an end with the arrest of Tomo no Yoshio in the cart. The soldiers are not running to the end like the firefighters in the opening scene, but are moving rather sedately forward. The sense of rhythmical progression is therefore not necessarily related to the density of figures. In fact, reading speed is somewhat inversely related to pictorial density: Our visual examination of the scroll moves along faster over a vast space where few people appear, while the psychologically and emotionally invested narrative takes place in more compact, densely populated scenes such as the fire scene and the boys' fight.

Measured Movements: the Boys' Fight

The boys' fight, illustrated in the second half of the second scroll, marks the turning point that led to the eventual arrest and the ultimate fall of the Tomo clan. In this tableau, the artist employed what art historians observe as the illustration technique of layering multiple moments in a single scene. The composition brilliantly heightens the tension, as it utilizes one background for four sequential, measured movements. First, a gathering crowd encircles two boys scuffling in the street (Fig. 8). The contrasting patterns on each kimono help to distinguish the boys, and make it easier to follow the sequence of events. In a clockwise direction, we see a

Figure 8. "The boys' fight," fight scene sequence, detail from *Ban Dainagon ekotoba*, scroll 2. Attributed to Tokiwa Mitsunaga. Second half of twelfth century. Handscroll, ink and color on paper. Idemitsu Museum of Arts, Tokyo.

bearded man coming full speed from the right-hand side. His shoulder is bared to show his readiness to aid his son. At the bottom of the frame, the man holds his son's hand while kicking hard at the other boy's back (although the accompanying text reads that the man threw the boy on the ground while holding his hair and then walked on his back). At the top, the mother drags the injured boy home.

The whole sequence is framed within a compact space. Had this been a modern comic book (*manga*), or film, this fight scene would have taken up multiple frames, but more importantly, the continuous or diachronic narration technique quickens the tempo of the scene. What immediately follows is another scene of a gathering crowd, this time a crowd that encircles a middle-aged couple. The couple turns out to be the parents of the beaten boy in the polka dot kimono. The father, the man in a blue kimono jacket with his arms akimbo, shouts that he knows about the Oten Gate arson. Fearing involvement in the investigation however, he held his silence. But now, feeling resentful of the unfair way his son was treated by the boy who bragged about his politically powerful master (Tomo no Yoshio), he hints that he has knowledge of the names of the arsonists. The rumor ripples through the gathering crowd. This group of passersby, who congregate differently from the figures gathered around the children's fight, breaks into groups of two and three, multiple packs from which rumors will spread. But who could imagine an

innocuous children's feud would bring down a mighty noble house? If the boys had not fought, if the fathers had not intervened, and if the second boy's father had not come forward with the information about the months-old arson, then it seems that history would be different. The sense of irony, revealed in this pivotal moment, is aptly conveyed in a circular composition.

Gendered Modes

Medieval picture scrolls illustrate various different subjects, including historical stories, romantic tales, war epics, religious anecdotes, and parables. *Major Counselor Ban* belongs to the category of historical stories. The famous scroll of *Minister Kibi's Adventures in China* (ca. twelfth century, Museum of Fine Arts, Boston), which is attributed to the same artist, Tokiwa Mitsunaga, is also another fine example of the same category. Illustrated scrolls with historical, religious, or war subject matter often depict figures in action, through animated body language—running, shouting, crying, fighting—with exaggerated facial expressions. As we have seen, the *Ban* scroll is packed with lively movement (e.g., fluttering garments), fast action (e.g., galloping horses), and expressive poses and body angles. Professional painters are primarily responsible for the production of these action-packed paintings, which were categorized as "male-gendered painting" (*otoko-e*) by the Heian-period viewers.

The term "male-gendered painting" naturally implies its counterpart, "female-gendered painting" (*onna-e*). The Heian audience clearly differentiated painting styles. The female-gendered style illustrated romantic novels and fictions in a more sedate, richly colored imagery.[16] Female-style paintings featured a passive mode of expression with seemingly motionless figures, as depicted in the illustrated scrolls of *The Tale of Genji* (twelfth century; Tokugawa Museum, Nagoya, and Goto Museum, Tokyo). Interestingly, although the artist of the Ban scroll primarily employs the male-gendered style, he also incorporates female-gendered stylistic motifs. The interior of the emperor's private chamber and the households of the courtiers (both Minamoto Makoto's and Tomo Yoshio's) are depicted in female-gendered style. According to the pictorial convention, the interior of a room is exposed through the invisible roof (a pictorial practice known historically as a "blown-off roof technique"). Note here that the stylistic differentiation corresponds with the classes, not the gender, of the painted subjects. The world of the aristocracy, painted in female-gender, is separated from the world of commoners.

Male-gendered paintings use strong calligraphic strokes as dynamic contour lines. The artist's deft handling of the brush animates the movements and actions

Figure 10. "An old man running up the stairs; a young man climbing up to the gate's floor," detail from *Ban Dainagon ekotoba*, scroll 1. Attributed to Tokiwa Mitsunaga. Second half of the twelfth century. Handscroll, ink and color on paper. Idemitsu Museum of Arts, Tokyo.

of figures in thick and thin lines as demonstrated in the opening scene of the Oten Gate fire. There is an old man with a cane who is pictured with mouth open wide in his effort to catch sight of the inferno (Fig. 10). In the same scene, to the old man's right, a young man climbs up the gate's upper step. His comical tightlipped expression and awkward pose—leg raised above his shoulders—depict the effort required to ascend to that position. Simple yet assertive brushstrokes trace various psychological states on the faces of the gathered crowd: raw curiosity, fascination, panic, or dread. Such artistry recalls what the audience at "A Picture Contest" in *The Tale of Genji* saw as the dexterity and ingenuity of the strokes and a certain impressionism mentioned at the beginning of this essay.

Visual Framing and Viewing Angles

Picture handscrolls literally unroll scenes much like a film unrolls. But, unlike a film, the "frames" in a narrative handscroll illustrate episodes and have different lengths. The boys' fight scene, as discussed above, uses six or seven frames in a cut that is about twenty-four inches, while the fire scene takes one long frame that is over 280 inches long. This kind of flexible framing can be seen as analogous to film editing. The fight scene is depicted as though the camera were left to keep rolling,

Figure 9. "Arrest of Tomo no Yoshio" and the reversing "camerawork," detail from *Ban Dainagon ekotoba*, scroll 3. Attributed to Tokiwa Mitsunaga. Second half of twelfth century. Handscroll, ink and color on paper. Idemitsu Museum of Arts, Tokyo.

without changing the position. Heian paintings, when compared with modern film, could be seen as anachronistic, yet a study offered by Takahata Isao, an *anime* film director and producer, presents a compelling analysis from his professional point of view.

Takahata points out aspects related to camerawork in the compositions of the illustrated handscroll of Counselor Ban. For example, the opening fire scene would resemble a documentary filmed from a hovering helicopter above the Oten Gate.[17] Here, the depiction is like a tracking shot with the camera horizontally panning from right to left from a high vantage point. The scene is a single shot and thus no same figure appears twice. The fire scene alone brings to the action more than two hundred men and women, each with a unique expression.[18]

Takahata further discusses the artist's construction of horizontal space. The scene of the protagonist's arrest at the end recalls the opening fire scene in that it features multiple male figures moving from right to left. But unlike the single camerawork from a helicopter, so to speak, the final scene is composed as if the "director" were maneuvering two cameras nine centuries ago. The police, who approach the house from the right, would then in actuality go back in the direction from which they originally came, but instead they continue to move leftward as though leaving from the back gate. The two gates represented in the scroll (one on the right side of the interior scene and the other on left side) are actually the same gate but pictured

from two different directions (Fig. 9). It is as though two cameras were moving in opposite directions, and then swung back in a U-turn inside the house. Noticing the young maid already crying at far left in the room, and then appearing out to the left through the screen door, Takahata infers that this is the point where the second camera starts to pan back to the main gate.

Architecture provides a convenient frame for a jump cut to another moment within the same location. The interior scene of Minamoto no Makoto's house (the second scroll) showcases this method by presenting a later moment in an adjacent room. The artist uses a room to narrate one event, as seen in the single-room scene of the emperor's conference with Fujiwara no Yoshifusa (the first scroll) or Tomo's house (the third scroll). In the case of Minamoto's house, the repetition of spaces shows two different moments in time. In the first room seven women, pictured mostly from the front, show despair. In the next room seven women and a child express joy. A woman at the doorway appears to be the bearer of good news, and the two rooms to represent the two different emotions before and after the news is heard.

The interior scenes frame psychological moments, be it anxiety, torment, fear, grief, mirth, or mortification. As though a camera would zoom in for portraying intense emotion, the artist uses the blown-off roof technique to reveal the interior of rooms without a roof. All three interior scenes in the Ban scroll capture the interiors of noble or imperial residences. In short, the blown-off roof method is a technique used for intimate glimpses at aristocratic lifestyles. Scrolls of *The Tale of Genji* (early twelfth century) make extensive use of this technique.[19]

Artistic Expression

The *Major Counselor Ban* portrays Tomo no Yoshio as an ambitious villain to offer the viewer a moral lesson with justice prevailing in the end. The text accompanying the final illustration reads:

> Later, [Tomo no Yoshio] was interrogated, and as the truth came out, he was sent into exile. He burnt down the Oten Gate to censure the Minister [Minamoto no] Makoto, expecting a promotion to the Minister position. But instead, he received punishment. How spiteful he must be![20]

Reference to nature, such as seasonal landscapes, also affects the thematic and stylistic unity of pictures. As hinted in *The Tale of Genji*, Genji's diary won praise because of the poetic unity of image and emotion. The story of Ban is an urban story, yet the artist appropriates elements of natural landscape to reflect human emotion. The trees that surround the house of Minamoto in late winter are depicted in lush green, as though in early summer, while the tree leaves around Tomo's house are painted in autumn colors, red and yellow, even though Tomo's arrest took place in high summer. Clearly the artist takes the liberty to forecast fate: Minamoto's house survived the ordeal and would flourish while Tomo's house fell. The autumn colors evoke ensuing winter and the chilling end of the once proud, noble household, and the end of the story.

Whether the boys' fight was a fictional application of artistic license, or even if Tomo no Yoshio were not guilty, the fall of the house of Tomo is historical fact. The 866 fire of Oten Gate came to be known ominously as the "Oten Gate Incident" not only because of the arson of an imperial gate, but also, more importantly, because of the disgraceful fall of a powerful clan. The twelfth-century scroll champions the ninth-century Fujiwara's power to shape historical memory, as though it were a documentary drama designed and filmed by pro-Fujiwara factions.

The chaotic fire scene that commemorates the incident and the condemnation of Tomo in history are made especially memorable by the artist's animating brushstrokes and composition. Such qualities remind us what the audience at the Picture Contest in *The Tale of Genji* appreciated: the graceful sense of unity, dexterous brushwork, and artistic sensibility that expressed sentiment, or "sensation," in this case. Illustrated handscrolls, veritable "motion pictures" in a continuous roll of paper, hold rhythmic storylines, fluid calligraphic technique, and creative viewing frameworks that are at the core of the Japanese illustrated handscroll tradition.

Endnotes

1. Kenji Matsuo, "Explaining the 'Mystery' of *Ban Dainagon ekotoba*," *Japanese Journal of Religious Studies* 28, No. 1-2 (2001): 103.

2. Murasaki Shikibu, *The Tale of Genji*, trans. and introduction Edward Seidensticker (New York: Alfred A. Knopf, 1989), 316.

3. *Ibid.,* 314.

4. Laurence Binyon, *Painting in the Far East: An Introduction to the History of Pictorial Art in Asia Especially China and Japan* (London: Edward Arnold, 1908), 68. I am deeply grateful to Martin Powers who pointed out the Western scholarship on this topic and directed me to this citation.

5. John Hay, "Values and History in Chinese Painting, I: Hsieh Ho Revisited," *RES: Anthropology and Aesthetics*, No. 6 (1983): 72-111.

6. Tanaka Ichimatsu, *Suibokuga* [Japanese ink painting], series *Genshoku nihon no bijutsu,* 11 (Tokyo: Shogakkan, 1970), 158-164.

7. Recent global interest in *anime* inspired several exhibitions. The aptly titled exhibition, "Illustrated scrolls—the origin of *anime,*" held at Chiba City Museum of Art exhibition (summer 1999), focused on the affinities between medieval drawings and modern *anime.* The special exhibition "Monster-heaven, Japan," at Kyoto International Manga Museum (summer 2009) exhibited images of fantastic and imaginary creatures from the premodern and modern eras.

8. Komatsu Shigemi closely compares the imperial accounts of events during the reigns of three emperors (the *Sandai jitsuroku,* 858 and 887), a collection of Buddhist tales called the *Hobutsushu* (1177-1181) and the *Uji shūi monogatari* (Collection of Tales from Uji, thirteenth century), along with other diaries, storybooks, journals, and private records. Komatsu Shigemi, *Ban Dainagon ekotoba, Nihon no emaki,* Vol. 2 (Tokyo: Chuo Koronsha, 1977), 114-120. See also Kuroda Taizo, *Ban Dainagon emaki: Shinpen meiho Nihon no bijutsu,* Vol. 12 (Tokyo: Shogakkan, 1991), 78.

9. Komatsu writes that Prince Sadanari (1372-1456) of the Imperial Fushimi branch mentions in his diary his viewing the single scroll of Ban the Senior Counselor in 1440s. Komatsu, *Ban Dainagon ekotoba,* 98-99. Regarding the measurements of the scrolls, to be precise, the height of all three scrolls measures 31.5 cm (12.4 inches); the length of the first scroll is 839.8 cm (330 inches), the second scroll 859.8 cm (338.5 inches), and the third scroll 933 cm (367 inches).

10. *Ibid.* The prince was so impressed that he had the scrolls, together with two other painted scrolls, presented to Emperor Go-Hanazono. These scrolls belonged to the Shinto shrine, Shin Hachiman, in the province of Wakasa (present-day Fukui prefecture) by the Japan Sea. The provenance up to that point is not clear.

11. Melissa McCormick, *Tosa Mitsunobu and the Small Scroll in Medieval Japan* (Seattle, WA: University of Washington Press, 2009), 58-64.

12. Takahata Isao, *Jūniseiki no animēshon: kokuhō emakimono ni miru eigateki animeteki naru mono* [Twelfth-century animation: cinematic and anime-like aspects in the National-Treasure designated illustrated handscrolls] (Tokyo: Tokuma Shoten, 1990), 67.

13. Kobayashe Chiso, trans. *Uji shūi monogatari* [the Collection of Tales from Uji]: *Nihon koten bungaku zenshu,* Vol. 28 (Tokyo: Shogakkan, 1973), 326.

14. Although the discussion of identifying the standing figure is not a focus in this article, the subject has become an art historical issue of notable dispute (sometimes dramatically called the "issue of the mystery man"), since art historian Fukui Rikichirō first brought it up in 1932. What contributed to the "issue of the mystery man" is the confusing resemblance between the two men in black court robes. Fukui Rikichirō, *Emakimono gaisetsu* [An outline of *emakimono*] (Tokyo: Iwanami Shoten, 1932). Gomi Fumihikō proposed that the two men represent Tomo no Yoshio in two different moments, first on his way to the authority and then at the moment of his testimony. Gomi Fumihiko, *Emaki de yomu chūsei* (Tokyo: Chikuma Shobo, 1994). See also: Okudaira Hideo, *Emakimono, Nihon no bijutsu,* Vol. 2 (Tokyo: Shibundo, 1966) and *Emakimono sai-hakken* [Rediscovering *emakimono*] (Tokyo: Kadokawa Shoten, 1987); Akiyama Terukazu, *Emakimono, Bukku obu bokkusu Nihon no bijutsu* [Books of books, Japanese art], Vol. 10 (Tokyo: Shogakkan, 1975); Mushakōji Minoru, *Emaki no rekishi* [History of *emakimono*] (Tokyo: Yoshikawa Kobunkan, 1990); Kuroda Hideo, *Nazotoki Ban Dainagon emaki* [Solving the mysteries of *The Illustrated Scroll of Major Counselor Ban*] (Tokyo: Shogakkan, 2002); Takahata, *Jūniseiki no animēshon;* Gomi Fumihiko, *Emaki de yomu chūsei* [Reading

the middle ages through *emakimono*] (Tokyo: Chikuma Shobo, 1994); Yamane Yuzo, "Ban Dainagon emaki oboegaki [Notes on *The Illustrated Scroll of Major Counselor Ban*]," in *Kokuhô Ban Dainagon emaki* [National treasure *The Illustrated Scroll of Major Counselor Ban*] (Tokyo: Idemitsu bijutsukan, 1994); Komatsu Shigemi, *Ban Dainagon ekotoba, Nihon no emaki*, Vol. 2 (Tokyo: Chūō Kōronsha, 1977).

15. Amino Yoshihiko, *Shokunin uta-awase: Koten kōdoku shirīzu, Iwanami seminā bukkusu* 106 [Artisans' poetry matches: classical reading series, Iwanami seminar books 106] (Tokyo: Iwanami Shoten, 1992), 131.

16. Kaori Chino applies gender discourse in her semantic analysis of Heian art and culture between feminized Heian Japan and dominant Tang China. Kaori Chino, "Gender in Japanese Art," in *Gender and Power in the Japanese Visual Field,* ed. Joshua Mostow, Norman Bryson, and Maribeth Graybill (Honolulu: University of Hawai'i Press, 2003), 17-34. Her theory is complex, as was the cultural climate of the Heian period. See also Joshua Mostow "Female Readers and Early Heian Romances: The Hakubyo Tales of Ise Illustrated Scroll Fragments," *Monumenta Nipponica* 62, No. 2 (Summer 2007): 135-177.

17. Takahata, *Jūniseiki no animēshon*, 71.

18. *Ibid.* Takahata, however, is of the opinion that these different gestures and emotions actually portray the basic types of human behavior that could be expressed by a single person.

19. Masako Watanabe, "Narrative Framing in the 'Tale of Genji Scroll': Interior Space in the Compartmentalized Emaki," *Artibus Asiae* 58, No. 1/2 (1998): 115-145.

20. Translation into English is mine from the transcription in Komatsu Shigemi, ed., *Ban Dainagon ekotoba,* (Tokyo: Chūō Kōronsha, 1977), 153-154. Incidentally, this passage does not appear in the Collection of Tales from Uji.

Japanese Prints: Two Views of Ukiyo-e

Sandy Kita

"... the research worker is likely to get lost unless he can see where his work fits into some comprehensible whole."
— Robert Maynard Hutchins, *The University of Utopia*[1]

In examining a Japanese woodblock print such as Utagawa Kuniyoshi's (1797-1861) *Benkei Fighting Yoshitsune and the Tengu* (ca. 1850), also called *Yoshitsune and Benkei* (Fig. 1), we might follow Robert Maynard Hutchins' advice and think about the various schools of thought on the art of *ukiyo-e* that are part of this work's larger "comprehensible whole." [2] This essay considers two art historical perspectives or views of *ukiyo-e* that provide very different ways of looking at Kuniyoshi's *Yoshitsune and Benkei*. It is important to clarify these two approaches to *ukiyo-e* because, while not mutually exclusive, they are sometimes applied without adequate recognition that they are separate. In addition, alternative interpretations of *Yoshitsune and Benkei* help in teaching about this print and the larger tradition of Japanese art to which it belongs, allowing lessons that engage students intellectually by showing how knowledge can result from the weighing of opposing viewpoints.[3]

What is *ukiyo-e*? *Ukiyo-e* is a form of Japanese art that first appeared in the city of Edo (now Tokyo) in the Tokugawa Period (1615-1868). The word *ukiyo-e* is composed of the phrase *ukiyo*, which can be written with the characters for either "floating world" or "sorrowful world," and *e*—picture, illustration, or art. The term *ukiyo* originally connoted a philosophical and religious concept of the nature of our everyday reality, but by the Tokugawa Period had come to refer to the brothel district, or Yoshiwara, and the Kabuki or popular theaters of Edo. The Kabuki

Figure 1. Utagawa Kuniyoshi, Japanese (1797-1861), *Benkei Fighting Yoshitsune and the Tengu* (ca. 1850), color woodblock print, signed *Ichiyūsai Kuniyoshi-ga,* 30 x 15 inches. Bequest of Dr. James B. Austin, Carnegie Museum of Art, Pittsburgh, Pa.

theaters stood within the confines of the city of Edo, but the brothel district was in a gated enclosure of its own near the Sumida River. Thus, the term *ukiyo* in the Tokugawa Period curiously referred to two geographically separate places, although both were equally cultural centers of the commoners called *chōnin* (townsmen).[4]

Townsmen were the main buyers, patrons, and makers of *ukiyo-e*, although others owned and enjoyed them as well. Often identified with prints, works of *ukiyo-e* actually were made in many different media, including painting. Three people collaborated to produce an *ukiyo-e* woodblock print. An artist painted a composition. This sketch, or later a copy of it, was taken by a second person, the cutter, who carved it into wood blocks. A third person, the rubber, colored and inked the blocks, and having applied a sheet of paper, took the print by rubbing from behind with a pad of coiled rope covered with a bamboo leaf.

The artist signed and sealed his sketch for the print, which was submitted to a government censor for approval before being carved into the blocks. Thus, the seal and signature of Utagawa Kuniyoshi, using his alternate name "Ichiyūsai" (*Ichiyūsai Kuniyoshi-ga*), are printed in the lower part of each of the three sheets that comprise *Yoshitsune and Benkei.* Other text on the print includes the publisher's seal, a censor's mark, a long explanation of the scene,[5] and labels identifying the various figures shown. Depicted is the legendary fight on Gōjō Bridge between "Noble Son Ushiwakamaru" (*Onzōshi Ushiwakamaru*), or Minamoto Yoshitsune (1159-

1189), and the Warrior-Monk Saitō Musashibō Benkei (1155-1189) (*Musashi no bō Benkei*). Yoshitsune is the youth in blue and red and Benkei is the older bearded man. Famous for his strength, Benkei had sworn to steal a thousand swords from a thousand warriors, accosting them as they crossed Gōjō Bridge. Benkei was successful in his sword-stealing enterprise until he met Yoshitsune, who was trained in the martial arts by the long-nosed demons (*tengu*) of Mt. Kurama. Yoshitsune used agility, not strength, to quickly defeat Benkei, who thereafter became his steadfast follower. The print shows Yoshitsune to the left, leaping high onto the railing of the bridge, his thrown fan striking Benkei, who is on the far right. In the middle ground are apparitions of long-nosed demons that seek to hamper Benkei and the spirits of Yoshitsune's former teachers, who look on approvingly.

Images of warriors are not uncommon in *ukiyo-e*, but the art's main subjects during the first half of the Tokugawa Period were actors and courtesans. Later, interest in other themes developed, including landscape. *Ukiyo-e* landscape prints are among the most famous works of Japanese art, so well known that they have led to the misconception that *ukiyo-e* is Japan's only art of the print. The reality is that there are woodblock-printed Buddhist images from the Nara Period (645-710) and the portrayal of secular scenes in this medium from the Heian Period (794-1185). The Japanese art of the woodblock print also did not end with the Tokugawa Period but continued on into modern times in the Creative Print School (*Sōsaku hanga*) and the New Print School (*Shin hanga*). Creative Print masters abandoned the three-man collaborative production method of *ukiyo-e*, pioneered new themes, and moved into abstraction. New Print artists were more conservative in technique, subject matter, and style.

There is general consensus on the above. Less agreement exists on how exclusively we should identify *ukiyo-e* with the medium of woodblock printing, how we might understand its development, and what its place may be among the arts of Japan. With regard to these issues, one can distinguish two quite distinct perspectives. *The Dictionary of Ukiyo-e* (*Ukiyo-e jiten*) outlines both, referred to in this essay as View 1 and View 2.[6]

View 1 regards Ukiyo-e essentially as prints and traces its origins back to Hishikawa Moronobu (ca. 1618-1694). This view is clear in writings on *ukiyo-e* in Japan during the period between 1930 and the end of WWII in 1945 and subsequently became well known in the United States through the publications of James A. Michener, Harold P. Stern, and Richard Lane. The very title of Lane's famous 1978 book, *Images From the Floating World: The Japanese Print,* establishes his affiliation to View 1.[7]

View 2 acknowledges the paintings of *ukiyo-e* as well as its prints and traces its origins back to Iwasa Katsumochi Matabei (1578-1650). View 2 is less prominent in publications on Ukiyo-e in Japan in the period between 1930 and 1945, despite being inherent in much of the research conducted on this art in that time. Fujikake Shizunari introduced View 2 to English readers as long ago as 1938,[8] but the approach did not prove as popular in the United States as View 1. However, elements of View 2 can be found in the writings of Jack Hillier, Hugo Munsterberg, and Donald Jenkins. Jenkins' mentor, Harrie Vanderstappen, taught View 2 at the University of Chicago, and Jenkins' own affiliation to this approach is clear in the title of his 1971 *Ukiyo-e Prints and Paintings, The Primitive Period, 1680-1745*.[9] After 1945, View 2 of *ukiyo-e* became more prominent in Japan, a change that Okudaira Shunroku made clear to American scholars in 1989 at *The International Conference on Japanese Art History: The State of the Field*, University of California, Berkeley.[10] Interest in View 2 in this country thereafter increased.

View 1 of *Yoshitsune and Benkei*

A look at Kuniyoshi's *Yoshitsune and Benkei* through the lens of View 1 emphasizes the qualities that this work has as a woodblock print. Because images in woodblock prints were carved into wooden blocks before being printed, they have clear edges. The clarity of the edges of the figures, structures, and objects in *Yoshitsune and Benkei* is immediately apparent from even the most casual glance. It is impossible not to know that this work is a woodblock print as soon as we look at it.

Our consciousness of the medium in which *Yoshitsune and Benkei* is made can affect our assessment of its worth by making us think about the relative value of prints versus paintings. Prints exist in multiples, and so are not unique objects of art as are paintings. For this reason, *Yoshitsune and Benkei* can be considered less valuable than a painting of the same subject would be. Following this line of thought further, an important question for View 1 is whether *ukiyo-e*, if considered as essentially prints, is as worthy of study as are the many traditions of painting in Japan?

View 1 argues that *ukiyo-e* is worth scholarly investigation because of its special place among the arts of Japan. According to Lane: "like the era which nurtured it, . . . *ukiyo-e* represent[ed] a *unique* [italics added] development in Japanese art."[11] Lane also noted *ukiyo-e*'s "*unparalleled* [italics added] position in Japanese art,"[12] and, to show how unprecedented *ukiyo-e* was, quoted a poem:

Kanō ha mo/ Tosa ha mo kakenu/ Naka no chō
Neither Kanō nor Tosa/ can paint it/ Main street, Yoshiwara.[13]

A print might never be the only one of its kind, but to proponents of View 1 such as Lane, *ukiyo-e* was, nonetheless, unparalleled, unprecedented, and indeed unique among the arts of Japan.

Lane and others of his view could see *ukiyo-e* this way because of how they saw it develop. Key to the development of *ukiyo-e* in View 1 was the Tokugawa shogunate's attempt to control the rich merchants of Edo whose wealth posed a threat by classifying the population of that city into four ranks that were, from top to bottom, warriors, farmers, artisans, and merchants. Since this classification amounted to placing some of the richest people in Edo society on the bottom of the official social order, it required a mechanism by which to diffuse the resentment that it would inevitably create. View 1 saw that mechanism to be the identification of the Kabuki theaters and the brothel district of Edo as realms of fantasy wherein the strictures against rich merchants in the real world would not apply. In the Kabuki theaters and the brothel district of Edo, rich merchants were free to create a reverse social order in which they could rise to the top and, because it was all just play, the warriors would take the bottom positions. Havens of freedom for rich merchants, the Kabuki theaters and the brothel district of Edo became centers of their culture. As this merchant culture spread among the townsmen of Edo in general, a milieu called the Floating or Sorrowful World (*Ukiyo*) appeared. Out of it, according to View 1, came the art of *ukiyo-e*.

Seeing *ukiyo-e* develop this way made this art seem, first of all, unique, for while there had been class divisions in Japan earlier than the Tokugawa Period, an official policy of dividing society into the four ranks of warrior, farmer, artisan, and merchant was unique to that time. Second, the above view of the development of *ukiyo-e* made it seem unprecedented, for scholars of this art in Lane's day were generally unaware of precedents for the culturally active but politically marginalized rich merchants of Edo, although such, in fact, did exist among the people called the *machishū*.[14] Third, the above interpretation of the evolution of *ukiyo-e* gave the impression that this art was unparalleled, for the very idea of the richest people in society being the bottom of the official social order seemed so odd as to be unlikely to have parallels.[15]

Most scholars of *ukiyo-e* in the United States in Lane's day also did not know of the work then being done in Japan on the philosophical and religious concept of *ukiyo*. Thus, Hashimoto Mineo, in his 1975 *The Concept of Ukiyo: A Japanese*

Life-view (*Ukiyo no shisō: nihonjin no jinseiken*), had shown how the term *ukiyo* connoted an understanding of human existence as sorrowful and transitory; had established this idea's importance among the aristocrats of the Heian Period; and had demonstrated how it had changed and expanded during the Middle Ages to become a fundamental part of the philosophy of the common people of the Tokugawa Period. Without knowing of these studies of the concept of *ukiyo*, scholars of *ukiyo-e* in this country, although they generally understood that the word *ukiyo* was an old Buddhist one, tended to think of it primarily in terms of its Tokugawa-Period meaning as a name for the Kabuki theaters and brothel district of Edo. This affected their understanding of *ukiyo-e*.

To the degree that the word *ukiyo* was understood to refer to the Kabuki theaters and the brothel district of Edo, *ukiyo-e* seemed to be a portrayal of those places by virtue of its very name. That is to say, it appeared possible to define *ukiyo-e* as the depiction of a certain subject matter—actors and courtesans—so that these themes became essential to this art in this view of it. Thus, Lane stated: "although *ukiyo-e* was always concerned with genre representations of ordinary scenes from daily life, leisure, and entertainment, it was soon to choose as its special domain the amusement quarters of the great Japanese cities, the courtesan districts and the Kabuki theater."[16]

In this respect, a typical View 1 approach to Kuniyoshi's *Yoshitsune and Benkei* would ask whether the work should be categorized as an "actor print" or a "warrior print." Usually, prints of theatrical scenes in *ukiyo-e* provide the title of the play shown and the names or crests of the actors in question. Since there are no such labels or identifying marks on *Yoshitsune and Benkei*, it is likely that it is an example of a "warrior print" and as such, not a portrayal of one of the two themes considered essential to *ukiyo-e* in View 1. Adopting this approach to *ukiyo-e* in assessing Kuniyoshi's *Yoshitsune and Benkei,* therefore, can make this work seem of only secondary importance in this art.[17]

The name *Ukiyo* also referred only to the Kabuki theaters and the brothel district of Edo and not to similar establishments elsewhere. Accordingly, while View 1 acknowledges that the culture that developed among the rich merchants of Edo inspired print production in Osaka, Kyoto, and other cities, it tends to regard these works as less important than those made in Edo.

To this geographical limit on *ukiyo-e*, View 1 adds a temporal one. Seeing *ukiyo-e* as Lane did—as a unique development in Japanese arts—meant that whatever connections this art might have to earlier ones could not be that important.

Adopting View 1 to investigate *Yoshitsune and Benkei* for this reason can discourage comparison of these images of warriors to those made in previous times.

In addition, images of actors and courtesans dominate the production of *ukiyo-e* in the first half of the Tokugawa Period but give way in the second to interest in other themes, such as landscape. As the portrayal of actors and courtesans was thought essential to *ukiyo-e* in View 1, this change in subject matter was interpreted as a loss of key qualities and so as a decline. Not surprisingly, Lane had much to say that was negative about nineteenth-century *ukiyo-e*, describing the work of the late Utagawa School to which Kuniyoshi belonged as "stereotyped,"[18] "easily dismissed,"[19] and "unlikely ever to win again the kind of fame it once enjoyed."[20]

A View 1 interpretation of Kuniyoshi's *Yoshitsune and Benkei* thus might condemn the action-filled poses of these two warriors as melodramatic over-exaggeration, or see the similarities that this composition has to others as a lack of creativity. It could criticize the print's bright aniline chemical dyes as garish and take its use of cheaper paper as a decline in quality. It might compare the work dismissively to comic books, magazine pictures of movie stars, and other forms of popular-image production to suggest that this example of *ukiyo-e* is "*e*" in the meaning of that word only as illustration or picture, not as art.

Finally, Lane expressed the development of *ukiyo-e* in teleological terms such as "Primitive," "Golden Age," and "Decline and Death." In positing a death of *ukiyo-e*, View 1 implied that this art had no significant relationship to modern developments in Japanese prints. Accordingly, using View 1, an investigator might not consider what the Creative Print or New Print masters might have had to say about *ukiyo-e* or judge the aesthetic value of a work such as Kuniyoshi's *Yoshitsune and Benkei* in terms of art as art is understood today.

View 2 of *Yoshitsune and Benkei*

View 2 provides a very different perspective on *Yoshitsune and Benkei* in seeing *ukiyo-e* as a tradition of painting as well as woodblock printing. Such a view is possible not only because many *ukiyo-e* paintings survive, but also because the *ukiyo-e* method of making woodblock prints endowed them with features in common with paintings.[21] No press was used to make *ukiyo-e* woodblock prints. Instead, the carved blocks were laid face up on pads and the inks and colors were applied by hand with a wide brush.[22] In effect, the rubbers of *ukiyo-e* woodblock prints painted the pigments onto the blocks and so, as the Creative Print master Hiratsuka Un'ichi (1895-1997) observed, could easily "adjust" them to obtain

Figure 2. Detail of central panel.

tonal variations similar to those in painting.[23] Examples of these subtle changes in tone in Kuniyoshi's *Yoshitsune and Benkei* include the brown robe of the white-bearded-man with the scepter labeled Kurama Sōjōbō and the light blue on the face of the long-nosed demon squatting next to him (Fig. 1).

Magnification further reveals the relationship between painting and printing in *ukiyo-e*. The sharp borders of the images of people, structures, and things in Kuniyoshi's *Yoshitsune and Benkei* are not always the result of printed lines but also can be places where the tone of color is particularly dense. For example, the round areas that represent hollows in the folds of robes of the figures dressed in white have their boundaries formed by the migration of particles of pigment to the edges of these blue-grey areas (Fig. 2). The pigment has moved in this way because the rubber is likely to have worked much as Hiratsuka describes doing in the Appendix (p.112). As a result, the inks and colors dripped on the surface of the block are drawn by capillary action to the dry edges, where they stop and are concentrated. This produced the darker pigment at the edges of color in the print.

Identical "lines" appear in the paintings of the Rimpa School that developed during the Momoyama Period (1573-1615) out of the revival of the age-old tradition of painting in the Imperial court called *yamato-e*. A famous Rimpa painter is Tawaraya Sōtatsu (?-1643?), a hallmark of whose paintings is the technique called *tarashikomi* or "dripping onto."[24] We see this method of painting in *Flower and*

Figure 3. *Flowers and Leaves,* no date, signed *Hokkyō Kōrin*, ink and color painting, 13.25 x 10.125 inches. Walter and Dörte Simmons Collection.

Leaves (Fig 3.), a work attributed to Ogata Kōrin (1658-1716), a follower of Sōtatsu important in the codification of Rimpa. Here, the artist drew a leaf in an outline so thin as to be nearly invisible and filled in the enclosed area with water. When he introduced ink into the resulting pool of liquid, the pigment spread to the edges where it concentrated to form a "line" just like those in *Yoshitsune and Benkei.*

The similarity between the *tarashikomi* technique of Rimpa painting and the method of inking and coloring *ukiyo-e* woodblock prints has not escaped the attention of scholars. Thus, Suzuki Jun has referred to the application of the pigments to the blocks in *ukiyo-e* as *tarashikomi* and Yamane Yūzō has suggested that Sōtatsu's experiences working with woodblock printing may have inspired his pooled-ink paintings. It is also natural to apply terms used in discussing the paintings of Rimpa to the woodblock prints of *ukiyo-e* when adopting View 2 because this approach connects *ukiyo-e* and *yamato-e.*

Indeed, the connection of *ukiyo-e* and *yamato-e* is a fundamental difference between View 2 and View 1. As noted earlier, View 2 differs from View 1 in iden-

tifying Matabei as the founder of *ukiyo-e* and in recognizing the importance of the paintings of this art. Matabei can be identified as the founder of *ukiyo-e* only with acknowledgment of this art's paintings, as he made only paintings and is not known to have ever designed a print. So, too, if Matabei is the founder of *ukiyo-e,* then this art must connect to *yamato-e,* for Matabei claimed to be a painter of *yamato-e* and both documentary evidence and his paintings support this claim.

Moreover, because View 2 connects *ukiyo-e* and *yamato-e*, it does not discourage consideration of earlier images of warriors as View 1 did in assessing works such as Kuniyoshi's *Yoshitsune and Benkei*. In this respect, a typical View 2 approach to *Yoshitsune and Benkei* is to look at the long history of the depiction of these two men in *yamato-e*. Yoshitsune and Benkei appear in *yamato-e* because of their prominence in such classics of court literature as the twelfth- to thirteenth-century *Tales of Heike*[25] and *The Tales of the War of the Hōgen and Heiji Periods*,[26] and the fifteenth-century *Yoshitsune*.[27] In fact, *The Illustrated Hand Scroll of the Tales of Heike* and *The Illustrated Hand Scroll of the Tales of the War of the Hōgen and Heiji Periods* are among the most famous examples of *yamato-e*.[28] These paintings were also of enduring importance, providing the source for many of the figures in Sōtatsu's screens, fans, and scrolls.[29]

In addition, *The Tales of Heike* and *The Tales of the War of the Hōgen and Heiji Periods* became part of the repertoire of the sermon singers, lute-priests and other itinerant performers who developed the tradition of song, music, and puppetry called *ko-jōruri*. They in turn were a source of the Tokugawa-Period puppet theater that strongly influenced Kabuki. Matabei depicted lute priests,[30] portrayed the legendary founder of the sermon-singing tradition Semimaru of Ausaka,[31] and may even have illustrated the *Tale of Lady Jōruri,* the story from which *ko-jōruri* takes its name.[32] Finally, Torii Kiyonobu I (1664-1729),[33] Torii Kiyomasu I (fl. 1696-1716), Torii Kiyomasu II (1702-1763),[34] and innumerable other *ukiyo-e* artists illustrated, alluded to, or otherwise drew materials from *The Tales of Heike* and *The Tales of the War of the Hōgen and Heiji Periods.* Thus, adopting View 2 to assess *Yoshitsune and Benkei,* we do not have to relegate this work to secondary status in *ukiyo-e* because of its warrior subject, but can take it instead as part of one this art's oldest traditions of imagery.

Our assessment of *Yoshitsune and Benkei* further improves when we consider why View 1 evaluated such nineteenth-century works of *ukiyo-e* negatively. View 1 does so because defining *ukiyo-e* as essentially the portrayal of actors and courtesans fixes its nature across time to the point that any change indicates decline. View 2 rejects such a static view of art in connecting *ukiyo-e* to *yamato-e*. *Yamato-e*, when it

first appeared in the Heian Period, differed in its refined style, courtly subject matter, and aristocratic patronage so much from *ukiyo-e* as to preclude any connection. However, *yamato-e* changed over time into portrayals of festivals, horse races, fairs on dry riverbanks, brothels, theaters, and aspects of everyday life that all the classes bought and enjoyed.[35] This change in *yamato-e* is what connects it to *ukiyo-e*. Thus, insofar as the connection of *ukiyo-e* and *yamato-e* is fundamental to View 2, this approach inevitably makes us aware of how arts can and do change.

Moreover, assuming that *ukiyo-e* had the same capacity to change as *yamato-e* and so was different in its later as opposed to earlier stages, we would then want to read this art's nineteenth-century products as closely as possible in terms of the particular features of these works' specific time. Here, the writings of Herman Ooms, Conrad Totman, and other historians of Tokugawa Japan who have shown how relationships between warriors and merchants altered during this long period in Japanese history improves the assessment of nineteenth-century *ukiyo-e* such as Kuniyoshi's *Yoshitsune and Benkei*.

As these scholars have pointed out, government in the Tokugawa Period was remarkably stable, but its very stability changed the identity of warriors by ending the wars. The Pax Tokugawa made warriors warless. Warriors had always maintained a need to balance military arts with literary ones so they survived the ending of the wars as bureaucrats of the ever-expanding shogunate rather than as fighting men. Eventually, their martial function was reduced to marching in the great warrior processions of the alternate attendance system that required every warlord to spend every other year in Edo. The steel in warrior armor—too hot for the marches— was then replaced by light woods and *papier mâché*. By the late Tokugawa Period, warriors were literally paper tigers.

Similarly, although the shogunate maintained the social order that placed warriors over merchants unchanged throughout its long rule, its unwise economic policies empowered the latter at the cost of the former. For instance, the shogunate paid its retainers in rice, measured in bales. The rice had to be exchanged for money, a process left in the hands of merchants. The shogunate also saw economics as a zero-sum game, i.e., it believed that wealth could not be created but only had by taking it from others. However, wealth was being created in the Tokugawa Period as agriculture improved and the population stabilized. Not surprisingly, the new wealth went mostly to the merchants, who grew ever richer, just as warriors became poorer.

As the Tokugawa Period progressed, the gap between the wealth of warriors and merchants became ever harder to ignore. Eventually, even the shogunate began

borrowing money from merchants. Once that happened, the social order that placed warriors over merchants no longer reflected economic realities. By the late Tokugawa Period, therefore, elements of the officially sanctioned view of power and authority had lost much of their substance and the supposedly fantastic reverse social order that had been allowed to develop in the Kabuki theaters and the brothel district of Edo was becoming the better model for how society actually functioned. In this way, the boundary separating real and unreal was increasingly blurred.

Consider now the style in which Kuniyoshi portrayed Yoshitsune and Benkei in his print of these two warriors. Note the wealth of painstaking descriptions of real details. Every one of the innumerable facets of Benkei's armor is portrayed by colored squares, and Yoshitsune's wavy coiffure is delineated hair by hair. And yet, the final image is quite fantastic. Myriad ghosts and demons appear in the scene, and can one really leap so high as Yoshitsune does?

The work of art called *Yoshitsune and Benkei* is neither realistic nor fantastic, but rather a mix of the two. Considering how real and unreal were being conflated in the late Tokugawa Period, we need not see *Yoshitsune and Benkei* as over-exaggerated or melodramatic as View 1 did, but can take it instead as a reasonable enough comment on how warriors who dress in *papier mâché* armor and who never go to war are as much image as substance. Indeed, we might even interpret *Yoshitsune and Benkei* as a subversive reflection on how a government that survives by borrowing money from the very merchants that it oppresses lacks credibility.

So, too, we can reconsider the other negatives raised against *Yoshitsune and Benkei* in View 1 of *ukiyo-e* in light of Laurence Kominz's understanding of the development of the Kabuki theater during the Tokugawa Period. Kominz notes how Kabuki actors, by the eighteenth century, "penetrated the daily lives of Edoites" not only through their work on stage but also through endorsements, advertisements, and portrayals in literature and art.[36] These methods of manufacturing fame are the same used by Hollywood and advertisers today. Thus Kominz's work supports Allen Hockley's application of the ideas of John Cawelti, Park Sung Bong, and other scholars of popular culture to rescue the reputation of *ukiyo-e* artist Isoda Koryūsai (1735-1790).[37] Proponents of View 1 of *ukiyo-e* such as Lane had seen Koryūsai as a follower of Suzuki Harunobu (ca. 1724-1770) who only "came close to equaling his master,"[38] who was "deficient in inventiveness,"[39] and whose work was sometimes "gross."[40] Since Lane criticized nineteenth-century *ukiyo-e* for many of the same reasons, we might apply Hockley's ideas on Koryūsai to *Yoshitsune and Benkei*.

Doing so, we would then interpret the stereotyped imagery and conventional composition of *Yoshitsune and Benkei* not as a lack of creativity, but as necessary for product recognition, i.e., for creating what advertisers call "branding" or what modern pop artists call signature styles. So, too, the bright aniline dyes of *Yoshitsune and Benkei* that View 1 considered garish can be taken as increasing the image's power by allowing it to more forcefully capture the eye. Third, the cheaper paper common in nineteenth-century *ukiyo-e* that View 1 took to be a loss of quality might be regarded instead as essential to larger-scale production and so wider distribution. Finally, comparisons of nineteenth-century *ukiyo-e,* such as *Yoshitsune and Benkei,* to comic books, magazine pictures of movie stars, and other forms of popular-image production need not be seen as reason to dismiss these works, but on the contrary, as evidence of their stature as pop-culture arts.

Historiographical Considerations

We have seen how reading Kuniyoshi's *Yoshitsune and Benkei* relative to View 1 or View 2 serves to deconstruct assumptions and value judgments in *ukiyo-e* scholarship. The following review of developments between 1930 and the end of World War II in 1945 throws additional light on political issues related to *ukiyo-e* studies. The period from 1930 to 1945 was one of fascist oppression in Japan, called by many "The Dark Valley" (*kurai tanima*). On May 15, 1932, nine young naval and army officers, having prayed to the Heavenly Ancestress of the Japanese Imperial House Amaterasu Ōmikami, shot and killed incumbent prime minister Inukai Tsuyoshi (1855-1932). On February 26, 1936, a cadre of young officers, without orders from the higher echelon, marched 1,500 troops of the First Division into central Tokyo, where they instituted four days of terror. Catching the elderly finance minister, Korekiyo Takahashi (1854-1936), at home in bed, the "officer assassins" slashed and stabbed him to death in the name of Heavenly Punishment.[41]

The terror was far-reaching, affecting intellectuals as well as politicians. As Maruyama Masao notes: "It is no easy task to convey a convincing picture of the spiritual atmosphere . . . in those days of the so-called Dark Valley of Japanese history. It is even difficult to convey it to the younger generation brought up in post-war Japan, let alone to the Western reader."[42] To illustrate his point, Maruyama tells an anecdote about how even the most innocent scholarly misstep—writing the name of the Emperor Ōjin with the character *jin* for "benevolence" rather than that for "god"—was serious enough for friends to warn him to publish an apology. Maruyama states that he did so, using language so "portentous [that a modern

reader] would laugh out loud."[43] Writing in 1974, Maruyama concludes: "Thirty years ago, it was no laughing matter."[44]

This was the climate in which debate over Matabei began. The debate had its origins in a discovery in 1898. Until that year, Matabei was known only through textual references, innumerable traditional histories of Japanese art identifying him as the "founder of *ukiyo-e*." No actual works by Matabei were then known, but this was not because his art did not survive. Rather, Matabei's work was being overlooked because he had signed everything "Iwasa Katsumochi" and no one knew that he had this other name. In 1898, a set of plaques of *The Thirty-six Poets* was found in the Tōshōgū, Kawagoe, bearing the signature "Last of the Line of Tosa Mitsunobu, Iwasa Matabei Katsumochi."

The discovery of the *Thirty-six Poets* began the modern study of Matabei with the identification of the many paintings signed "Iwasa Katsumochi" as his work, but it also laid the seeds for debate over him. Mitsunobu (1434-1525) was the Third of the Three Great Brushes of Tosa, the family and school of artists who specialize in painting *yamato-e*. Matabei's signature of the *Thirty-six Poets* thus amounted to a claim to be a painter of *yamato-e*. Since Matabei was so well known as the "founder of *ukiyo-e*," the possibility arose that *ukiyo-e* might have developed out of *yamato-e*.

In 1898, this possibility was just a possibility and little more, as the only evidence identifying Matabei as a Tosa was his claim to be one. However, by 1930, *ukiyo-e* scholars had discovered Matabei's family lineage record, letters, and other documentation confirming his connection with the art of *yamato-e*, if not the Tosa School. In addition, Matabei's body of work had been largely established by this time and it turned out to consist almost entirely of portrayals of court poets, illustrations of classical literature, or depictions of other themes typical of *yamato-e*. Finally, at the same time that scholars confirmed Matabei's identity as a painter of *yamato-e*, they also established the consistency with which he had been identified as the founder of *ukiyo-e* in historical sources. By 1930, therefore, Matabei's significance as a bridge between *ukiyo-e* and *yamato-e* could no longer be ignored.

For this reason, debate over Matabei began, as the connection of *ukiyo-e* and *yamato-e* contradicted a nationalistic paradigm of Japanese culture called "old art." As Mimi Hall Yiengpruksawan has explained, the old arts were Japan's ". . . 'national treasures' that represented through a canon of masterpieces [the] imperial line and, by extension, the Japanese people whose identity was one with the Emperor."[45] Essential elements of the cultural patrimony of Japanese people in the view of the nationalists, the old arts were protected from sale abroad, and thus distinguished

from the "export arts," which included prints. Many *yamato-e* handscroll paintings were designated national treasures and so became representatives of old art. *Ukiyo-e* is famous for its prints. Connecting *ukiyo-e* and *yamato-e*, therefore, brought the separation of the old and export arts into question.

Given the nationalistic implications of the paradigm of old art, the military extremists would not have wanted it doubted. Even more, they would not have wanted *ukiyo-e* given roots in Imperial *yamato-e*. As an art born among the rich merchants of the Tokugawa Period who had been oppressed by the shogunate, or warlord government of their day, *ukiyo-e* was often critical of warriors, prone to making fun of their foibles and to exposing their weaknesses.

These anti-warrior aspects of *ukiyo-e* could be read as anti-military. Given how sensitive the military extremists of the Dark Valley were to even the most minor slight, and academia's lack of immunity from attack, scholars seeking to connect *ukiyo-e* and *yamato-e* had to be careful. Their caution is clear in any reading of the literature on Matabei published in Japan in that time. Often the discussion of this artist's importance in bridging *ukiyo-e* and *yamato-e* is couched in language so circumspect as to all but obscure its meaning.

Another way that scholars connecting *ukiyo-e* and *yamato-e* could protect themselves during the period of the Dark Valley was to acknowledge that, even if *ukiyo-e* evolved out of *yamato-e*, *ukiyo-e* differed in its greater exploitation of the medium of woodblock printing. So, too, scholars could admit that, if Matabei had founded *ukiyo-e*, Moronobu had a role in the development of this art as well. Thus, the very scholars who we now see as proponents of View 2 can be found espousing elements of View 1 during the period of the Dark Valley. The two views of *ukiyo-e* did not develop sequentially in opposition to one another but were used together and only really acquired meaning in relation to one another.

Conclusion

This discussion has shown how an awareness of at least two different views on an issue can help us to think more critically about a historical topic. No matter which perspective on *ukiyo-e* one favors, View 1 or View 2, clearly it is useful to consider both. Neither is superfluous for purposes of teaching or research, for we gain a much better sense of the historical events that we study when there is free and open debate between opposing points of view.

Endnotes

1. Robert M. Hutchins, *The University of Utopia* (Chicago: University of Chicago Press, 1953)

2. Long vowels in Japanese words are marked unless the term is already in common use without them, as for example in the case of Tokyo. Long vowels are also not marked where the term is commonly published without them or when the publication has been inconsistent.

3. I wish to express my heartfelt thanks to Katherine Tsiang and Martin J. Powers for their editing and other advice in composing this essay. I also thank Joel Trosch and my wife Terry for reading innumerable drafts. Finally, I wish to express my appreciation to Honda Shojo for his inestimable aid in translating Japanese documents.

4. The word *chōnin* is sometimes used as if it literally meant "merchant." The term is written with the characters for "city people" and can refer to urban commoners not engaged in commerce, such as laborers.

5. The inscription reads: This picture portrays the courage of Noble Son Yoshitsune, who in planning the revival of the Genji [or Minamoto clan], had, as if they were shadows, [followers] from Sōjōbō to the eight *tengu* (long-nosed demons) of the various mountains [who also] hated the atrocities of the great men of the Heike [or Taira clan].

6. Yoshida Teruji, *Ukiyo-e Jiten* (Tokyo: Gabundô, 1965-1971).

7. Richard Lane, *Images from the Floating World: The Japanese Print* (New York: Dorset Press, 1978).

8. Shizunari can also be read Shizuya and Seiya. In the book in question, Fujikake's first name appears as Shizuya. See Fujikake Shizuya, *Japanese Woodblock Prints* (Tokyo: Japan Travel Bureau, 1938).

9. Donald Jenkins, *Ukiyo-e Prints and Paintings: The Primitive Period, 1680-1745* (Chicago: Art Institute of Chicago, 1971).

10. Okudaira Shunroku, "Painting, Literature, and the Theatrical Arts in Edo Genre Painting: Images of *The Beauty on the Verandah*," *International Conference on Japanese Art History: The State of the Field*, University of California, Berkeley, Feb. 19-20, 1989.

11. Lane, *Images from the Floating World*, 10.

12. *Ibid.*

13. *Ibid.*

14. The *machishū* or *chōshu* first appear as leaders of the autonomous, egalitarian, urban communities that appeared in Japan during the Age of Wars (1482-1558) as a result of the collapse of the central administration of government. With the reunification of Japan, *machishū* lost their political role and many of them turned to the arts, where they became the most famous tea masters, poets, calligraphers, and painters of the Momoyama Period. The *machishū* included many rich merchants, out of whose ranks came the great commercial families of Edo. The *machishū* and their role in arts were introduced to English readers as early as 1972 when John M. Shields translated Hiroshi Mizuo, *Edo Painting: Sotatsu and Korin,* Vol. 18, Hiebonsha Survey of Japanese Art (New York: Weatherhill, 1972); but little attention was paid to them until fuller historical treatments appeared such as John Whitney Hall and Toyoda Takeshi, *Japan in the Muromachi Age* (Berkeley: University of California Press, 1977) and George Elison and Bardwell L. Smith, *Warlords, Artists and Commoners: Japan in the Sixteenth Century,* (Honolulu: University of Hawaii Press, 1981).

15. That there are European parallels for the socio-political situation of the Edo merchant is apparent from James L. McClain, John M. Merriman, and Ugawa Kaoru, *Edo and Paris: Urban Life and the State in the Early Modern Era* (New York: Cornell University Press, 1994).

16. Lane, *Images from the Floating World*, 21.

17. Logically, if *ukiyo-e* is essentially the portrayal of actors and courtesans, landscape prints should be

secondary works in this art, especially as they develop late in the history of this art. However, given the popularity and fame that *ukiyo-e* landscape prints enjoyed, proponents of View 1 found it hard to denigrate them. A common solution was to treat landscape prints as "exceptions," something often done by stressing the eccentricity of their creators. However, this leaves unanswered the question of how the most famous works of a tradition can be exceptions to it.

18. Lane, *Images from the Floating World*, 187.

19. *Ibid.*

20. *Ibid.*, 135, 186.

21. The role of the artist in the collaborative printing process of *ukiyo-e* was confined to making the sketch for the composition. Thus, those artists whose names we know from the signatures on *ukiyo-e* woodblock prints were painters and nothing more.

22. A similar method of working the block in the West is known as printing *á la poupée* (dolly printing) from the doll, or wad of fabric, that is used in applying inks and colors to the blocks. See André Beguin, *A Technical Dictionary of Printmaking* (Paris: A. Beguin, 2000), or consult online *Colorful Impressions: The Print-making Revolution in Eighteenth Century France at www.nga.gov/ exhibitions/clrflimpr-tech.shtm.* Printing *a la poupée* is a rather specialized technique in the West, but in *ukiyo-e*, painting the pigments onto the block was standard practice.

23. Hiratsuka's comment is in a letter in the collection of Walter and Dörte Simmons, who purchased Hiratsuka's print of *Woman with Shawl* and the letter is in reference to that work. Since the letter contains much interesting information on Hiratsuka's working method and its relationship to *ukiyo-e*, it is translated in its entirety in Index 2.

24. The term *tarashikomi* has been translated in various ways. *Tarasu* means "to drip" and *komu* means "to permeate or infuse." "Dripping onto" is given in the *Dictionary of Japanese Art Terms*, but "splashed ink" is a common translation as well. Some believe that the method involves a masking agent, but on the back of Sōtatsu's *Kneeling Bull* in the Chōmyō-ji, a famous example of *tarashikomi*, a very faint outline can be seen. Sōtatsu apparently drew the image in this light line first, filled it in with water, and then touched a brush loaded with ink into the resulting pool of liquid. Thus, Sōtatsu's method of making *tarashikomi* paintings is basically the same used in *Leaves and Flowers*. See *A Dictionary of Japanese Art Terms. Bilingual [Japanese and English] A Popular Edition* (Tokyo: Tokyo bijutsu Co., ltd., 1990).

25. Hiroshi Kitagawa and Bruce T. Tsuchida, *The Tale of the Heike,* Vol. 1-2 (Tokyo: University of Tokyo Press, 1975).

26. The Hōgen Period is 1156-1159 and Heiji Period is 1159-1160. See William R. Wilson, *Hōgen Monogatari: Tale of Disorder in the Hōgen* (Tokyo: Sophia University, 1971).

27. A translation of the *Tales of Yoshitsune* or *Gikeiki* is Helen Craig McCullough, *Yoshitsune, A Fifteenth Century Japanese Chronicle* (Stanford: Stanford University Press, 1971).

28. See Ienaga Saburo (Saburō) and John M. Shields, trans., *Paintings in the Yamato Style,* Heibonsha Survey of Japanese Art, Vol. 10 (New York: Weatherhill, 1973), 148.

29. Yamane provides a handy chart showing the sections of an illustration of *The Tales of the War of the Hōgen and Heiji Periods* from which various figures and scenes in the paintings of Sōtatsu are taken. See Yamane Yūzō, *Sōtatsu to Kōrin, Genshoku nihon no bijutsu,* Vol. 14, Tokyo: Shōgakkan, 1969), 163-164.

30. Sandy Kita, *The Last Tosa: Iwasa Katsumochi Matabei, Bridge to Ukiyo-e* (Honolulu: University of Hawai'i Press, 1999), 191-192.

31. A painting of this subject is attributed to Matabei. See the frontispiece of Susan Matisoff, *The*

Legend of Semimaru Blind Musician of Japan (New York: Columbia University Press, 1978).

32. Kita, *The Last Tosa*, 205-210.

33. Jenkins, *Ukiyo-e Prints and Paintings* (Honolulu: University Press of Hawaii) pl. 53.

34. Works by these two artists can be found in Howard A. Link, *Primitive Ukiyo-e from the James A. Michener Collection in the Honolulu Academy of Arts* (Honolulu: The University Press of Hawaii for the Honolulu Academy of Arts, 1980) 41, 56.

35. Narazaki Muneshige, Kondō Ichitarō, Fujikake, and other scholars generally refer to such later examples of *yamato-e* as "*fuzokuga.*" The word *fuzokuga* is usually translated as "genre painting" but can refer to representations of the everyday life of aristocrats as well as commoners. Thus, Yamane has called certain Heian-Period works of *yamato-e* "*fuzokuga* for aristocrats." The works that Yamane has in mind include many that Ienaga Saburō identifies as part of the category of *yamato-e* called "Records of Old Customs (*kojitsu kiroku*)." This category includes such obvious examples of genre painting as *The Hand Scroll of Events and Ceremonies in the Imperial Court* (*Nenchūgyōji emakimono*). See Ienaga and Shields, *Handscroll Paintings*, 161. On the connection between the later *yamato-e* and *ukiyo-e*, see Kondo Ichitaro (Kondō Ichitarō) and Roy Andrew Miller, trans., *Japanese Genre Painting: The Lively Art of Renaissance Japan* (Rutland, VT: Charles E. Tuttle Company, 1961).

36. Laurence Kominz, "Ichikawa Danjūrō V and Kabuki's Golden Age," in Donald Jenkins, *The Floating World Revisited* (Portland, OR: Portland Art Museum, 1993), 63-84, esp. 66.

37. Allen Hockley, *The Prints of Isoda Koryūsai, Floating World Culture and Its Consumers in Eighteenth Century Japan* (Seattle: University of Washington Press, 2003), 41-133, esp. 80-81.

38. Lane, *Images from the Floating World*, 11.

39. *Ibid.*

40. *Ibid.*

41. "Heavenly punishment" means a punishment that is well deserved. The Japanese word for "heavenly punishment" is *Tenchū, Tennō* being the word for "Emperor."

42. Masao Maruyama, *Studies in the Intellectual History of Tokugawa Japan,* trans. Mikiso Hane (Tokyo: University of Tokyo Press, 1974), xvi-xvii.

43. *Ibid.*

44. *Ibid.*

45. Mimi Hall Yiengpruksawan, "Japanese Art History 2001: The State and Stakes of Research," *Art Bulletin* LXXXIII, No. 1 (March 2001): 114.

Appendix

Concerning *Woman with Shawl*

The print is a life-sketch of my wife Teruno at age twenty, made when we were in Senogawa (?) in 1936.

Here is the explanation to the color plate inserted in *Hiratsuka gashû (Collected Work of Hiratsuka)* that was published by Kodansha (1978): "… based on a pencil sketch with added color, I tried to bring out the pencil line in the cutting of the zigzags using a 2-*bu*-wide *aizuki* [square end] chisel. I used the watercolors of Nihonga for the face but there was a bit to bringing out the changes while using as little color-mix as possible. But, the finished work is one of the ones I feel good about."

The shawl is why the work draws the eye and was one that my wife sought out and bought at Ueno Hirokōji that year we were in Tokyo.

I used as the block for this print a 4-*go*-size oil-painting sketchboard that was made of cherry wood and which had grain because this is the very best of materials, identical to that loved by Utamaro, Hokusai, etc. In this way, I was able to engender line drawing of a fineness that you will not have seen until now. The *baren* that I used was the *tsubushi baren* and the *ito baren*. A *tsubushi baren* is made with sixteen twists of the bamboo leaf, and so is convenient for applying pressure. Because the *ito bare* is made of paper *(gampi)* soaked in persimmon juice and twisted four times, you can rub thin lines skillfully. In any case, the job required applying light pressure. First, using the *tsubushi baren*, I applied the ground using pink *(taisha)* for the face—that is how I made the skin color. It was the work of seconds to drip softly onto the face of the block with the tip of a *waribashi* chopstick a few drops of paste that I had thinned and then adjust with the brush *(hake)*.

I rubbed the shawl with indigo watercolor six, seven times; the hair was ivory black mixed with white rubbed six, seven times; the lips of the face were done in red *(shû)* in two passes. [I] used layers of thin color so that the color would have depth.

The reason why paste is mixed in [the pigment] is in order to make the particles of color small. There is also the positive point of slowing down the drying of the block. The process is not to mix paste into the pigment but to drip a few drops of paste onto the block and then adjust with the brush *(hake)*. I hope you will understand the process because [if you do] you will come to appreciate [the work more].

The order of the rubbing was ground color, shawl, hair, lips, and, last, the black lines, which were done in one pass.

I used a *tsubure baren* that was made special for me by Suganuma Kahei who had National Treasure-like skill. My *ito baren* was used by the Tanaka family of Saikamachi ni-chôme. The younger sister of my grandmother married [into that family] when their profession became woodblock-printing textbooks after they lost their fief. It is said that the rubbing of the grandmother of the Tanaka family was "first under Heaven."

With the *ito baren* came a tool to remove the eyes (rough spots) on the bamboo leaf [of the *baren*]. This tool was made of five 2-*bu* pieces with 1-*bu* pieces in between and with a square shaft put through [the square holes in the coins] and a handle applied. Because the coins will not turn, they can be used to flatten the rough spots on the bamboo leaf quickly. This was a precious tool of the sort that the Edo Period rubbers had to have.

With these hard-to-obtain tools, with the same spirit as the Edo-period makers of Ukiyo-e, with all my heart, and adding in my best devices, [I] made this work.

Woman with the Shawl that was born in these fortunate circumstances has been "top" in self-cut prints since the Taishô period (1912-1926), and even now still stands on the front line. Of all the work that I have seen, East and West, including America and Japan, there is no other example like this one in terms of paper, block, carving, brush, and *baren*. The color [is] in harmony with my own feelings as [I] sang the marches and songs of my youth. Therefore, with my breast filled with pride, it is my great pleasure to give to all lovers of the print on this day this work.

1982
Third month
Outside Washington, D.C.
Hiratsuka Un'ichi

First Lines, Final Scenes: In Text, Handscroll, and Chinese Cinema

Jerome Silbergeld

When I have presented one corner of a subject to anyone, and he cannot from it learn the other three, I do not repeat my lesson.
— Confucius, *The Analects*[1]

I always write the last sentence first. Or second, and then I write the first sentence. And then I fill in everything in between.
— Toni Morrison[2]

Long after the details have been forgotten, one's memory of the opening lines still remains intact: "It was the best of times, it was the worst of times, it was the age of wisdom, it was the age of foolishness, it was the epoch of belief, it was the epoch of incredulity..."[3] Likewise, from China's classic novel *The Romance of the Three Kingdoms*: "Empires wax and wane; states cleave asunder and coalesce"[4] (in the original: "*fen jiu bi he, he jiu bi fen* 分久必合，合久必分, the separated must eventually conjoin, the conjoined must eventually separate"). Long after these novels' epic twists and turns have challenged and defeated the best-honed memories, their opening lines remain fixed in memory, pointing to the careful attention that any writer might pay and want paid to his own first words—and perhaps to his last, although who remembers the final lines of either of these two classics? Shakespeare's *Richard III* sets its own stage with an unforgettable, if melodramatic, soliloquy including these lines:

> I, that am curtailed of this fair proportion,
> Cheated of feature by dissembling nature,
> Deformed, unfinished, sent before my time
> Into this breathing world, scarce half made up,
> And that so lamely and unfashionable
> That dogs bark at me as I halt by them....
> And therefore, since I cannot prove a lover,
> To entertain these fair well-spoken days,
> I am determined to prove a villain.[5]

Yet the most quoted play of all, *Hamlet*, begins simply, "Who's there?" One might, at least briefly, imagine that the playwright here has let down his guard. Hardly memorable, both understated and prosaic, the two words nevertheless prove prophetic and profound in a scene that introduces to the audience the sleepless ghost of a murdered monarch. Who's there, indeed? At least one *can* remember the words, and once their subtlety is manifest, one might well feel the impetus to do so. By contrast, however much one may like or dislike Faulkner, the one hundred and twenty-three word opening sentence of his magisterial *Absalom, Absalom!* doesn't stand a chance of being remembered except as a statistic, although it certainly lets readers know right off what they are in for; and if it doesn't suit them, they can stop right there.[6]

Last lines, too, remain in the memory and embody the whole, if the author is master enough of his craft. In literature, there is Fitzgerald's requiem for Gatsby's failure of a dream, "So we beat on, boats against the current, borne back ceaselessly into the past."[7] The ending of Faulkner's *Absalom, Absalom!* is as unforgettable as its beginning was forgettable; asked why he hates the South (presented throughout the novel's nearly four hundred pages in terms as lurid and sinful as the biblical sins of King David, referred to by the title), the storyteller replies with an outburst one both feels intensely and yet cannot believe: "*I don't. I don't! I don't hate it! I don't hate it!*"[8] In film, there is "Forget it, Jake. It's Chinatown!"—incomprehensible, impenetrable Chinatown—although a few concluding words still remain to be spoken by a secondary character.[9] In *Heart of Darkness* (unlike its cinematic counterpart, *Apocalypse Now*), one is liable to forget that such memorable "last" words as "The horror! The horror!" don't really come last, although that is what sticks in the mind; in the book, after still more conversation, it is "...the tranquil waterway leading to the uttermost ends of the earth flowed sombre under an overcast sky—seemed to lead into the heart of an immense darkness."[10] But who

remembers the last lines of *Richard III* or *Hamlet* or any Dickens novel? Who remembers the final lines that follow "Call me Ishmael" by some eight hundred and twenty pages, or the first lines that preceded this memorable conclusion: "The creatures outside looked from pig to man, and from man to pig, and from pig to man again; but already it was impossible to say which was which."[11] Remember or forget, it is worth remembering Proust's admonition that "great works of art do not begin by giving us the best of themselves."[12] It is certainly true that most of China's classic novels do not begin with classic first lines or end with memorable last words.

It is rare when both first and last lines are memorable, yet perhaps what is most memorable are the few cases in which first and final lines or scenes foreshadow and recall each other to form a well-structured frame around all the other words between. "Mother died today," wrote Camus in *The Stranger* ("*Aujord' hui, maman est morte*"). "Or maybe yesterday; I can't be sure." And that death, about which the son cannot form any certain emotion at the outset, is matched by his similar lack of feeling for his own demise at the end, and for which it would take more emotion than others possess to trigger any regret: "For all to be accomplished, for me to feel less lonely, all that remained to hope was that on the day of my execution there should be a huge crowd of spectators and that they should greet me with howls of execration."[13] On the second page of his novel *Red Sorghum*, Mo Yan offers a paean to the plant that his father's generation ate "out of preference," which "shimmered like a sea of blood," and which (like blood) embodied the irrepressible vitality, passionate and violent, of the long-suffering Chinese people of that era.[14] And matching this, on the second page from the last, we discover what has happened to that sorghum:

> ...the lush green sorghum now covering the rich black soil of Northeast Gaomi Township is all hybrid. The sorghum that looked like a sea of blood, whose praises I have song over and over, has been drowned in a raging flood of revolution and no longer exists... High-yield, with a bitter, astringent taste, it is the source of rampant constipation.

From eating this hybrid sorghum, "All the villagers' faces are the color of rusty iron," and only the Party cadres "above the level of branch secretary" are free of its scourge.[15] It is by means of this bracket, strategically inset as a bow to the censors, that one can determine the author's underlying motivation for having dragged his readers through all the passion and violence that his stunning novel has to offer:

Figure 1. Zhang Zeduan, *Qingming shanghe tu*, early twelfth century. Handscroll (section), ink and color on silk. Palace Museum, Beijing. From Zhang Guosheng and Li Hong, eds., *Zhongguo meishu quanji, huihua bian, 3, liang Song huihua* (1999), 128.

to record the tragic loss of public vitality imposed by the Communist revolutions' sterile materialism, pseudo-egalitarianism, and repressive bureaucratization of Chinese (agri)culture and social life. But the author cannot quite say this; only his red sorghum, tucked in at either end of his tale (slightly indented at both), is able to convey this interpretation to the savvy reader. All this is lost in Zhang Yimou's 1987 *Red Sorghum* film, which supplies its own trope—not a bad one, but entirely different, at the conclusion: an eclipse of the sun.[16]

One would think that a writer would pay no more attention to anything than to the impression made by the first and final moments of his or her work, and that any film director would do so, too. Whether one appreciates their genre or not, the opening moments of an entertainment film like *Mars Attacks,* with a herd of cattle on fire stampeding down a rural roadway, or the closing instant of *Carrie,* which saves its biggest scare for last, a hand thrusting out of the grave to seize the hand of Carrie's sole surviving tormentor, can be remembered for their ingenuity as audience "grabbers."[17] But not every artist sets out to make such an impression,

Above, Right: Figure 2. Anonymous, *The Feast at Hongmen*, first century BCE. Ink and colors on clay-and-lime surface. Lintel mural excavated from Luoyang Tomb 61. (From *Han Tang bi hua* (1974), fig. 2.)

and many prefer to slide more gradually and "naturally" into their narrative, with what cinema calls an establishing shot, writ large, and eventually, at the far end to depart more gracefully. Regardless, we must imagine that all such choices are carefully considered.

Chinese handscroll painting has often been compared to cinematic narration by modern viewers and writers,[18] and like cinema, Chinese painting has at least a few formal terms to describe the sequential developments that enliven and diversify a work and sustain interest over time: *kai he*, literally open and close, which refers not to the start and finish of the work but to the spatial density and sparseness of composition; *qi fu*, which refers to the alternating rise and fall of landscape form, like intensified and discharged emotions.[19] Like filmmakers, handscroll painters must give special consideration to their opening and closing passages. Like *Hamlet*, the opening passage of the *Qingming Festival* scroll by Zhang Zeduan (early twelfth century) (Fig. 1) is understated but, on reflection, especially poignant. Establishing the theme of travel, it offers a number of routes and passages, on land and by water, for the viewer to take, as well as a small group of travellers to join; but most strikingly, the first object introduced is a gnarled old tree that has survived the passing by of countless travellers over the ages, putting them all into a natural and historical perspective. Just how the scroll originally ended is not known since it is now truncated in the middle, so viewing it is like a theater experience in which the film breaks and cannot be repaired.[20]

The earliest identifiable historical narrative that still survives in Chinese painting, *The Feast at Hongmen* (Fig. 2), from a first century BCE tomb in Luoyang, employs a visual strategy that endured for centuries and became a classic.[21] The two main figures, contenders for the throne of China after the sudden fall of Qin, sit passively in the center of the composition (Xiang Yu, favored but soon to fail, on the right; Liu Bang to his left, soon to found the long-lived Han dynasty) as the subjects

of a drama that swirls around them. From the far left enters Liu Bang's would-be assassin, while from the right enters Liu Bang's charioteer and bodyguard, Fan Kuai, charging to the rescue—the two framing the work with their dynamism. The details of the tale are complex and could hardly be better told than in Sima Qian's classic account, but neither could the essence of relationships be better captured or more simply reduced than by this illustration, right down to the most critical secondary characters.[22] The elegance of this symmetrical composition could still be found in handscroll paintings nearly a millennium later, like Yan Liben's seventh-century composition, *Xiao Yi Seizes the Orchid Pavilion Manuscript*, and Zhou Fang's late-eighth-century composition, *Ladies Playing Double-Sixes*, with the action, whether consequential or mundane, now transferred to the central figures. The figure at the opening of *Xiao Yi* is no longer present in the oldest surviving version of this composition, but his former presence can be deduced from the structure of the whole (and confirmed by other copies; as a witness, he scratches his head in dismay at the gullibility of his master). In both *Xiao Yi* and *Double-Sixes*, the placement of additional figures looking forward from behind the main characters draws the viewing audience into a configuration that surrounds the central characters on all four sides.[23]

Some landscape handscrolls abstractly mirror this classic balance, as does Xu Daoning's *Fishing in a Mountain Stream*.[24] *The Red Cliff* (Fig. 3), attributed to Wu Yuanzhi, illustrating Su Shi's first *fu* with this title, does this especially well, closely yet creatively following Su's poem and, like the poem, dividing the composition into three distinct parts, symmetrically balanced both thematically and visually.[25] But other landscape handscrolls, with or without narrative features, just as often (or perhaps much more frequently) preferred asymmetry—taking their departure, for example, from an opening foreground set nearby and articulated in quotidian terms, and closing in depth, remote, spacious, and perhaps otherworldly. Zhao Mengfu's *Water Village* does this; Zhou Chen's *Dreaming of Immortality in a Thatched Hut* asymmetrically balances the dreamer, sleeping in the material here-

Figure 3. Wu Yuanzhi, attributed, *The Red Cliff*, twelfth century. Handscroll, ink on paper. National Palace Museum, Taipei. (From Yu Jianhua and Chen Songlin, eds., *Zhongguo huihua quanji, 3* (1988), 92-93).

and-now, with his immortal self, released through dream and floating in the void; Shen Zhou's *Gazing at the Mid-Autumn Moon* similarly contrasts the mundane and the evanescent, the contemplator and the contemplated, earth and moon, balanced around a central axis occupied by a crane which is poised to fly back and forth between Heaven and earth. A musical parallel to such works would begin with a bang and end in silence. Some paintings do just the opposite. The possibilities of what to do in the course of a handscroll are limitless; but the possibilities of how to begin and end a scroll are far more limited, and only a small number of examples stand out as distinctive enough to capture the memory and the imagination.

A similar statement about possibilities could be made of Chinese cinema and, similarly, only a limited number of Chinese films stand out by virtue of their opening and closing moments. Some of these best moments are incorporated, wordlessly, right into the film's opening or closing credits. Remembering Proust's caveat, and with specificity rather than generalization in mind, I offer the following ten personal favorites as examples of excellence in the Chinese cinematic art.

Best Opening Scenes (5)

Old Well (1986, director Wu Tianming) describes the desperate search for water to sustain a village in a rocky, mountainous north Chinese landscape strikingly like that in Fan Kuan's famous early Song dynasty painting, *Travellers among Streams and Mountains*. Here, the opening credits roll against a tight close-up shot inside a well shaft, showing only the muscular arms and back of young actor (and cinematographer) Zhang Yimou, deep in shadow, hammering away at hard rock (Fig. 4). As the hammering continues, it is joined by background music, two notes

Figure 4 and 5. *Old Well*, director Wu Tianming, cinematographers Zhang Yimou and Chen Wancai, 1986. Film frame.

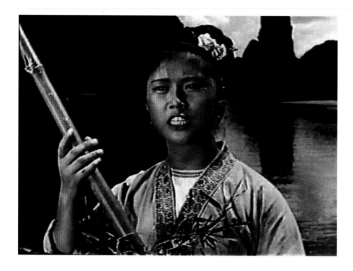

Figure 6. *Liu Sanjie/Third Sister Liu*, director Su Li, cinematographers Guo Zhenting and Yin Zhi, 1961. Film frame.

at first, a wailing sound, repeated high and higher on the scale, and on the fifth repetition further joined by percussion that picks up on the sound and rhythm of the hammer. At that moment, the camera begins a slow, symbolic journey up the shaft toward the round circle of light far above, the music becoming syncopated, more animated, finally in double-time as the camera arrives at the entrance (fig. 5), like a birthing process that through hard labor and sheer determination gives new life, and brings new hope to the community.

Third Sister Liu (1961, director Su Li), transforms an authentic eighth-century songstress, Liu Sanjie, anachronistically, into a proto-Communist propagandist. The Guilin scenery is also historically inaccurate (Liu Sanjie came from central China), but the music and voice are lovely and the camera carefully picks out successive details from the landscape that match one detail after another of Liu's opening lyrics (Fig. 6) about the necessity of song in the lives of the oppressed and otherwise voiceless masses:

> Whatever sentiment is in the mind suppressed
> Erupts like fire in songs from the breast.
> Mountain songs are like springs so clear,
> Sung in vales and jungles everywhere.
> They rush and roar like floods unfurled
> Breaking all dykes, inundating the world....
> It's really hard to live in this world,
> Like sailing up against the stream.
> If songs are not sung, sorrow will spread.

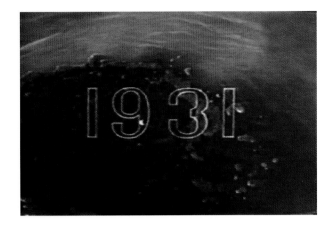

Figure 7. *The Lin Family Shop*, director Shui Hua, cinematographer Qian Jiang, 1959. Film frame.

If roads are not walked upon, weeds will grow.

If steel knives are not sharpened, rust will erode them.

If heads are not held high, backs will bend...

China's ancient song-gathering tradition and its tradition of allegorical rhetoric are well-wedded here, as is text to visual image.

The Lin Family Shop (1959, director Shui Hua) is based on Mao Dun's classic short story (1932) about a petty—and petty-minded—shopkeeper struggling for survival amid the double-edged hardships of anti-Japanese boycotts and Guomindang corruption. Associated with the failure of capitalism that opened the way to the Communist Revolution, the film begins with an image of Mao Dun's book, opened to the title page and film credits, followed by a political analysis in rolling script and voiced-over narration. As this commentary concludes, the book's pages begin to turn and this motion turns into the rowing oar of a boat making its way down the canal of the Lin family's unnamed Zhejiang village. Nearing the family shop, the canal narrows, the boat is blocked by another one parked in its path; and as it comes to a halt, a villager empties a pail of night-soil right next to it into the canal. The camera focuses close in on the bubbling muck, and from this foulness up bubbles the date in script: "1931." (Fig. 7) One knows immediately just what kind of year this is going to be. As a diagetic introduction, it looks toward a murky future (this was the year Japan seized Manchuria); yet as an exegetic post-revolutionary film, it looks back to the morass that no longer lurks antagonistically between a darkened past and the bright socialist future anticipated at the time of China's Great Leap Forward.

In *The Day the Sun Turned Cold* (1994, director Yim Ho), a young man accuses his mother of having murdered his father ten years earlier, pitting the traditional

Figure 8. *The Day the Sun Turned Cold*, director Yim Ho, cinematographer Ho Yung, 1994. Film frame.

avoidance of public shame against the private urge to confront and cope with guilt, and imagining what might become of traditional family values and systems of justice as a modernizing China imports the ethical values of a modern West. To quote my own account of this introduction,

> As a bicycle rider steers his way through traffic down a busy street, the scene is viewed from the level of the pedals. [Figure 8] While the cycle approaches its destination, dodging all obstacles in its way, the parts of the machine go round and round, driving its rider there with an almost palpable mechanical certainty. When the cyclist arrives at his destination, a police station, the wheels seem to have become the fabled wheels of justice, the great Wheel of the Law dispensing karmic retribution. The forward movement is relentless, irreversible. Only later will the audience be in a position to wonder whether the train of events thus set in motion wasn't misdirected, and whether the tragedy unleashed by this journey could not have been stopped.

In the first scene of *Street Angel* (1937, director Yuan Muzhi), which follows a photomontage that accompanies the opening credits and a rapid camera pan down an architectural maquette to the "lower depths" of Shanghai where the story takes place, the film introduces its male protagonist, the young musician Xiao Chen, and his girlfriend in a semi-comic introduction to this tragic tale. The occasion is a street parade celebrating an elaborate wedding with two large marching bands, one in Western semi-military uniform playing Western music (for which Xiao Chen is a trumpeter), the other in Chinese robes playing traditional music—both performing at the same time, the result of which is sheer cacophony. The bride, as it turns out,

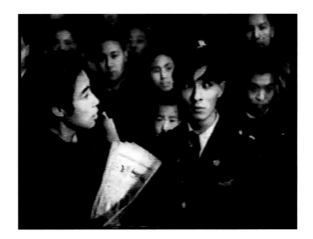

Figure 9. *Street Angel*, director Yuan Muzhi, cinematographer Wu Yinxian, 1937. Film frame.

is cross-eyed; when he sees her, our young musician briefly goes cross-eyed as well (Fig. 9)—and why not, since the aural and visual confusion of the scene serve to introduce the chaos of an era in painful transition. The film's romantic couple will get caught in the vice of social corruption, and role of the main character is to discover that the cause of this corruption lies not so much with individuals (especially not his girlfriend's sister, a "street angel" or prostitute forced into the trade by the "parents" who bought her) as with China's flawed social structure and its ragged encounter with modernity. The racket of the opening scene's wedding music masks the sound of characters talking; but throughout, *Street Angel* only halfway enters the "talkie" era and still (wonderfully) indulges in the pantomime of silent film. It likewise represents an era before film genrefication set in, freely mixing comic with tragic and politics with entertainment, blending film with stage theater with musical cabaret, and managing like a fine juggler to keep all of these in balance. This opening scene captures all of this.

Best Closing Scenes (3)

Director Hou Hsiao-hsien's *Good Men, Good Women* (1995) tells two stories in one through the device of a film within a film, with the unusual twist that the inner film is nonfiction, performed by the fictional characters of the outer film. Moreover, like a cinematic version of the classic Chinese box, both inner and outer narratives are periodically framed by a third cinematic level, a documentary record of the actual filming of the pseudo-filming and of rehearsals that are both fictional and real at the same time. The film-within is based on the lives of Chinese freedom fighters against Japan, Chung Hao-Tung, who was executed by the Nationalist

Figure 10. *Good Men, Good Women*, director Hou Hsiao-hsien, cinematographer Chen Hwai-en, 1995. Film frame.

government in Taiwan in the White Terror of the early 1950s, and his wife Chiang Bi-Yu. Set within a bracketing device that is repeated to both open and close the film (documenting the arrival on location in Guangdong of the actual performers in Hou Hsiao-hsien's film), the final scene of the film-within (i.e., the penultimate scene of the entire film) shows the newly widowed Chiang ritually burning paper money beside the corpse of her martyred husband (Fig. 10). Chinese film is often accused of being too melodramatic or else not dramatic at all, but *Good Men, Good Women* is neither. This remarkably humane film about so much injustice, profound suffering, and pain of reconciliation is steeped in an unimaginable stoicism and leaves its brief moment of most intense and emotionally devastating expression for the very end. These few seconds, made all the more unbearable by the slow accumulation of grief kept inaccessible until this instant when self-discipline itself momentarily fails, represent a bygone culture and a past time scarcely available to those performing these roles in our own time. At this funerary moment, the camera begins high up, lofty and ethereal, then slowly descends, as if into a tomb, to the level of the dead and the grieving; the black-and-white shot slowly saturates into color, intolerant of abstraction. The nobility of Hao-Tung's self-effacing last testament to his family ("Guard your dreams"), voiced over in this scene, is carried forward by a sublime musical score into the final scene which stitches beginning and end and all three filmic levels together, informing the audience by subtitles that Chiang Bi-Yu herself did not live to see the finished film—dying at the age of 74 as the performers left Taiwan for Guangdong.

In the Heat of the Sun (1994, director Jiang Wen) narrates the story of a gang of spoiled children, sons and daughters of the Communist elite, coming of age in Beijing during the Cultural Revolution when the adults have all gone out to "make revolution" and left no one to watch over them. For those who look beneath the romantic surface of this tale, the film provides an allegory of falling in love with the trappings of revolutionary grandeur but awakening to find it an illusory, failed

126

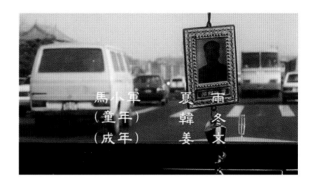

Figure 11. *In the Heat of the Sun*, director Jiang Wen, cinematographer Gu Changwei, 1994. Film frame.

affair. The myth of social equality in the revolutionary era is subtly undermined throughout the course of the film, but it is held up for explicit comment at the end of this color film as the credits roll against a backdrop of black-and-white footage. The closing segment looks like a recycled outtake, but this critical scene cues the audience—those who haven't stood up and walked out on the credits—to the film's deeply structured critique. The characters are shown one last time, now all grown up (including director Jiang Wen as the main character), dressed in business suits, drinking hard liquor as they ride about the new Beijing in a white stretch-limousine; and despite their mockery of China's revolutionary rhetoric in their youth and their breach of faith with Communist ideals past and present, they have clearly become the economic masters of today's New China by virtue of their revolutionary inheritance. In the last words of the film, a local half-wit from their childhood is spotted by them, and as they ride by he shouts one dirty, derogatory name at them—a sexual slur that sticks and helps to account for why this film (after leading at the box office and winning all the major film awards of that year) was belatedly suppressed by the current government. The film opened with a towering image of Chairman Mao, glistening in the sunlight; it closes in black and white, drained of vitality, with the chairman (Fig. 11) dangling from the rear view mirror of their limousine, a much-reduced god of traffic safety.

Yellow Earth (1984, director Chen Kaige) begins with the arrival in north China's dusty, dry landscape of a Communist Party song gatherer, intent on transforming the lyrics of the local songs into inspirational propaganda. But the locals cling to their traditional ways and hold the cadre to an ideological standoff. Only the young daughter at the cave dwelling he has stayed in is converted to the cause, but he refuses to take her to the Communist stronghold at Yan'an because "We officials are bound by official regulations"–that is, Party bureaucratism. The cadre promises to return but he is too late, for she has left on her own to join the troops

Figure 12. *Yellow Earth*, director Chen Kaige, cinematographer Zhang Yimou, 1984. Film frame.

and died in the attempt. Still, he seems to return in the final scene, but only sort of, for in a film that is otherwise remarkable for shedding revolutionary heroism in favor of matter-of-fact realism, his return is shown three times, surrealistically, each time starting over as if to question whether it ever actually occurred, or mattered, and finally the camera pans slowly downward to the yellow earth itself—China's unchanging reality—and he is not there. (Fig. 12) The final frame is just as empty, and just as ambiguous, as the answers to the questions implied by this sequence: Did the revolution really matter? Can China *really* change? And yet, with this, the revolution in modern Chinese filmmaking had begun.

Best Opening *and* Closing Scenes (2)

Farewell My Concubine (1993, director Chen Kaige) is bracketed by opening and closing scenes that frame six decades, seen in flashback, of life in the Chinese theater, beset by the turbulent politics of the twentieth century. Increasingly, politics turn the theater upside down (and one could read film or literature into this, as well as theater), until finally revolutionary politics itself *becomes* theater. The two main characters and the contrast between them embody and explore the question of whether life and art in China can effectively be separated from political reality, and the clear answer is no, they cannot. On stage, they play the failed political aspirant Xiang Yu (Fig. 2) and his faithful concubine Yu Ji, and in the first scene of the film they return from an eleven-year exile from the theater to a personal reunion on stage. As they recount the years of separation, one of them stutters false data and the other repeatedly corrects him; when they come to the insincerely spoken lines, "Everything's fine now" and "It's due to the Gang of Four and the Cultural

Figure 13 and 14. *Farewell My Concubine*, director Chen Kaige, cinematographer Gu Changwei, 1993. Film frame.

Revolution.... Isn't everything?" (Fig. 13), the audience can only conclude from the preceding errors, the stutter and the hesitation that everything *isn't* all right, that there are others still in authority who share in the blame for these events, and that in the year 1993 this film was shaped primarily by the tragic and alienating recent events of 1989, as well as by the Chinese censorship that requires such roundabout locutions. Coming as a prelude, this dialogue alerts the audience to read everything that follows in ironic terms: the past is not past; the theater is the stage of real life. What follows is a nearly three-hour flashback and then a return to the opening scene in which the main figures reenact the demise of Xiang Yu's concubine through the ultimate act of loyalty, in suicide. As Yu Ji's female impersonator actually kills himself, the cinema audience is left to wonder just what he has decided, in this last act, to be loyal to. Is it the theatrical life, kept pure throughout his career by his

willingness to compromise politics but not art? Is it his lifelong homosexual love, unrequited, for the other actor? Or—in his last lines ("I am by nature a boy, not a girl!") he finally denies the homosexuality that the theater has forced on him (Fig. 14)—is it a standard of truth that neither politics nor theater have managed to live up to?

Suzhou River (2000, director Lou Ye) begins with sound and no sight, with the screen pitch black. Heard but not seen, two figures, one female and one male, exchange these words:

> (She) "If I leave you someday, would you look for me?"
> (He) "Yes."
> (She) "Would you look for me forever?"
> (He) "Yes."
> (She) "Your whole life?"
> (He) "Yes."
> (She, after a pause) "You're lying."

A cinematic bracket like those in *Farewell My Concubine* and *Good Men, Good Women*, the above conversation is repeated verbatim at the far end of the film. By which time it is recognized that the initial iteration of these words was the prefiguration of a conversation yet to come, spoken by figures the audience gradually comes to know (Fig. 15), and whose meaning finally makes sense at the film's conclusion. The course of the film—an intricate mystery about cynicism and faith, surveillance and sincerity, with double-identities and something like karmic transmission from one character to the next—proves the woman's final words correct.

But rather than proving a cynical dead-end, all of this leads her to take a romantic leap of faith into an unseen future, as black and unknowable as the pitch-blackness of the opening seconds and the final instant of the film; her faithless boyfriend refuses to take the leap ("I could run after her...but I won't"), abandoning himself instead to alcohol and voyeuristic pursuits. The film is based on Hitchcock, his voyeuristic *Rear Window* and his deeply cynical *Vertigo*, but it inverts the plot of *Vertigo* in order to undermine Hitchcock's negativity and by analogy to critique China's profound loss of idealism in this post-socialist era. The dramatic bracketing of this dialogue shifts the emphasis from the film's stylishly *noir* mystery to its unfashionably sincere message about romantic faith and the high social price of rampant cynicism and distrust.

Figure 15. *Suzhou River*, director Lou Ye, cinematographer Wang Yu, 2000. Film frame.

In literature, painting, and cinema alike, a good opening line or closing scene is no guarantee of what lies in between; conversely, a consistently fine work does not require an especially dramatic or distinctive first or final moment to establish its quality. "One corner" of a work, to use Confucius' term (quoted at the outset of this essay), may prove to be an inadequate basis for a judgment of the whole. As a historian and not a critic, I would rather deal with qualities than with quality. But speaking critically, it is simply a matter of logic that a high-quality work depends on consistency, among other things, while a lesser work can, equally well, either suffer from inconsistency or else be consistently mediocre or "bad." (Consistently bad work at least clings to the possibility of being enjoyed as kitsch.) In the cinematic examples selected above, my critical judgment was not based simply on the opening or concluding moments themselves, as isolated events, but rather on the ways in which such moments effectively introduced, intensified, and summarized the qualities of what followed or preceded them. As such, these examples not only reify Confucius' "one corner-three corners" standard as a universal principle but also, and more importantly, uphold the lofty standard he brought to his own uncompromising critical judgments.

Endnotes

Father Harrie Vanderstappen's teaching emphasized visuality and looking closely at the details. Like Father Harrie, his student and my own wonderful teacher Esther Jacobson often asked students to extrapolate a whole work from a part which she had shown. This essay uses their emphasis on the particulars; rather than adducing general principles, I hope this will encourage readers to go look at the real thing.

1. Confucius, "Confucian Analects," in *The Chinese Classics*, Vol. 1, trans. James Legge (Hong Kong: Hong Kong University Press, 1960), 197.

2. Toni Morrison, public lecture, "Invisible Ink: Reading the Writing and Writing the Reading," Princeton University, March 1, 2011.

3. Charles Dickens, *A Tale of Two Cities* (London and New York: Penguin Classics, 2000), 5.

4. Lo Kuan-chung [Luo Guanzhong], *Romance of the Three Kingdoms*, Vol. I, trans. C. H. Brewitt-Taylor (Rutland, VT and Tokyo: Charles E. Tuttle, 1959), 1.

5. William Shakespeare, "The Tragedy of Richard III," in *Shakespeare: The Complete Works*, ed. G. B. Harrison (New York: Harcourt, Brace, and World, 1968), 226.

6. William Faulkner, *Absalom, Absalom!* (New York: Modern Library, 1993), 1.

7. F. Scott Fitzgerald, *The Great Gatsby* (New York: Scribner Library, 1953), 182.

8. Faulkner, *Absalom, Absalom!*, 395.

9. *Chinatown* (1974, director Roman Polanski). The final, less memorable words are not unworthy: "Alright, come on, clear the area! On the sidewalk, get off the street! Get off the street!"

10. Joseph Conrad, *Heart of Darkness and The Secret Sharer* (London and New York: Penguin Classics, 2007), 96.

11. Herman Melville, *Moby Dick, or The Whale* (New York: Modern Library, 1952), 1; George Orwell, *Animal Farm* (New York: Signet Classics, 1962), 128.

12. Marcel Proust, *Within a Budding Grove*, trans. C. K. Scott Moncrieff and Terrence Kilmartin (New York: Vintage Books, 1982), 571. By "begin," Proust primarily means on a first reading or listening. "...the beauties that one discovers soonest," he continues, "are also those of which one tires most quickly."

13. Albert Camus, *The Stranger* (New York: Vintage, 1946), 1, 154.

14. Mo Yan, *Red Sorghum*, trans. Howard Goldblatt (New York: Penguin Books, 1993), 4.

15. *Ibid.*, 358.

16. See Jerome Silbergeld, *China Into Film: Frames of Reference in Contemporary Chinese Cinema* (London: Reaktion Books, 1999), 53-79, 76-79 for a discussion of this eclipse. I once asked Mo Yan how he felt about Zhang Yimou's alterations. His reply was something close to, "I write books. He makes films. It's up to him, and I don't mind." When I asked what he made of the eclipse, he replied that he hadn't thought about it and didn't really know.

17. *Mars Attacks* (1996, director Tim Burton); *Carrie* (1976, director Brian De Palma).

18. For a critique of this comparison, see Jerome Silbergeld, "Cinema and the Visual Arts of China," in *Companion to Chinese Cinema*, ed. Yingjin Zhang (Malden MA and Oxford: Blackwell Publishing, forthcoming).

19. Cf. Susan Bush, "Lung-mo, K'ai-ho, and Ch'i-fu: Some Implications of Wang Yüan-ch'i's Compositional Terms," *Oriental Art*, N.S. 8 (Autumn 1962): 120-127.

20. A complete view that one can scroll through is available online at http://en.wikipedia.org/wiki/Zhang_Zeduan.

21. Jonathan Chaves, "A Han Painted Tomb at Loyang," *Artibus Asiae*, 30.1 (1968): 5-27.

22. See Ssu-ma Ch'ien [Sima Qian], *Records of the Historian: Chapters from the Shih-chi* [*Shi ji*], trans. Burton Watson (New York: Columbia University Press, 1969), 79-86. For his bravery and talents, the lowly Fan Kuai was later enfeoffed by Liu Bang. Second and third from the left in this illustration, after the swordsman Xiang Zhuang, are Fan Zeng, Xiang Yu's crafty minister who hatched this plot, and Zhang Liang, Liu Bang's advisor who went to fetch Fan Kuai; just to the left of Liu Bang is Xiang Bo, who placed himself protectively between the swordsman and his would-be victim; the bear-like figure in the center is apotropaic, relevant to this only in its function as a tomb painting.

23. Both works are known only in copy. For discussion of both paintings, see Jerome Silbergeld,

Chinese Painting Style: Media, Methods, and Principles of Form (Seattle and London: University of Washington Press, 1982), figs. 12-15. The opening pair of figures in Zhou Fang's *Double-Sixes* were also previously separated but eventually reappeared and were rejoined to the others; James Cahill, "The Return of the Absent Servants: Chou Fang's 'Double Sixes' Restored," *Archives of the Chinese Art Society of America*, 15 (1961): 26-28.

24. See Lin Boting, ed., *Grand View: Special Exhibition of Northern Song Painting and Calligraphy* (Taipei: National Palace Museum, 2006), 66-71.

25. Jerome Silbergeld, "Back to the Red Cliff: Reflections on the Narrative Mode in Early Literati Landscape Painting," *Ars Orientalis* 25 (1995): 19-38.

26. For Zhao Mengfu's *Water Village*, see James Cahill, *Hills Beyond a River: Chinese Painting of the Yuan Dynasty, 1279-1368* (New York and Tokyo: Weatherhill, 1976), fig. 13; for Zhou Chen, see James Cahill, *Chinese Painting* (Lausanne: Skira, 1960), 138-139; for Shen Zhou, see Cahill, *Chinese Painting*, 128-129.

27. Frequently reproduced, including Wen C. Fong and James C. Y. Watt, *Possessing the Past: Treasures from the National Palace Museum, Taipei* (New York and Taipei: The Metropolitan Museum of Art and National Palace Museum, 1996), 126, plate 59.

28. See Wang Yuejin [Eugene Wang], "The *Old Well*: A Womb or a Tomb?" *Framework*, 35 (1988): 73-82.

29. See Wai-fong Loh, "From Romantic Love to Class Struggle: Reflections on the Film *Liu Sanjie*," in *Popular Chinese Literature and Performing Arts in the People's Republic of China*, ed. Bonnie McDougall (Berkeley: University of California Press, 1985), 165-176.

30. Mao Tun [Mao Dun], *Spring Silkworms and Other Stories*, trans. Sidney Shapiro (Beijing: Foreign Languages Press, 1979), 91-135.

31. Jerome Silbergeld, *Hitchcock with a Chinese Face: Cinematic Doubles, Oedipal Triangles, and China's Moral Voice* (Seattle and London: University of Washington Press, 2004), 48-72. For thoughts on framing and paintings within paintings, see Wu Hung, *The Double Screen: Medium and Representation in Chinese Painting* (Chicago: University of Chicago Press, 1996).

32. Silbergeld, *Hitchcock with a Chinese Face*, 74-116.

33. *Ibid.*, 106-107 and accompanying DVD track 3.5.

34. See Jerome Silbergeld, *Body in Question: Image and Illusion in Two Films by Chinese Director Jiang Wen* (Princeton: Princeton University Press, 2008).

35. See Silbergeld, *China Into Film*, 14-52.

36. *Ibid.*, 96-120. The book ends entirely differently and lacks this structural balance, although book author Lilian Lee (Li Pik-Wah) contributed to the cinematic rewrite; see Lilian Lee, *Farewell to my Concubine*, trans. Andrea Lingenfelter (New York: William Morrow and Company, 1993).

37. The film actually is double-bracketed in an "A-B-film proper-A-B sequence," positioning trust and cynicism as clear alternatives that the protagonists, the audience, and China itself must face. The conversation quoted here constitutes the faith-affirming A-frame. The B-sequence, equally important, consists of the boyfriend/film narrator boating down Shanghai's Suzhou River in search of stories: "There's a century here," he says at the outset, "of stories and rubbish, which makes it Shanghai's dirtiest river." His decision at the end, to passively "just take another drink and close my eyes and wait for the next romance to come along" rather than actively follow this girlfriend into her future ventures, poses the negative alternative. See Silbergeld, *Hitchcock with a Chinese Face*, 10-46.

38. See epigram and note 1, above.

III. VISUAL AND CULTURAL CONTEXTS

Recontextualizing an Extraordinary Sixth-Century Chinese Bodhisattva

Katherine R. Tsiang

An essential part of an art historian's practice and understanding comes through the viewing and the juxtaposition of visual evidence—analyzing, comparing and contrasting, sequencing, and historical contextualization. In this study we approach the visual evidence relating to a Chinese Buddhist stone sculpture, examining the work in various viewing contexts or frames of reference. Many art objects and historical artifacts, such as the bodhisattva discussed here, are in museum collections, removed from their original cultural settings. In such cases, comparative analysis enables us to detect artistic and conceptual links with other work and to place them in their proper historical and cultural frameworks. This offers possibilities to recapture aspects of the significance that the work might have had for those who viewed it in its time and place.

The focus of this study is a well-known and much published, larger-than-life-sized limestone figure of a bodhisattva believed to be from the Northern Qi dynasty (550-577) and attributed to the Xiangtangshan cave temples in northern China. This Buddhist sculpture was removed a century ago from its former location in a Buddhist cave temple and taken to Europe for the purpose of sale in the art market. It was purchased in 1916 by the University of Pennsylvania Museum of Archeology and Anthropology. Because of the lack of documentation of the sculpture in its original location, its attribution to Xiangtangshan is not without question and calls for additional supportive evidence.

For this study we examine the featured object in a series of viewing frames: 1) in its current placement in a museum gallery, 2) as one of a group of sculptures

which was taken out of China in the early twentieth century, 3) within the context of groups of images arranged on altars in Chinese Buddhist rock-cut cave temples, and 4) as a component in visual representations of religious concepts, visions, and events described in Buddhist scriptures. These multiple perspectives provide insights into the meaning and function of this sculptural figure within its original historical and religious contexts.[1]

Figure of a Bodhisattva in the University of Pennsylvania Museum of Archeology and Anthropology, Philadelphia.

The limestone sculpture of a bodhisattva is a free-standing figure (Fig. 1a), more than six feet tall, upright in pose, lavishly attired, and regal in appearance. The figure wears a long skirt tied at the waist and falling in pleated folds down to the ankles. His bare feet rest on a small circular base carved in one piece with the figure. The base is convex on the bottom and has been inserted into an indentation in the wooden pedestal constructed for it. The convex base would have been similarly placed into a stone pedestal in its former location.

The upper body has strongly proportioned thick shoulders and arms. The torso is bare, but long scarves cover the shoulders, a large collar-like necklace encircles the upper part of the torso, and heavy strands of jewelry with clusters of gems, oval cabochons, and large round beads strung together drape down the front of the body. The scarves and elaborate jewelry fall in layers over the skirt. These are carefully carved in great detail and high relief, giving the figure a rather bulky and imposing appearance. Taken all together, these features of the bodhisattva give it a powerful physical presence that also suggests spiritual strength. The carving, however, does not show specific anatomical details of bone, muscle, and sinew, as seen in exaggerated form on contemporary sculptures of guardians of Buddhism or in the Greco-Roman athletic ideal. Seen frontally, the freestanding image appears to be sculpted in the round, but in fact it is quite flat and only very roughly finished on the back and therefore was most likely placed against a wall where it would not be seen from behind.

The bodhisattva, "enlightenment being" or one destined for enlightenment, is one of the principle types of divine images represented in Buddhist art. Shown as a princely figure, it derives from conventions in India for representing the young Prince Gautama Siddhartha, or Śākyamuni, before he left his palace in search of enlightenment. After he attained enlightenment or Buddhahood, his teachings became the foundation of the Buddhist religion that spread across Asia.[2]

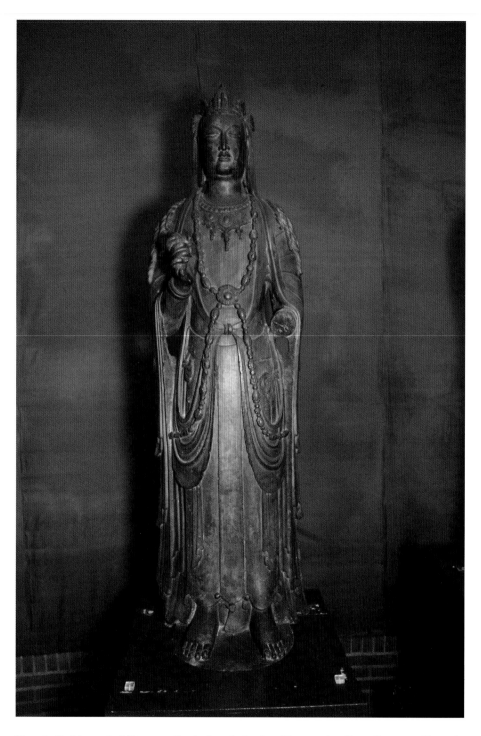

Figure 1a. Bodhisattva Avalokitesvara said to be from the Southern Xiangtangshan Caves. University of Pennsylvania Museum of Archeology and Anthropology, C113. Purchased from C.T. Loo, 1916. Height: 187 cm.

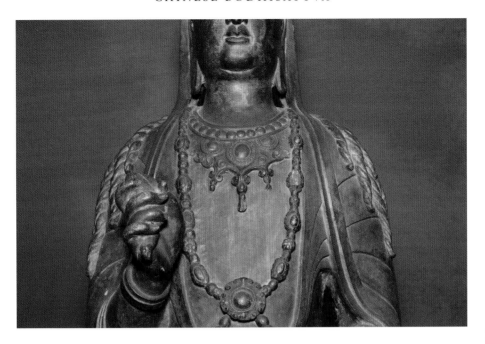

Figure 1b. Detail, torso of bodhisattva, same as above.

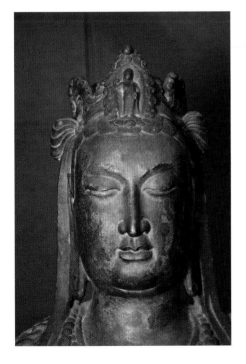

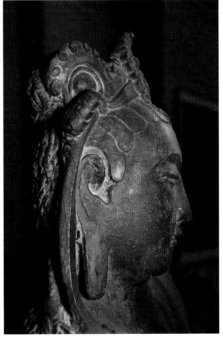

Figure 1c. Detail, head of bodhisattava, same as above, front.

Figure 1d. Detail, head of bodhisattva, same as above, right side.

The figure's raised right hand holds a small lotus flower bud, an emblem of purity and potential enlightenment and a common attribute of bodhisattvas (Fig. 1b). The hand is large and fleshy, with its supple fingers subtly modeled, showing the rounded finger tips curling slightly backward. The head has strongly modeled features and finely finished details—an oval face with full cheeks and jaw, a rounded chin, long straight nose, and a high curving forehead that slopes back toward the crown of the head (Figs. 1c and 1d). The head is upright, but the large eyes gaze downward, appearing to be nearly closed. The carving shows an interesting combination of volumetric and flattened linear or more schematic approaches. The smoothly modeled contours of the forehead and cheeks are offset by sharply defined linear ridges at the eyebrows, edges of the eyelids, and lips. The short hair along the forehead is rendered as flattened overlapping sections in a repeating pattern which contrasts strikingly with the three-dimensional treatment of the longer hair falling in spirals over the shoulders and upper arms.

The hair is tied up in part and held on the top of the head by a three-sectioned tiara-like crown with a single large teardrop medallion at the front that is edged with curling ornamental elements. Circular jeweled medallions at either side have similar curling borders. At the front of the central medallion of the crown a tiny standing figure appears, dressed in a robe wrapped around the body and exposing the right shoulder. Scarcely visible from floor level in the museum, the figure can be seen clearly in the photographic detail of the bodhisattva's head to be a Buddha standing on a lotus flower. The small Buddha in the crown is an identifying feature of the bodhisattva Avalokiteśvara, commonly regarded as the bodhisattva of mercy (Ch. Guanyin).[3]

Locations and Groupings

Museum Setting—The bodhisattva has long been displayed in the Harrison Rotunda, a large, domed circular gallery with brick walls, where it is installed on its own pedestal. The, University of Pennsylvania Museum of Archaeology and Anthropology (UPM), Philadelphia, purchased it in 1916 in preparation for the museum's opening. The sculpture shares the gallery space with other Chinese statuary removed from their former religious or funerary contexts and displayed primarily as works of fine art and excellent craftsmanship. The bodhisattva has long stood against a bright turquoise cloth together with two other figures purchased by the UPM in the same year. The three are part of a group of six Buddhist sculptures brought out of China nearly a century ago by C. T. Loo and published

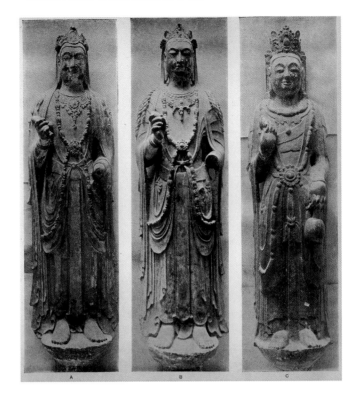

Figure 2a. Chinese Bud-
dhist sculptures in the
possession of Charles
Vignier in 1914. After *The
Burlington Magazine*, 25
(1914), pl. 1. Photograph
courtesy of *The Burlington
Magazine*.

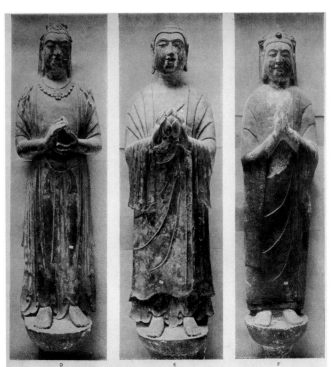

Figure 2b. Same, *Bur-
lington Magazine*, 25
(1914) pl. 2. Photograph
courtesy of *The Burlington
Magazine*.

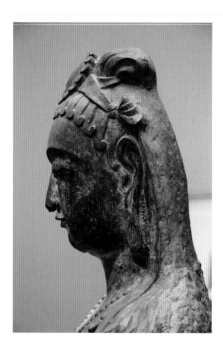

Figure 3. Head of bodhisattva said to be from the Southern Xiangtangshan Caves Freer.Gallery of Art, Smithsonian Institution, Washington, DC: Gift of Eugene and Agnes E. Meyer, F1968.45. Height of figure: 173.3 cm.

in 1914 in *Burlington Magazine* (Figs. 2a and 2b). The brief accompanying article reported, incorrectly, that they were "brought from Lung-men," (i.e., Longmen in the currently used Pinyin spelling), referring to the large Buddhist cave temple complex near Luoyang, Henan province.[4]

Among the sculptures in this group of six, four are closely related in their impressive size and excellent quality of workmanship. These include, in addition to the Avalokiteśvara, a second bodhisattva in the UPM that is considered its pair and identified as Mahāsthāmaprāpta "Achievement of Great Power" (Ch. Dashizhi) (Fig 2a, A). The Mahāsthāmaprāpta is also very imposing in size and appearance and taller than the Avalokiteśvara (78 inches). These two bodhisattvas are the principal attendants of the Buddha Amitābha, and they are frequently depicted accompanying the Buddha in sculptural groupings in China and Japan.

The third figure in the University Museum is not a bodhisattva but wears a monastic robe and holds a large lotus bud between the palms of his hands (Fig. 2b, E). Although he stands between the bodhisattvas in the museum display, originally he would not have been the central figure of an altar group. The fourth closely related image, a more plainly attired bodhisattva also holding a large lotus bud in two hands, is now in the Freer Gallery of Art and Arthur M. Sackler Gallery, Washington, D.C. (Fig. 2b, D) The detail of the head shows a very similar profile and treatment of the hair in flattened sections, but curled at the ends, along the forehead (Fig. 3).[5]

Figure 4. View of Southern Xiangtangshan Caves, Fengfeng Mining District, Hebei Province, showing Caves 1 and 2 on the lower level. Photograph by the author, 2005.

Cave Temple Site—The dealer's correspondence with the museum at the time of purchase gives the cave-site the attribution "Nan Siang Tang Temple," or Nan Xiangtang Temple.[6] This refers to the Southern Xiangtangshan cave site, located in the present-day mining town of Fengfeng in southern Hebei province, northern China. According to an inscription at the site, work on a group of caves began there in 565 CE of the Northern Qi dynasty after the court official Gao Anagong visited the location in the company of the newly crowned boy emperor Houzhu (r. 565-576). Seeing initial plans for the caves, he decided to sponsor the construction.[7] This cave site is one of two main groups of Buddhist cave temples of the Northern Qi period in southern Hebei province near Ye, the capital (Fig. 4).[8] There are seven caves believed to be from the second half of the sixth century at the Southern Xiangtangshan site, two on the lower level and five smaller ones on the upper level. Most of the principal sculptural images that originally occupied the altars of these caves are missing; those that remain are nearly all damaged. Many were freestanding figures that were carved separately from the caves and could be easily removed and leave no trace.[9] Thus the original arrangement of figures in the caves is uncertain, and even the attribution of the Avalokiteśvara and related above-mentioned figures

Figure 5. Head of demon from the North Cave, Northern Xiangtangshan, Arthur M. Sackler Museum, Harvard University: Gift of Samuel Cabot and Mrs. George R. Agassiz, 1926. H: 63.5 cm.

to the site is considered unreliable by some scholars. However, other evidence supports the association of these figures with the Southern Xiangtangshan site and even to a specific cave. In addition to the few images left in the caves there are numerous other sculptures outside of China and also many fragments that remain at the site with which they can be compared.

The caves of Northern Xiangtangshan are larger in scale and recorded to have been initiated with imperial sponsorship from the early years of the Northern Qi dynasty.[10] In spite of the differences in scale and patronage, the sculptures from the two sites share similar features. Like the Avalokiteśvara, the sculptures from the northern site combine naturalistic-looking modeling of rounded forms with flattened, abstracted or ornamental elements. This distinctive treatment is seen, for example, in the carving of the head of a winged leonine demon known to be from the North Cave at Northern Xiangtangshan (Fig. 5).[11] The flat relief sections of the mane and other details resemble the hair on the forehead of the Avalokiteśvara and the Freer-Sackler Gallery bodhisattva. The North Cave is the earliest and grandest in scale of the Xiangtangshan caves and was a model for other caves.

There are two caves at Southern Xiangtangshan that might have accommodated statues of the size of the Avalokiteśvara and Mahāsthāmaprāpta. These are the two

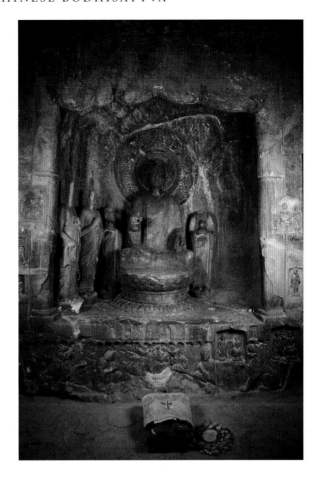

Figure 6. Cave 1, Southern Xiang-
tangshan, main altar in the central
pillar, 2007.

largest ones at the site, Caves 1 and 2, both on the lower level and with main altars
cut into square central pillars. Unfortunately there are no photographs or other
visual documentation of their appearance before the removal of the sculptures.[12]
The main altar of Cave 1 now has three stone figures that are likely to have been
part of the original group, including two headless figures dressed in monks' robes
standing beside the central seated Buddha (Fig. 6). There are indentations on the
altar that may have held the pedestals of the other sculptures. Photographs taken in
1936 show the caves repaired with modeled clay replacement figures and heads so
that they could once more function as places of worship.[13] At that time the main
altars of Caves 1 and 2 each had six standing attendants, which likely reflects the
original number of figures. Two of the clay sculptures still remain in Cave 1 on the
left side of the altar—they are now headless and have lost their painted decoration,
but the wood posts that formerly supported the heads still remain. At less than five
feet in height, they are considerably smaller than the UPM figures.

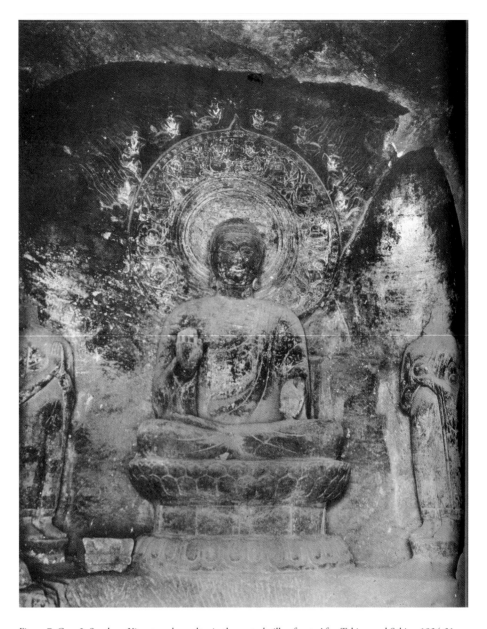

Figure 7. Cave 2, Southern Xiangtangshan, altar in the central pillar, front. After Tokiwa and Sekino,1924-31, vol. 3, pl. 99.

The earliest known photograph of Cave 2, taken in 1922, shows a central Buddha on a similar large altar with two headless standing figures dressed in monk's robes in the corners of the niche (Fig. 7). All three of these remaining figures were carved in one piece with the stone matrix of the central pillar, unlike the others that were freestanding. A rare photograph shows subsequent repairs to the altar and the remaining figures, and four freestanding clay replacement images (Fig. 8). Since

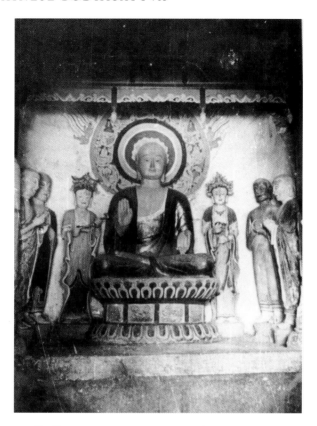

Figure 8. Cave 2, Altar in the
central pillar with images restored,
Photograph ca. 1930-1940, cour-
tesy of Zhao Qinglan.

then, Cave 2 has suffered catastrophic damage so that only part of the central pillar remains. The main altar is gone but for the upper part of the back wall of the niche where the Buddha's halo and the flying divinities hovering over it were carved in relief (Fig. 9).[14]

Fragments from the central pillar of Cave 2 were identified in recent years among the broken sculptures at the cave site, including parts of the principal Buddha's legs, throne, and a hand. Comparison of measurements of the Buddha's haloes in Cave 1 (128 cm wide) and Cave 2 (155 cm wide) and the relative sizes of the figures that stood on the altars indicates that the main niche and the figures standing on the altar of Cave 2 were substantially larger in size than those of Cave 1. Considering the size and quality of carving remaining in Caves 1 and 2, it seems that the bodhisattvas in the University of Pennsylvania museum could originally have stood on the altar of Cave 2, rather than Cave 1.[15]

To support this conjecture, we can refer to other sculptures of Caves 1 and 2. A carved relief frieze on the front wall of Cave 1, above the entrance, depicts a vision of a Buddhist paradise with a central Buddha seated under a canopy surrounded by a large group of figures (Fig. 10). At the far sides, there are palatial buildings with

Left: Figure 9. Cave 2, showing damaged central pillar, 2007.

Below: Figure 10. Cave 1, Southern Xiangtangshan, relief paradise scene, front wall above entrance.

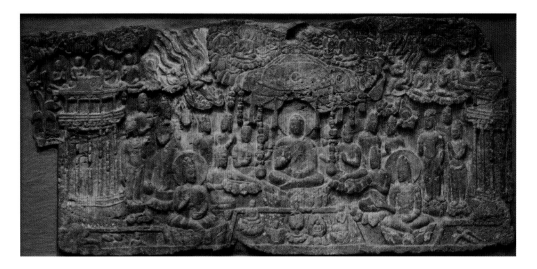

Figure 11a. Western Paradise scene, relief frieze, limestone, from Cave 2, Southern Xiangtangshan. Freer Gallery of Art, Smithsonian Institution, Washington DC: Purchase, F1921.2. H:159 cm., W: 334 cm.

assemblies of seated and standing figures inside them, shown separately from the Buddha's assembly. At the bottom of the carved frieze there is a large pond, in the middle of which an incense burner rests on a large lotus flower. At both sides, water birds and people wade and swim, and smaller lotus flowers grow from the pond. On closer inspection, these flowers can be seen to support small human figures, Buddhist practitioners in their past lives, newly reborn in paradise. This kind of imagery is most frequently associated with the Western Paradise of the Buddha Amitābha.

The corresponding carved relief frieze in Cave 2 is now missing and the wall is repaired with stone blocks (See Fig. 4, left). Removed in the early part of the last century, the frieze is today in the Freer-Sackler Gallery, (Fig. 11). Its size and contours show conclusively that Cave 2 is the source.[16] Though similar to the paradise frieze in Cave 1, the Freer-Sackler frieze has finer workmanship, with the figures larger and more carefully defined and differentiated. In fact the frieze from Cave 2 appears to be the model on which the Cave 1 frieze was based. The bodhisattvas in the Cave 2 relief frieze resemble the large freestanding figures in the UPM and Freer in the volumetric modeling and proportions of the torsos, arms, oval heads, and long skirts. Details of scarves, crowns, and jewelry are also similar. The carved scenes remaining in the upper corners of the cave front wall have similar figures seated in architectural structures. The long oval head and sturdy body were also standard features in the depiction of many figures in painting and ceramic funerary sculptures found in tombs of the middle and late sixth century, such as

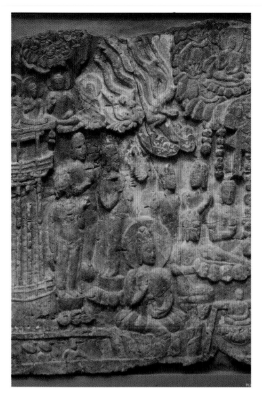

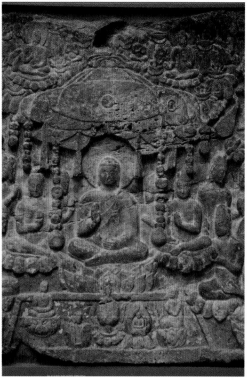

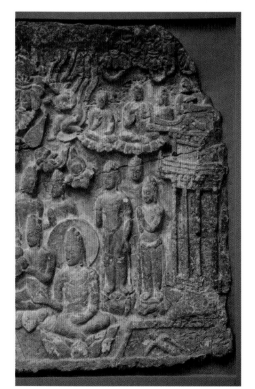

Above, Left: Figure 11b. Detail. Western Paradise scene, left section.

Above, Right: Figure 11c. Detail. Western Paradise scene, middle section.

Left: Figure 11d. Detail. Western Paradise scene, right section.

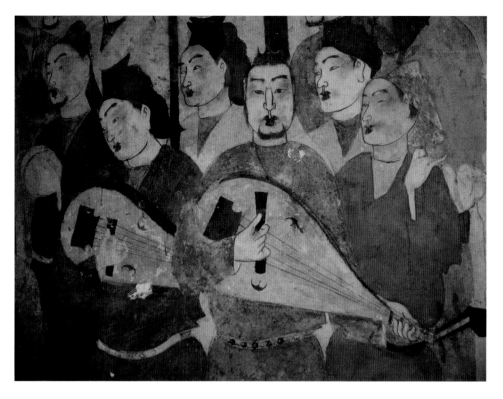

Figure 12. Musicians, detail of mural paintings, north wall, in the tomb of Xu Xianxiu, died 571. Near Taiyuan, Shanxi province.

the painted murals in the Northern Qi tomb of Xu Xianxiu who died in 571 (Figs. 12 and 13).[17]

Historical Frames—Cultural and Religious Contexts

While the jewelry and scarves worn over the bare torso, the long earlobes, and bare feet of the Avalokiteśvara sculpture can be traced to Indian prototypes and a set of iconographic conventions for representing Buddhist images ultimately derived from Indian Buddhist art, the image is at the same time the product of the sixth century in northern China. The long voluminous skirt is a Chinese adaptation of the Indian *dhoti* that is closely wrapped around the legs. The facial features of the bodhisattvas shown above appear to be non-Chinese, which might have referred to the Indian origins of Buddhism or possibly also to the non-Chinese ethnic identity of the rulers and courtiers of the Northern Qi dynasty.

We can speculate on how these figures were envisioned in their time only through knowing something of the history of this period. After the fall of the Han dynasty (206 BCE to 220 CE) the Chinese empire was divided, and the northern half

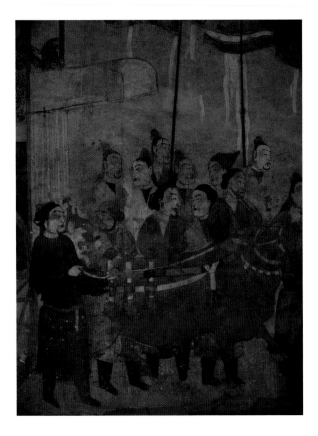

Figure 13. Figures accompanying the funerary carriage, detail of mural painting, east wall, in the tomb of Xu Xianxiu.

largely controlled by people of non-Han Chinese ethnicity. Among these people the Xianbei formed a powerful tribal alliance that established the Northern Wei dynasty (386-534) and unified northern China through their military superiority. The collapse of the Northern Wei and its division into Eastern and Western Wei resulted in the formation of the rival states of Northern Qi and Northern Zhou (557-581) from the two halves. Many of the Northern Wei and Northern Qi rulers promoted Buddhism as their official religion, supporting the construction of monasteries, the translation of scriptures, the production of Buddhist images for worship, and the hollowing out of large-scale cave-temples from stone cliffsides.[18] They came to adopt a political policy of integration with many aspects Chinese culture—including official use of the language at court, intermarriage with prominent Chinese families, and employment of Chinese as well as non-Chinese officials—in spite of ethnic rivalries and tension.[19] Foreign merchants and Buddhist monks from the so-called "Western Regions" of Central Asia and India were an important presence in the multicultural society of this period, as recorded in history and seen in depictions of facial features and clothing styles and from objects found in tombs. Foreign products, including glass, metalware, jewelry, and

textiles brought by transcontinental trading caravans, and foreign forms of music and dance, were popular among Chinese and non-Chinese alike. Foreign Buddhist monks worked together with Chinese monks to translate Buddhist scriptures from Sanskrit and other languages into Chinese and served as teachers to the laity, and advisors to rulers.

In the Buddhist context, an important concept of this time was the identification of the bodhisattva as an ideal for the lay practitioner, as one who has embarked on the path to enlightenment for the benefit of all beings. Buddhism began as a monastic movement based on renouncing secular life, but it developed into religious Buddhism based on faith and moral and spiritual cultivation and dependent on the support of lay practitioners who progressed by stages toward enlightenment without leaving their places in society. The enlightened lay person is celebrated in scriptures like the "The Holy Teaching of Vimalakīrti" (Sanskrit, *Vimalakīrtinirdesa sūtra,* Ch. *Weimojie jing*) and "The Lion's Roar of Queen Śrīmālā" (Sanskrit, *Śrīmālādevisimhanada sūtra,* Ch. *Shengman shizihou jing*) that were studied in the sixth century by Buddhist followers. These scriptures and others also expounded the belief in the presence of the Buddha Nature, a seed-like or germ-like quality of potential Buddhahood in all beings and the universal possibility of enlightenment. Buddhist patrons of the Northern Qi period had these and other scriptures engraved in stone at Xiangtangshan and other sites.[20]

At the same time, bodhisattvas were worshipped as divinities who occupy and preside over heavenly realms. Bodhisattvas accompany the central Buddha in image groups made for worship in caves and temple halls. They are also featured as principal images and can have a central position in other sculptural groups. The central Buddha in the Freer-Sackler relief panel sits under a canopy with numerous bodhisattvas gathered around him and palatial buildings standing at both sides (Fig. 11a and 11c). Two of the bodhisattvas are larger than the rest and sit at the front of the group. One has a small Buddha on the crown (Fig. 11d) and the other a precious bottle (Fig. 11b), and are thus identified as Avalokiteśvara and Mahāsthāmaprāpta, respectively, the principal bodhisattvas accompanying the Buddha Amitābha, who presides over the Western Paradise. In the foreground of the relief panel there are three rectangular ponds, the side ones occupied by birds and people swimming and bathing, and the middle one with figures seated on or inside lotus blossoms. In the central pond, two of the four lotus-born figures are seated on fully opened flowers (Fig. 11c). A third figure has its head just emerging from the top of the blossoming flower, and the fourth figure is still enclosed in the womb-like bud and is seen through the petals.

The relief scenes on the front walls of Caves 1 and 2 are among the earliest known representations of the Western Paradise in Chinese art in which the faithful are depicted being reborn from lotus blossoms. They correspond with paradise scenes commonly painted in murals at the Dunhuang caves beginning in the seventh century.[21] The elements depicted in the Freer relief frieze, such as musical instruments, flowering jeweled trees, and bathing ponds, have been carefully identified by scholars and can be associated with Buddhist textual descriptions of the Western Paradise of Amitābha, the "Buddha of Measureless Light." The texts and images served the faithful as aids to visualization.

The scriptures describe the pure land of the Western Paradise as a place where inhabitants enjoy a peaceful environment without want, filled with gentle and fragrant breezes, beautiful music, pristine bathing ponds with jeweled lotuses, and luxuriant trees laden with radiant gems:

> . . . There are trees of gold, trees of silver, trees of lapis-lazuli, trees of rock crystal, trees of coral, trees of agate, and trees of mother-of-pearl. Some trees are made of two precious substances; some are made of three, and so on, up to trees made of the seven precious substances. . .
>
> Inside and outside, on the left and on the right, are bathing ponds—some measuring ten leagues, some twenty, thirty, and so on, up to a hundred thousand leagues. In width, length, and depth each measures the same and is filled to the brim with water possessing the eight good qualities. Pure, clean, and fragrant is the water and most sweet to taste, like ambrosia. . .[22]

The Sanskrit *Longer Sukhāvatīvyūha sūtra* specifies that the faithful are born in Sukhāvatī, the Land of Bliss, seated in the middle of huge lotuses which grow in the ponds. It describes two kinds of rebirth. One is for people who have been fully meritorious in their commitment and practice and whose faith has been free of doubt. Their rebirth is a miraculous and instantaneous appearance in the world of Sukhāvatī, in which they are sitting cross-legged on open lotus flowers and exposed to all the world's wonders and to the presence of the Buddha and his company. For others, the lotus blossoms remains shut, though their occupants enjoy themselves just like the gods of the Heaven of the Thirty-Three (Triastrimsa Heaven of the god Indra and his court) in their palaces. This explains the depiction of the architectural structures at the sides of the assembly. Rebirth in

the Western Paradise is a superior state of being in a perfect world where housing is not a necessity.

The existing Chinese version of *Longer Sukhāvatīvyūha sūtra* (*Wuliangshou jing*) states the conditions of rebirth differently. While in the Sanskrit text there are those who are reborn in the Western Paradise in lotus blossoms that remain closed, sealing them off from the Buddha's presence, in the Chinese version they are said to be "born in a womb" and to inhabit palaces. Only those whose belief is pure and untainted by doubt are reborn in lotus blossoms that open in the midst of the ideal realm and the Buddha's assembly.

> Those [inhabitants of this land] who are reborn in a womb inhabit flying palaces of a hundred leagues or five hundred leagues; and in those palaces each and every one experiences all manner of delightful pleasures; and, again, all of these they experience spontaneously, exactly as in the Heaven of the Thirty-Three. . . .
>
> Some living beings cultivate all virtues with the intention of being reborn in this land, but harbor doubts in their mind—doubts with regard to the inexhaustible knowledge of a Buddha, the inconceivable knowledge of a Buddha These living beings will be reborn in one of these palaces, and will spend in it five hundred years of their life span without seeing the Buddha, without hearing the teaching of the sūtras, without seeing the holy assemblies of bodhisattvas and disciples.
>
> But if, on the other hand, living beings have a pure faith in the knowledge of the Buddha, . . . and practice all forms of meritorious actions, and with a trusting mind, dedicate this merit to rebirth in the Pure Land, all beings will be reborn spontaneously, by miraculous transformation, in a flower made of the seven precious substances and will appear in it with their legs crossed. Immediately, and in one instant, they will obtain the same corporal marks, the same shining light, the same knowledge and merit with which all bodhisattvas are endowed and made perfect.[23]

Another sūtra on the theme of the Buddha Amitābha's paradise that was widely circulated in China, the "Meditation Sūtra" or *Guan Wuliangshou jing*, makes no mention of the "womb-born" but defines nine grades of rebirth in paradise in terms of a timetable of the opening of the lotus blossoms. The most meritorious people

will be born sitting cross-legged on fully blossoming lotuses, while those with less accumulated merit will be reborn in lotuses that remain closed for varying periods of time—ranging from a day, or a day and a night, up to as long as twelve long *kalpas* or eons—before they open and the people inside are allowed to look upon the Buddha Amitābha and his Land of Bliss.[24] Verses wishing for rebirth in the Pure Land are also engraved in stone on the façade of the South Cave at the Northern Xiangtangshan cave site.[25] It appears that by the late sixth century, the Western Paradise had been established in popular belief and imagery of Chinese Buddhism.

Conclusion

In the early twentieth century, when the Avalokiteśvara in the University of Pennsylvania collection was acquired, the West was only beginning to become aware of Chinese Buddhist sculpture as an art form. The publication in 1909 of Edouard Chavannnes' landmark photographic record of his extensive travels in China to study archeological and cultural monuments marks the awakening of interest in Chinese sculpture in the international art market for Asian art. Popular interest in Buddhism and Asian religious philosophy had emerged around this time as well.[26] Because of the social and political disorder in China, many important cultural artifacts were easily taken out of the country without documentation. For many objects in museums lacking full and reliable documentation of provenance, art historical research provides additional information. Based on visual investigation and analysis that offer perspectives pointing to directions for further research, we can better understand the historical, cultural, and religious contexts of the production of this bodhisattva figure in the distant past, its worship through the centuries, and its acquisition and reception in the West.

Endnotes

1. This investigation is part of a larger research project on Northern Qi Buddhist art and visual culture of the sixth century and the Xiangtangshan cave temples that has resulted in an extensive database of the caves and their sculptures and an exhibition with published catalogue. The close viewing of this sculpture and others in this study draws on detailed images of excellent quality, which the Center of the Art of East Asia in the Department of Art History, University of Chicago has compiled for the project. The photographs, unless otherwise noted, are by Dan Downing. For more information about the project and images of the caves and sculptures, see Katherine R. Tsiang et al., *Echoes of the Past: The*

Buddhist Cave Temples of Xiangtangshan (Chicago: The Smart Museum of Art, University of Chicago, 2010); and the website for the Xiangtangshan Caves Project, http://xiangtangshan.uchicago.edu/.

2. For further reading on the life of the Buddha and the beginnings of Buddhism, see John Strong, *The Buddha: A Short Biography* (Oxford: Oneworld, 2001); Donald S. Lopez, Jr., *The Story of Buddhism: A Concise Guide to its History and Teachings* (San Francisco: Harper Collins, 2001), 36-51; and Lopez, *Voice of the Buddha, The Beauty of Compassion: The Lalitavistara Sūtra* (Berkeley: Dharma Publishing, 1983).

3. See also Tsiang, *Echoes of the Past*, catalogue no. 20. There is extensive literature on Avalokiteśvara, probably the most popular deity in the East Asian Buddhist pantheon, who appears in many manifestations in order to save those in need of assistance. He appears early as a merciful savior and principal divinity in one chapter of the popular *Lotus Sūtra*. Chün-fang Yü, *Kuan-yin: the Chinese Transformation of Avalokiteśvara* (New York: Columbia University Press, 2001). See also Leon Hurvitz, trans. *Scripture of the Lotus Blossom of the Fine Dharma* (New York: Columbia University Library, 1976).

The bodhisattva holding a large lotus flower, Padmapani, is considered a form of Avalokiteśvara in Indian depictions of the deity. See for example the fine standing Avalokiteśvara of the Gupta period (second half of the fifth century), holding the stem of a lotus (now lost) in the left hand and showing a small seated Buddha on his head, from Sarnath, in the National Museum of India. Susan L. Huntington, *The Art of Ancient India* (New York: Weatherhill, 1985), 204, fig. 10.22.

4. At the time, little was known about Buddhist cave temples of China. *Burlington Magazine*, 25 (1914), pl. 1 and 2. Edouard Chavannes' pioneering survey of historical and archeological material in northern China had recently introduced the Longmen caves and other Buddhist sites with published photographs to people outside of China. Edouard Chavannes, *Mission archéologique dans la Chine septentrionale*, 2 vols. (Paris: E. Leroux, 1909). Mizuno Seiichi, *Kanan Rakuyō Ryūmon Sekkutsu no kenkyu* [Study of the Cave Temples at Lung-men, Ho-nan] (Tokyo: Zayuhō Kankōkai, 1941). Longmen wenwu baoguansuo. *Zhongguo shiku: Longmen shiku* [Chinese Cave Temples: The Longmen Caves] (Beijing: Wenwu chubanshe, 1980). A recent study by Amy McNair presents a history of the caves through its donor inscriptions. Amy McNair, *Donors of Longmen: Faith, Politics, and Patronage in Medieval Chinese Buddhist Sculpture* (Honolulu: University of Hawai'i Press, 2007).

5. See Tsiang, *Echoes of the Past*, catalogue nos. 21-23.

6. The spelling of the name varies. It appears in the *The Museum Journal* as "Nan-hsien Tung" temple. C.W. Bishop, "Notes on Chinese Statuary," *The Museum Journal University of Pennsylvania*, 7/3 (1916), 171-174. Years later C.T. Loo confirmed in his introduction to the catalog of his 1940 exhibition of Chinese sculptures that he had been a partner in the sale of these objects and that they were from "Nan Hsiang tang." Ch'ing-tsai Loo, *An Exhibition of Chinese Stone Sculptures* (New York: C.T. Loo and Co., 1940). See also Angela Howard, "Reconstructing the Original Location of a Group of Sculptures in the University of Pennsylvania Museum," *Orientations* 32/2 (2001): 33, fig. 1.

7. The inscription, which refers to the caves as the Fushan Cave Temple, appears to date to the succeeding Sui Dynasty (589-618) when repairs were made at the site. The damage had been caused by measures to suppress Buddhism initiated under the Northern Zhou (557-589) and extended eastward into Northern Qi territory with the Northern Zhou conquest of Northern Qi in 577. Handanshi Fengfeng kuangqu wenguansuo and Beijing daxue kaogu shixidui, "Nan Xiangtang shiku xin faxian kuyan yiji ji kanxiang [The newly discovered eaves of the caves and images in niches at the Southern Xiangtang caves]," *Wenwu* 5 (1992): 1-15.

8. The name Xiangtangshan (Mountain of Echoing Halls) derives from the name of the old Xiangtang

monastery located at the southern group of caves in the Song dynasty (960-1279). This name was subsequently applied to two main groups of caves: Northern Xiangtangshan, which has three large-scale Northern Qi caves, and the southern group. For more information on the caves and their art, history, and religious affiliations, see Tsiang, *Echoes of the Past.*.

9. The sculptures were likely to have been carved in a workshop and then transported to and set into the caves. At the symposium "Art and Material Culture of the Northern Qi Period," held June 5-7, 2011 at the Freer-Sackler Gallery, Smithsonian Institution, Janet Douglas presented results of technical analysis of the limestone of the Xiangtangshan caves and of selected sculptures in the Freer-Sackler and UPM collections. While some of the sculptures matched that of the cave sites, the free standing figures discussed here appear to be carved from limestone from a different source.

10. The international scholarly study of the caves began in the 1920s after sculptures from the caves entered the art market and made their way into museums and private collections. The earliest published reports with photographs are those by Japanese scholars. Tokiwa Daijo and Sekino Tadashi, *Shina Bukkyō shiseki*, Vol. 3 (Tōkyō: Bukkyō shiseki kenkyūkai, 1924-31); Mizuno Seiichi and Nagahiro Toshio, *Kyōdōzan sekkutsu: Kahoku Kanan shōkyō ni okeru Hokusei jidai no sekkutsu jiin* [Buddhist cave-temples of Hsiang-T'ang-Ssu on the frontier of Honan and Hopei] (Kyōto: Tōhō bunka gakuin Kyōto kenkyūjo, 1937).

11. Similar heads remain in the North Cave. See also Katherine R. Tsiang, "Bodhisattvas, Jewels & Demons: Reconstructing Meaning in the North Cave at Xiangtangshan," *Apollo* (May 2008): 36-41.

12. The modern-day destruction of the caves began around 1910 with recognition in the West of Chinese sculpture as collectible art, and it continued for decades, spurred on by the appearance of sculptures from the caves on the art market. This period of modern history was one of constant turmoil in which China saw the fall of the Qing Empire and the establishment of tentative central authority under the Republican government, the Japanese invasion and the second World War, and then the communist revolution.

13. The view of the cave through the entrance in Mizuno ..nd Nagahiro's monograph on the caves shows the replacement bodhisattvas. Mizuno and Nagahiro, *Kyōdōzan sekkutsu: Kahoku Kanan shōkyō ni okeru Hokusei jidai no sekkutsu jiin*, pl. IIIb.

14. Fig. 8 is an unpublished photograph as far as I know. During the war with Japan and the revolution in the 1940s, the Southern Xiangtang caves were used as storage for an armaments factory and then in the 1950s for a People's Daily news publication. In the early years of the People's Republic, because of the communist disapproval of superstitious beliefs, the local people removed the broken remains of sculptures from the caves. Most of the caves have been virtually cleared of their sculptures, but the larger fragments that were left at the site are now preserved in storage. Today, with the loosening of restrictions on religious practice, the caves are once more visited by local people who come to pray and to leave offerings and burn incense.

15. This was also proposed by Zhang Lintang and Sun Di, *Xiangtangshan shi ku—Liushi haiwai shike zaoxiang yanjiu* [The Xiangtangshan Caves—A study of the stone sculptures dispersed abroad] (Beijing: Foreign Languages Press, 2004). The monk and disciples remaining on the altar of Cave 1 are approximately 115 cm high at the shoulder and would have been about 145 cm high with their heads. The other figures on the altar would presumably have been of approximately the same height or slightly taller with added crowns. These are considerably smaller than the University of Pennsylvania figures.

16. Freer Gallery, accession no. 1921.2, purchased from Lai-yuan and Co. (which was owned by C.T. Loo.) These have been examined in detail by Yen Chuan-ying, who has identified the scenes and their

compositional elements. Yan Juanying, "Bei Qi changuan ku de tuxiang kao: Cong Xiaonanhai shiku dao Xiangtangshan shiku [Imagery in Northern Qi meditation caves: From the Xiaonanhai caves to Xiangtangshan]," *Tōhō gakuho*, 70 (1998): 412-422. See also Angela Howard, "Highlights of Chinese Buddhist Sculpture in the Freer Collection," *Orientations*, 24/5 (1993): 97, fig. 6.

17. The figures painted in murals in the Northern Qi tombs of Lou Rui (570) and Xu Xianxiu (571) found in and near Taiyuan Shanxi are similar in type, as are the large modeled clay figures of officials in the imperial tomb at Wangzhang. See Shanxi Provincial Institute of Archaeology and Taiyaun Municipal Institute of Cultural Relics and Archaeology, *Bei Qi Dongan Wang Lou Rui mu* [The Northern Qi tomb of Lou Rui Prince of Dongan] (Beijing: Cultural Relics Publishing House, 2006); Institute of Archaeology of Shanxi and Institute of Archaeology of Taiyuan, "Taiyuan Bei Qi Xu Xianxiu mu fajue jianbao [Excavation of the Northern Qi Tomb of Xu Xianxiu in Taiyuan]," *Wenwu* No. 10 (2003): 4-41; and Institute of Archaeology CASS and the Hebei Provincial Institute of Archaeology, *Cixian Wangzhang Beichao bihua* mu [Mural tomb of the Northern Dynasties Period in Wanzhang, Cixian] (Beijing: Science Press, 2003).

18. Constructed temples have not survived from this early period, but many stone and bronze images and important cave temple sites survive. The most important and large-scale caves are those at Yungang near Datong, Shanxi province, and Longmen near Luoyang, Henan province. Mizuno Seiichi and Nagahiro Toshiō, *Yun-kang: The Buddhist Cave Temples of the Fifth Century A.D. in North China* (Kyōto: Kyōto daigaku Jimbun kagaku kenkyujō, 1951-1956).

19. For further reading on the history and culture of this period, see Mark Edward Lewis, *China Between Empires: The Northern and Southern Dynasties* (Cambridge, MA and London: Harvard University Press, 2009); and Albert E. Dien, *Six Dynasties Civilization* (New Haven and London: Yale University Press, 2007).

20. Vimalakīrti is the enlightened householder with inordinate spiritual insight and skill at debating, whom even Manjusri, the Bodhisattva of Wisdom, feared to meet for discussion. Śrīmālādevi is an enlightened queen whose authoritative words are likened to the "lion's roar" of the Buddha's teachings. For English translations and studies of these sūtras, see Burton Watson, *The Vimalakīrti Sūtra* (New York: Columbia University Press, 1996); Robert Thurman, *The Holy Teaching of Vimalakīrti: a Mahāyāna Scripture* (University Park: Pennsylvania State University Press, 1976); Alex Wayman and Hideko Wayman, trans., *The Lion's Roar of Queen Śrīmālā: A Buddhist Scripture on the Tathagatagarbha Theory* (New York: Columbia University Press, 1974). Both these sūtras were engraved in front of the South Cave at the Northern Xiangtang Cave site between 568 and 572 under the sponsorship of the official Tang Yong. Mizuno Seiichi and Nagahiro Toshiō, *Kyōdōsan sekkutsu* [The Buddhist Cave-Temples of Hsiang-t'ang-ssu on the Frontier of Honan and Hopei] (Kyoto: Tōhō bunka gakuin Kyoto kenkyujo, 1937); Katherine R. Tsiang, "Monumentalization of Buddhist Texts in the Northern Qi Dynasty: the Engraving of Sūtras in Stone at Xiangtangshan and other Sites of the Sixth Century," *Artibus Asiae* (1996): 233-261.

21. In Buddhist scriptures the lotus pond is mainly associated with the Western Paradise, but early depictions of lotus ponds in the murals at Dunhuang do not show scenes of rebirth or Amitābha Buddha. The lotus pond theme in art with reference to Amitābha Buddha begins around the middle of the sixth century. Other early examples have been identified in Cave 127 at Maijishan and in the middle cave at the Xiaonanhai, near Anyang. By the seventh century the Western Paradise at Dunhuang has very detailed depictions of children emerging from lotus blossoms, as in Cave 220. See Yan, "Bei Qi changuan ku de tuxiang kao: Cong Xiaonanhai shiku dao Xiangtangshan shiku", 375-440; and Ning Qiang, *Art Religion, and Politics in Medieval China: The Dunhuang Cave of the*

Zhai Family (Honolulu: University of Hawaii Press, 2004), 29-32, 37ff.

22. Luis O. Gomez, *The Land of Bliss: The Paradise of the Buddha of Measureless Light* (Honolulu and Kyoto: University of Hawai'i Press and Higashi Honganji Shinshu Otani-ha, 1996), 181.

23. Gomez, *The Land of Bliss*, 217-218. Of the Chinese versions of the *Longer Sukhāvatīvyuha sūtra*, the translation attributed to Kang Sengkai, the Sogdian Sanghavarman (ca. 252 CE), is considered the most authoritative. This version provided a foundation for the widespread growth of the Pure Land doctrine in East Asia. *Ibid.*, 126-129. See Takakusu Junjirō and Watanabe Kaigyoku, eds., *Taishō shinshū daizōkyō* [The Buddhist Canon] (Tokyo: Taishō issaikyō kankokai, 1924-1929), no. 360, vol. 11: 278a-b.

24. The version of the *Guan Wuliangshou jing* handed down is attributed to a fifth-century translation, but it is widely believed to have been composed in China. *Taishō shinshū daizōkyō*, no. 365, v. 12:344-6.

25. Verses on the vow to be reborn in the Western Paradise of Amitābha Buddha (*Sukhāvatīvyūha upadeśa*), attributed to Vasubandhu and translated by Bodhiruci in the first half of the sixth century. Tsiang, *Echoes of the Past*, 39. Zhang Lintang and Xu Peilan. *Xiangtangshan shiku beike tiji zonglu* [Collected stele inscriptions at the Xiangtangshan Caves], Vol. 1 (Beijing: Foreign Languages Press, 2007), 43, fig. 13.

26. Edouard Chavannes, *Mission archéologique dans la Chine septentrionale* (Paris: Ernest Lerou, 1909). A significant event for stimulating interest in Buddhism in the U.S. was the Parliament of the World's Religions held in Chicago in 1893 to coincide with the world Columbian Exposition. For a description of the event, see John R. McCrae, "Oriental Verities on the American Frontier: The 1893 World's Parliament of Religions and the Thought of Masao Abe," *Buddhist-Christian Studies*, 11 (1991): 9-27.

Landscape Elements in Early Tibetan Painting

Rob Linrothe

Since [Śraddhākara] varman says that [outside the borders of the maṇḍala] there must "be painted lakes, trees, flowers and birds" exactly so it has been done here.
— Inscription in the dome of the Gyantse Kumbum[1]

Landscape as a genre in itself never existed in early Tibetan painting traditions. Images of mountains, streams, lakes, trees, flowers, and wild animals certainly appear in early painting, but they are functionally subordinated motifs to Buddhist figural icons and to the narratives.[2] Constellations of landscape elements primarily act as backdrops for figures. Meditating monks, Buddhas, or ascetics sit or wander in remote natural settings often teeming with birds and monkeys. Images of nature are extremely stylized, each element depicted to its own scale. Although they rarely coalesce into a unified scene, the individual elements work together conceptually to connote—if not depict—wilderness and isolation from urban settings (which are presented as equally stylized architectural renderings).[3] Despite the range of strategies employed by artists to convey wilderness settings over the course of the five centuries briefly surveyed here, certain shared features can also be identified. Overall however, the forms and functions of landscape in early Tibetan painting are under-studied and under-theorized.[4]

One of the earliest Tibetan images with a relatively rich landscape setting is from Tabo monastery in Spiti, western cultural Tibet (now part of India). It is in the Dukhang, or main assembly hall, and is generally accepted as part of the repainting program datable to 1042. It represents scenes of the narrative of Sudhana from

Figure 1. Detail depicting Sudhana's visit to the monk Meghaśrī, from a mural in the Tabo Dukhang (Spiti, India), ca. 1042. Photo by Jaroslav Poncar, used with permission, courtesy of the Western Himalayan Archive Vienna (WHAV) at the University of Vienna.

the *Gaṇḍavyūhasūtra*, in which Sudhana visits a series of teachers. Identified by adjacent inscriptions written in Tibetan as the visit to the monk Meghaśrī,[5] in the scene in Figure 1, "Sudhana finds [the monk's] house empty, then he climbs Mt. Sugrīva looking for Meghaśrī, but finds the mountain inhabited only by mountain sheep, antelopes, and musk deer. Sudhana finds Meghaśrī on another peak but only on the seventh day."[6]

In this scene, three images of Sudhana are visible: one on the viewer's left, near the house; another to the left of the highest peak; and the third, to its right; in this case Sudhana kneels before Meghaśrī who sits atop the right peak of the same mountain with his hand extended toward Sudhana. The mountain as a whole is made up of eight sections with irregular, curved outlines, agglomerated into a single lumpy mountain, which recapitulates the shape of its parts. The sections are shaded at the edges with lighter or darker colors, emphasizing the contours of the shapes of the parts and of the whole, which stands out against a dark blue background. Flowers float down irregularly from the sky. The amorphous sections are meant to suggest the hills and ridges of a mountainous area. Three trees are planted along the ground line with a fourth just below Meghaśrī. Most of the internal sections,

Figure 2. Fragment of a mural in the Tholing Gyatsa Lhakhang (Ngari, Western Tibet), ca. mid-eleventh century. Photo by R. Linrothe, 2005.

distinguished by different-colored shading at the edges, contain animals facing opposite directions and carefully alternating in pose, standing and running. The same mountain motif serves multiple functions in the narrative. Various episodes are staged on and around the mountain form, beginning with Sudhana looking up at the slope he must climb. Then he is shown striving to surmount the peak and searching for the teacher. Finally, he finds the teacher and kneels before him. The mountain form acts as a convenient throne for the teacher, and the trees and animals suggest the wilderness setting.

Only a few other scenes in the Sudhana narrative feature landscape elements, such as Sudhana's search for Sarvagāmī on Mt. Sulabha, but in each case the mountain form is quite similar to that in Figure 1, though without the distinguishing shading.[7] Mt. Sulabha resembles a smooth iceberg, with curving interior lines but no trees or foliage, only two musk deer, one enclosed within one of the lappets, the other half

obscured "behind" an outlined ridge. Overall, the lower horizontal register, which wraps around the south and part of the west wall of the Dukhang and comprises the Sudhana narrative, features many more depictions of architecture and cities than scenes from nature to be construed as landscapes.

The convention of depicting mountains by building up similarly shaped outlined forms into a single modular unit proves to be both widespread and enduring in Tibetan painting, though always serving as a minor element, never taking center stage. It is found, for instance, in one of the few murals surviving from the Tholing Gyatsa Lhakhang founded in 996, the most important early temple at the old capital of the Guge Kingdom. The site continued to be worked on until 1028 and was restored after damage caused by a 1037 invasion by the Qarakhanids.[8] This fragment of a mural (Fig. 2), one of the very few in the building to have survived the Cultural Revolution, possibly dates from the eleventh century. Like the Tabo mural, the mountain is formed by a series of irregular forms, the smallest in front, largest in back. They are aligned so that they make up a single triangular shape. A whimsically placed head and upper torso of a Bodhisattva appears as if from within the mountain, between the farthest two of five ranges. The upper three sections are intensely colored, and all five are shaded at the edges as in the Tabo paintings. A large tree, independently scaled, appears directly adjacent to the mountain composition, as if person, mountain, and tree dictate foreground space.[9] Too little of the mural remains to identify its theme or the series to which it belonged.

Both Tabo and Tholing in western cultural Tibet are associated with the early phase of the revival of Buddhism in Tibet starting in the late tenth century. Further, both are closely linked to Kashmiri painting. It is likely that, as traditional accounts attest, artists from Kashmir came to the western Tibetan regions and participated in these early building campaigns before returning home. They also no doubt taught Tibetans to paint in the Kashmiri style, and for several centuries, as late as the fifteenth and early sixteenth centuries, examples of similarly formed mountains were produced. In the Demchok Lhakhang of Tsaparang, the later fortress-capital of the Guge kingdom, paintings in man-made caves datable to around the fifteenth century show remarkably similar mountains (Fig. 3). Here the mountains appear in horizontal compositions on the walls depicting the eight charnel grounds surrounding the Cakrasaṃvara maṇḍala, the central section of which is depicted sculpturally in the middle of the room. Each of the charnel grounds has a tree, stūpa, and Mahāsiddha. In this one, he sits on a tiger skin holding a skullbowl and antelope horn. The stūpa is located as if behind him within the familiar pale mountain form. This provides a setting for birds, hares, jackals, and an artfully

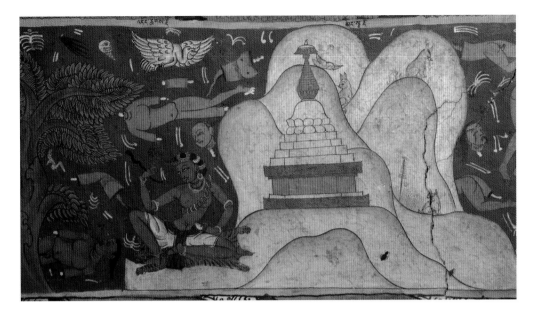

Figure 3. Detail depicting one of the eight charnel grounds surrounding a Cakrasaṃvara maṇḍala, from a mural in the Demchok Lhakhang of Tsaparang (Ngari, Western Tibet), ca. fifteenth century. Photo by R. Linrothe, 2005.

placed insect (bottom right), some of which feed on the decaying, half-cremated human bodies strewn over the landscape. The mountain form is deployed to evoke a terrifying setting—isolated, wild, and in this case, gruesome. Even the sky is an eerie reddish brown, as if aglow with cremation fires, and with clusters of blood-red dots to indicate the rain of flowers. At Tabo, in the Serkhang, datable to around the early sixteenth century, above a mural of Tārā, similar mountain forms are visible (Fig. 4), shorn of the dreadful associations but still indicating remoteness. The addition of clouds in different colors with long trailing stems indicates a later more developed sense of the spatial possibilities in landscapes: clouds float across the mountain range, in front of one hill and behind another.

Two different ways of indicating a rocky landscape can be observed in a single large cave built in a neighboring region of the Guge kingdom, at Dungkar. The murals in Cave 2 probably date to the late twelfth or thirteenth century. They present a series of imaginatively populated mountain caves in murals that surround sculptures of Buddhas in niches. In one cave, a monk sits with his staff and begging bowl beneath a spiritedly spikey mountain (Fig. 5). This landscape setting is once again built up of smaller segments, each outlined in both black and white, but instead of the rounded irregular forms of the first mode, these are sharply pointed shapes. Some splay out symmetrically in groups, and others are layered in repeating

Above: Figure 4. Detail of the Green Tārā mural in the Serkhang of Tabo (Spiti, India), ca. early sixteenth century. Photo by R. Linrothe, 2006.

Right: Figure 5. Detail of a mural in Cave 2 at Dungkar (Ngari, Western Tibet), ca. late twelfth-early thirteenth century. Photo by R. Linrothe, 2007.

wave-like patterns, all colored bright blue. Shading is no longer confined to the contours, and the color darkens away from the edges. The staves of the rocks are punctuated with small pennant-shaped red and black motifs, also outlined in black. They seem to indicate crevices or deformations in the otherwise smooth rocks.[10] Different mountain ranges are separated by black or red valleys. The fantastical effect is enhanced by such details as a serpent emerging from one of the crevices above the monk's head, wind-tossed trees, a seated monkey, and an ape jumping from the rock to the trunk of a tree where a large hawk rests in the branches.

Inside another cave, a lion and an elephant confront each other, while deer and a hunter with a bow and arrow are arrayed in the mountain ranges around the cave. Another cave holds an owl and a vulture, and in yet another, a snake wraps itself around a rat. Although the specific forms of the mountains differ from those at Tabo and Tholing, the sense of wildness and isolation continues to pervade. Additionally, the scale of each object (rocks, trees, animals) remains independent of other objects or settings, and the mountain is still an accumulation of similarly shaped forms that make up a larger whole. The differences from earlier renditions such as those of Figures 1 and 2 might be attributed to image-making by western Tibetan artists who continued to develop the early Kashmiri convention of mountain forms on their own, without reinforcement from Kashmiri masters.

On the other hand, the fact that a second convention for rock mountains appears in the same cave demonstrates the artists have been exposed to another formula for suggesting mountains. Above the top of the blue peak in Figure 5 a different composition begins with Bodhisattvas contained in round nimbi, set against a sky-blue background. The border of the two compositions (Bodhisattvas above, rocky landscapes with caves below) is marked by a register of projecting bricklike rocks drawn in one-point perspective. The outer surface of each illusionistic projection is subdivided into three rectangular sections with two straight lines resembling a sideways letter T. Each section is shaded in one color, but the underside of the rock is given an alternate color. This convention has a long history, and is routinely found in the much earlier fifth- to sixth-century Buddhist mural paintings of Ajanta, extending into Central Asia and Dunhuang cave murals by the sixth century, and, only slightly modified, in the ninth-century sculptural narratives at Borobudur in Java.[11]

From the Tibetan point of view, this visual trope for rock forms is most closely associated with painting of eastern India and Nepal. It appears in sculptural form, however, in the wooden lintels at the Jokhang in Lhasa, which are conventionally dated to the seventh century and attributed to Licchavi artists of the Kathmandu

Figure 6. Detail of a *jātaka* mural in the circumambulation corridor (*khorlam*) surrounding the main shrines at Shalu monastery (West-Central Tibet), ca. first half of the fourteenth century. Photo by R. Linrothe, 2007.

valley.[12] Kashmiri artists may have inherited this convention and used it occasionally, but no early murals survive in Kashmir to demonstrate this. In the absence of such evidence, in central Tibet it is thus associated with art from Nepal and eastern India (Magadha), rather than with Kashmir. The directions of the transmission are not clearly definable, so that by the late twelfth or thirteenth century, the artists of Dungkar Cave 2 may have seen it as an integral part of the Kashmiri-Tibetan style, or have been exposed to some conventions of the Indo-Newari style, which was prevalent in central Tibet. Perhaps this convention was part of both styles, and they reinforced each other.

At the site of the Shalu monastery in central Tibet, in the main circumambulation corridor (*khorlam*) that dates to the first half of the fourteenth century, the older style of irregularly shaped mountain-modules fusing into a larger unit reappears but in a smoother form (Fig. 6). A pair of opposed antelopes with a sleeping deer below is positioned on the hillock's slope, which is ornamented with a regular pattern of red flowers. The background has the reverse coloration, red with green floral patterns. In a similarly dated hall within the same complex, the Ṣaḍakṣara Avalokiteśvara Lhakhang, the cubicizing mode appears, transformed into units embedding bases for tapered tips of curling, staved peaks (Fig. 7). The edges are shaded as before, and some contours are also outlined in white. The most significant

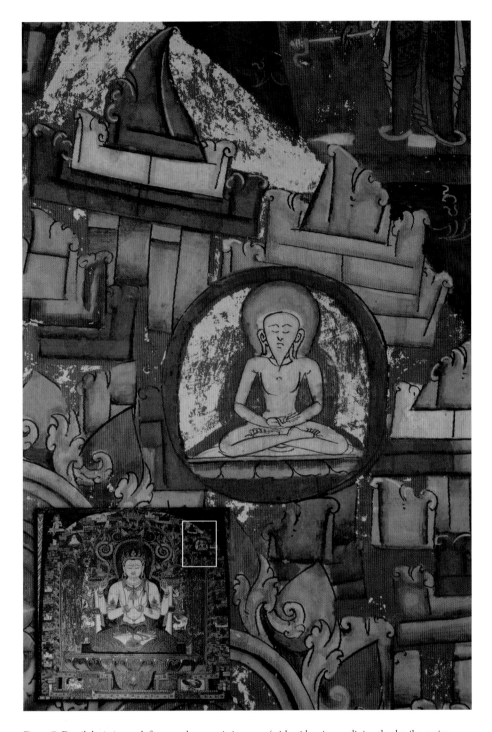

Figure 7. Detail depicting rock forms and an ascetic in a cave (with wider view outlining the detail superimposed), from a mural of the Ṣaḍakṣara Avalokiteśvara Lhakhang, Shalu monastery (West-Central Tibet), ca. first half of the fourteenth century. Photos by R. Linrothe, 2007.

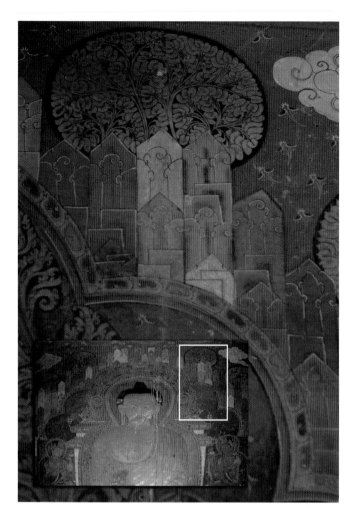

Figure 8. Detail depicting rock staves (with wider view outlining the detail superimposed), from a mural of the Śākyamuni Buddha with two Bodhisattvas in the Yumchenmo (Prajñāpāramitā) Lhakhang Khorlam of Shalu monastery (West-Central Tibet), ca. first half of the fourteenth century. Photos by R. Linrothe, 2007.

distinction is the intensity of the many colors. The rocky forms have a conceptual rather than perceptual relationship with the meditating ascetic who is contained in a circle superimposed on the rock conventions. The roundel is to be read as a cave in the wilds, which are otherwise empty of animals or plants, but this cave is even less integrated into the landscape than the cave in Figure 5. The rock motifs have such an abstract quality that even reading them as hills is difficult without prior knowledge of the convention. The Shalu murals are also closely associated with Newari painting from Kathmandu Valley.

A more harmonious, regularized, and abstracted version of the crystalline sheaves of cubic rocks is found in the circumambulation corridor at Yumchenmo Lhakhang, also at Shalu (Fig. 8). Set against regularly spaced rounded treetops with curving branches and layered leaves, these paintings also date to around the first half of the fourteenth century. Here the rocky forms stand stiffly upright, of nearly

Figure 9. Detail of a mural depicting Buddha, Bodhisattvas, and other figures, from the Gonkhang of Shalu monastery (West-Central Tibet), ca. mid. 11th c. Photo by R. Linrothe, 2007.

even width, in a pleasing palette of alternating orange, pink, green, and yellows. They seem to incorporate both the spikey and cubic forms, as well as scrolling cloud forms. The rock forms surround an elaborate throne and cusped screen-like backdrop enclosing a seated Buddha figure and two kneeling Bodhisattvas. The rocky landscape implies once again that the figures are to be found within a cave. The style of the figure painting on this mural is quintessentially Newari, but these startlingly stylized but charming rock forms are not found in later Newari painting. They appear to be the furthest abstractions of cubic mountain conventions found in earlier Tibetan art derived from both Indian and Nepalese art.[13]

Quite different from these stylized mountain-staves are the indications of landscape in the Gonkhang of Shalu. These date from a much earlier phase, possibly the mid-eleventh century. Elements of nature are crowded into the spaces above the figures of monks, Buddhas, Bodhisattvas, and heavenly females known as Apsarases (Fig. 9). It is not clear that the rocky ranges were intended as generic remote areas, or perhaps specifically represented Nepal's lowland *terai*, the strip of land bridging the foothills and the Himalayas "which provides sanctuary for a unique cross-section of Asian wildlife—chital deer, langurs, rhinos, leopards and . . . tigers . . . within the shadow of the highest mountains on earth."[14] Palm or banana-like trees are placed in front of a large white area subtly enlivened with parallel strings of jewels.

Figure 10. Detail of a mural in the Mañjughosa chapel (2Nb′) on the second level of the Kumbum at Gyantse (West-Central Tibet), second quarter of the fifteenth century. Photo by R. Linrothe, 2005.

Into this implied natural space are crowded flop-eared elephants, big-tailed yaks, antlered deer, wolves, birds of various types, a bristle-backed boar, slouching tiger, and a naked ascetic. Despite the rich naturalistic detail, we find these elements of forest landscape scenes only in the peripheral areas of dense figural compositions.[15]

A final example of an "early" site in central Tibet is that of the Gyantse Kumbum, a key monument in the development of Tibetan painting. Its hundreds of murals are datable to the second quarter of the fifteenth century. In them, one finds a combination of older styles as well as harbingers of what is to come. The pivotal status of Gyantse can also be seen in elements of landscape painting, which although still playing a minor role in much larger iconic and narrative compositions, were nevertheless gaining greater prominence. In Figure 10, for example, a detail from the Mañjughosa chapel on the second level (2Nb′), the lobe-like structure of the hills at the baseline directly above the inscriptions, will immediately be recognized as being the oldest mode of connoting landscape (Figs. 1, 2). Each pale-colored lappet, defined by a single curving outline, encloses a single tree. Long-stemmed

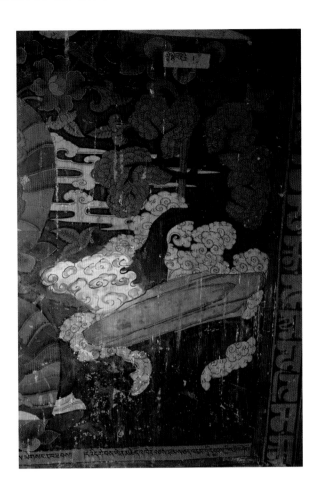

Figure 11. Detail of a mural in the Ṣaḍakṣara Avalokiteśvara chapel (2Sa′) on the second level of the Kumbum at Gyantse (West-Central Tibet), second quarter of the fifteenth century. Photo by R. Linrothe, 2005.

clouds emerge from behind the peak. Their juxtaposition with gigantic flowers that nearly obscure the hill motif underscores how minor this element of landscape remains in the overall composition. Similar hillocks are found in other chapels at all levels of the colossal multistoried stūpa.

On the same level of the Gyantse Kumbum, in the Ṣaḍakṣara Avalokiteśvara chapel (2Sa′), a completely different mode of landscape depiction is clearly indebted to both Chinese blue-and-green and monochrome ink landscape painting (Fig. 11). A gnarled tree emerges from a rock outcropping that bears a faceted, slanted boulder. The lower load-bearing rock is textured with modulated ink brushstrokes, and some of the surfaces have an extra outlining in a bright mossy green. Pink and orange swirling clouds emerge from behind the rock. The coloration is more natural, there is a compelling sense of spatial relations, and a consistent or shared scale not previously seen in Tibetan painting. This is just one example among the many at Gyantse of perceptual landscapes, some of which are inhabited by cranes, a motif straight out of Chinese painting.

Figure 12. Detail depicting two Drukpa Kagyu teachers, from a mural in the Lama Lhakhang of Chemre monastery (Ladakh, India), ca. seventeenth century. Photo by R. Linrothe, 2009.

Relative pictorial unity is the direction that later Tibetan painting takes, and the early stages of the appropriation of Chinese-style landscape for Tibetan purposes are visible here at Gyantse. The impetus of Chinese blue-and-green landscape painting—particularly in paintings of Arhats—has been comparatively well studied.[16] It ultimately served to intimate a coherent visual illusion of space for the action of immanence on the part of Buddhist or Bön deities. By the seventeenth century, the approximate date of Figure 12, from Chemre monastery in Ladakh (in India, westernmost cultural Tibet), the blue-and-green landscape style (outlined forms filled with color) combined with monochrome ink painting (modulated strokes and lines) had become standard even in the peripheries of Tibet. Note the scalloped rocks done in monochrome ink, the snow peak in the background above the right figure, and the tilted rocks in the foreground, overlapping with the seats of the two monks. The result is a greater illusionistic space shared by trees, rocks, plants, and figures. This type of landscape setting came to be used to visually bind together the disparate segments depicted in different scales in earlier proto-landscapes. In fact, the apparent unity of the landscape here may actually mask the spatial and thematic discontinuities that persist, but this is to phrase it negatively,

Figure 13. Detail of a mural of the Lokapāla Dhṛitarāṣṭra from the porch of a Galdan Gyatso shrine in Rongwo, Rebgong (Amdo, Qinghai China); signed by Sangdak Tsering, ca. 2006. Photo by R. Linrothe, 2007.

from the point of view of those looking at Tibetan landscapes with expectations of spatial consistency and coherency derived from familiarity with either Chinese or Western landscape painting traditions, or both.

The compositional landscape mode illustrated in Figure 12 remains integral to contemporary Tibetan painting traditions. Among some artists from Amdo Rebgong in northeast Tibet, the Chinese rock forms are recognizable but have been transformed from sedate, unifying naturalistic settings as in Figure 12 into bizarre kaleidoscopic hyper-real blue-and-green grottoes into which exotic animals and yogis retreat (Fig. 13). Though they look contemporary, they also seem to replicate the earlier conceptual abstractions seen in Figures 1-3, 5, and 7. The mountain forms, for example, are built up by the repetition of lappet-like sections: Objects in the landscape are rendered in independent scales (a butterfly as large as a human, a peony dwarfing all), and the same landscape element can function simultaneously as different things, such as the peak of a mountain and a perch for an oriole.

Figure 13 is a detail taken from a mural depicting Lokapāla Dhṛitarāṣṭra, the guardian of the East, which was painted around 2006 on the porch of the new shrine in Rebgong town's main monastery. It is signed in Tibetan, English, and

Chinese by Sangdak Tsering, an artist from the nearby Sengge Shong Mango village. In its churning outlines and underlying structure, the painting reasserts the uncanny animation of landscape. Like the earlier landscapes, it teems with life of all kind. This seems to reflect a deeply embedded attitude toward nature that has been recognized by investigators of religious aspects of Tibetan societies. This attitude is manifest in rituals that precede maṇḍala making, for example, in order to clear the space of spirits of all sorts. The earth is thus envisioned as being inhabited and animated, potentially dangerously, by beings visible and invisible.[17] In some of the examples illustrated in this essay, these elements of early Tibetan landscapes, such as mountains, trees, renouncers, animals, and birds, do not so much cohere as collide with each other. In this too, there may be deeper factors at work. Among Tibetans, "the human body, the house, and the local environment are so many microcosms nested one inside the other, but of equal validity. They are closed, complete worlds which are all that matters for the individual or group (family, village, community)."[18]

Perhaps the characteristics observable in Tibetan depictions of landscape elements flow more from such underlying cultural assumptions than from a consciously constructed "Buddhist" attitude toward the environment, if such a thing exists. Above all, they do not arise from observations of the dramatic mountain landscapes that artist and viewer experience simply by looking out the door of the shrine in which the paintings appear. Remarkably, with the possible exception of Figure 9, the painted landscapes bear little resemblance to landscapes familiar to the artists, i.e, the spectacular mountain scenery surrounding Tabo, Tholing, Tsaparang, Dungkar, Shalu, and elsewhere. Similarly, the blue-and-green style of landscape painting is equally divorced from the realities of the scenery near Chemre or Rebgong, to cite the examples given here (Figs. 12, 13).

In conclusion, in the sixteenth century, the landscapes familiar from paintings of Chinese Arhats in a blue-and-green setting had begun to spread in the art of Tibet. Prior to that, from the eleventh to twelfth centuries up to the sixteenth century, Tibetans used landscapes in ways that have hardly been explored by art historians. Our lack of awareness can be attributed in part to the peripheral, almost invisible role of landscape in painting during those centuries.[19] Paintings of landscapes, or rather of elements of landscapes, served quite different purposes than the landscapes of property or power theorized, for example, in Chinese and Western landscape painting.[20] Early Tibetan landscape painting was based on more abstract principles in which scale was conceptual, not perceptual. It used stylizations adapted from the twin roots in Indian painting of central or eastern India (and Nepal) as well as

from Kashmiri painting.[21] In early Tibetan painting, landscapes are subordinated to a larger religious significance or meaning, as one would expect with religious art. The conventional landscape elements, deployed with independent shifts of scale, thus contribute to the establishment of an environment of otherworldly retreat or idealized purity around the Buddha, his followers, and deities.

Aims other than the creation of what we call landscape exercised the imaginations and visual skills of the artists, who were not encumbered by the need to provide pastoral settings. Even this brief survey of elements of landscape in early Tibetan painting prepares one to understand why the systematic and cohesive aspects of landscape settings, once they were absorbed from Chinese painting, were so welcomed by the artists and educated patrons. One of the virtues of the fully developed system, which was adopted almost ubiquitously by the seventeenth century among Tibetan painters, is the power to create the illusion of coherence and consistency. It also offered flexibility by allowing radical shifts in subject matter. This modified blue-and-green mode fills the gaps and interstices with convincing space-cell settings which simultaneously divide and connect one scene from and to another. It is narrative-neutral and, if the artist feels so inclined, offers scope for imaginative details that serve little purpose other than to entertain and impress a viewer with the artist's sleight-of-hand, without disrupting the main narrative or overall theme. Rather than being premised on the illusion of a shared continuous spatial setting, this system is constructed with or through color and thematic repetition. These convey the impression of commonality and coherence but do not close off the time-cherished shifts of scale and setting with which artists were accustomed to work. Rather than jettison established methods for a radically new underpinning, artists could continue to work as they always had, but the familiar structure was now wrapped in a flexible new skin, one that enhanced their creations with added conviction and appeal. A search along the seams and margins of the newer blue-and-green landscape paintings still rewards the viewer with glimpses of the older elements treated independently. The fact that these elements threaten to unbalance the scheme's attempt at cohesion reminds us of the need to account for a distinctively Tibetan history of landscape elements within religious painting.

Endnotes

1. Giuseppe Tucci, *English Version of Indo-Tibetica*, Vol. 4, *Gyantse and Its Monasteries,* Part 2, *Inscriptions, Texts and Translations*, ed. Lokesh Chandra (New Delhi: Aditya Prakashan, 1989), 237. The variant "scarfs" for "birds" is also given. Śraddhākaravarman was a Kaśmīri paṇḍit, author, and teacher of Rinchen Zangpo (958-1055), with whom he collaborated on translations into Tibetan of Sanskrit Buddhist texts in the early eleventh century. I would like to thank Mary Roberts, Melissa R. Kerin, and Katherine R. Tsiang for useful comments on the draft of this essay, as well as Stephen J. Dinyer, IT-Media Service, Skidmore College, for technical help with figures 7 and 8.

2. Here I leave aside those elements serving a purely iconographic purpose, such as the lotus held by Avalokiteśvara and Tārā, the sow for Marīcī, a horse's head for Hayagrīva, and the bodhi tree of Śākyamuni.

3. For examples of such architectural renderings, see those at Alchi Tsatsapuri, illustrated in Rob Linrothe, "Conservation Projects in Ladakh, Summer 2008," *Orientations* 40, no. 8 (2009): figs. 1, 2.

4. See Pratapaditya Pal, "Nature in Indo-Tibetan Art," in Pal, *Divine Images, Human Images: The Max Tanenbaum Collection of South Asian and Himalayan Art in the National Gallery of Canada* (Ottawa: National Gallery of Canada, 1997), 34-59. Pal identifies China as the source of Tibetan landscape painting as early as the tenth century and emphasizes natural forms being used for "symbolic" and "decorative" significance.

5. Ernst Steinkellner, *Sudhana's Miraculous Journey in the Temple of Ta Pho: The Inscriptional Text of the Tibetan Gaṇḍavyūhasūtra* (Rome: Istituto Italiano per il Medio ed Estremo Oriente, 1995), 34-36.

6. Deborah E. Klimburg-Salter, *Tabo – A Lamp for the Kingdom: Early Indo-Tibetan Buddhist Art in the Western Himalayas* (Milan: Skira; New York: Thames and Hudson, 1997), 121.

7. Laxman S. Thakur, *Visualizing a Buddhist Sutra: Text and Figure in Himalayan Art* (New Delhi: Oxford University Press, 2006), 61-62, pl. XXIV.

8. Roberto Vitali, *Records of Tho.ling: A Literary and Visual Reconstruction of the "Mother" Monastery in Gu.ge* (Dharamshala: High Asia, 1999), 14; also Christian Luczanits, "A Note on Tholing Monastery," in *Art of Tibet: Selected Articles from* Orientations, *1981-1997* (Hong Kong: Orientations Magazine, 1998), 256-257.

9. Comparisons could be made with early phases in the development of landscape art in China, particularly to the landscapes associated with Gu Kaizhi and at Dunhuang as in Cave 285, as well as with later Persian and Mughal painting.

10. Somewhat related to this rendering are the cubic forms surrounding several of the main figures on the north and south walls of Cave 4 of the Tangut Xia Yulin grottos. See Dunhuang Yanjiusuo, *Zhongguo Shiku: Anxi Yulin Ku* (Beijing: Wenwu Chubanshe, 1997), pls. 181, 184-188, 190. The sheaves are more upright, like those in figure 8, but they have similar markings to indicate crevices, seen in figure 5. They must also be late twelfth to early thirteenth century in date, the Tangut Xia kingdom having been destroyed in 1227.

11. Jean Louis Nou, et al., *Ajanta* (Paris: Imprimerie Nationale Editions, 1991), 131, 207, 208; Benoy K. Behl, *The Ajanta Caves: Artistic Wonder of Ancient Buddhist India* (New York: Harry H. Abrams, 1998), 85, 181,193, 209, 231; Dunhuang Yanjiusuo, *Zhongguo Shiku: Dunhuang Mogao Ku* (Beijing: Wenwu Chuban she, 1987), Vol. 1, pls. 86, 93, 154, 181; Vol. 5, pls. 114, 125 (Tangut Xia period); John N. Miksic, *Borobudur: Golden Tales of the Buddhas* (Berkeley: Periplus Editions, 1990), 95, 113, 117; the Borobudur convention even more closely resembles those in figure 7 below.

12. Ulrich von Schroeder, "Wood Carvings in the Jo khang/gTsug lag khang of Lhasa," in *Buddhist Sculptures in Tibet,* Vol. 1, *India and Nepal* (Hong Kong: Visual Dharma, 2001), 407-431; Amy

Heller, "The Lhasa *gtsug lag khang*: Observations on the Ancient Wood Carvings," http://www.asianart.com/articles/heller2/index.html (accessed October 2009); and Mary Shepherd Slusser, "The Lhasa *gTsug lag khang* ('*Jokhang*'): Further Observations on the Ancient Wood Carvings," http://www.asianart.com/articles/jokhang/index.html (accessed October 2009).

13. See the discussion found in Marylin M. Rhie and Robert A.F. Thurman, *Wisdom and Compassion: The Sacred Art of Tibet, Expanded Edition* (New York: Tibet House and Harry N. Abrams, 1996), 129.

14. Ian Cameron, *Mountains of the Gods: The Himalaya and the Mountains of Central Asia* (New York: Facts on File, 1984), 19. Human population pressures have severely affected the wildlife of this region; see David Zurick and Julsun Pacheco, *Illustrated Atlas of the Himalaya* (Lexington: University Press of Kentucky, 2006), 82, 107, 118.

15. In some ways, the shapes, variety, and composition of the tree forms, including the banana trees extending beyond the curved treetops, recall the much more polished Green Tārā of the Cleveland Museum of Art, ca. twelfth or thirteenth century. Acc. #1970.156; illustrated on the CMA website, "Collections on Line," http://www.clevelandart.org/, accessed June 2010.

16. See Marylin Rhie, "Tibetan Painting: Styles, Sources and Schools," in Marylin M. Rhie and Robert A. F. Thurman, *Worlds of Transformation: Tibetan Art of Wisdom and Compassion* (New York: Tibet House New York and The Shelley and Donald Rubin Foundation, 1999), 56-60, 66; and Rob Linrothe "Between China and Tibet: Arhats, Art, and Material Culture," in Rob Linrothe, *Paradise and Plumage: Chinese Connections in Tibetan Arhat Painting* (New York: Rubin Museum of Art; Chicago: Serindia, 2004), 9-44.

17. Cathy Cantwell. "The Earth Ritual: Subjugation and Transformation of the Environment," *Revue d'Etudes Tibétaines* 7 (2005): 4-21. Prithvi, the earth goddess, is requested "to surrender her prior rights to the possession of the earth and to act as a benevolent protectress" during the course of maṇḍala rituals, and she and her retinue are then compensated with offerings. *Ibid*, 9, 12.

18. R. A. Stein, *Tibetan Civilization*, trans. J. E. Stapleton Driver (Stanford: Stanford University Press, 1972), 204.

19. As Pal points out, "In the early [Tibetan] paintings one occasionally encounters a few trees or a mass of crystalline rock formations of variegated hues but landscape is unfamiliar, as the art was primarily figurative." Pal, "Nature in Indo-Tibetan Art," 55.

20. Just to see the range of explorations of Chinese and Western landscape, consider Richard Vinograd, "Family Properties: Personal Context and Cultural Pattern in Wang Meng's *Pien Mountains of 1366*," *Ars Orientalis* 13 (1982): 1-29; Lothar Ledderose, "The Earthly Paradise: Religious Elements in Chinese Landscape Art," in *Theories of the Arts in China,* ed. Susan Bush and Christian Murck (Princeton: Princeton University Press, 1983), 165-183; Eric Hirsch and Michael O'Hanlon, *The Anthropology of Landscape: Perspectives in Place and Space* (Oxford: Clarendon Press, 1996); Simon Schama, *Landscape and Memory* (New York: Alfred A. Knopf, 1995); W. J. T. Mitchell, *Landscape and Power*, 2nd ed. (Chicago: University of Chicago Press, 2002).

21. Pal uses the binomial "symbolic" versus "pictorial," which I take to be roughly equivalent to "conceptual" versus "perceptual."

Looking for Common Culture in the Pictorial Décor of a Ming Cizhou-type Stoneware Jar

Kathlyn Liscomb

Human beings engage in relational looking: When they look at something, they consciously or unconsciously deal in relationships.[1] They notice how the details of an art object interact with the whole; they interpret it in light of the context in which they see it; and they compare it to other types of objects they have seen, noting differences as well as similarities. Often written and oral forms of literature also mediate visual experiences, as do the viewer's understanding of function, context, and social status implications. When operating in our own cultural milieu, we have years of experience guiding our relational looking and interpretation. However, in a different cultural environment, we often make mistakes in interpreting unfamiliar codes. When seeking to understand an art object from the past, art historians strive to familiarize themselves with a different visual culture, and they must do so based on fragmentary evidence.

Generally speaking, it is easier to find written evidence for the cultural practices of well-educated elite groups than for people possessing modest degrees of textual literacy and wealth. Relatively inexpensive ceramics made, used, and seen by many people from a broad spectrum of social positions in public and private settings thus can provide crucial evidence. In China, one such category of ceramics is Cizhou-type stoneware. These sturdy ceramics were decorated in various ways in northern China during the Northern Song (960-1127), Jin (1115-1234), Yuan (1279-1368), and Ming dynasties (1368-1644) and were inexpensive in their time.[2] Some were decorated with designs in iron oxide on a white slip. This had the advantage of covering the imperfections of the ceramic body prior to the application of a transparent glaze.

Here I shall focus on the pictorial imagery decorating a Ming Cizhou-type stoneware jar (*guan*) (Fig. 1a-1c).[3] Examining this densely embellished jar in a museum in the twenty-first century, we can discern easily the relationship of the individual details to the whole, but are left wondering what the stylistic features conveyed to contemporaries when it was first made. What did the figural scenes mean for viewers then? Different social positions and life experiences would have shaped how people interpreted the meanings of the decor, but in what ways? Where would people have seen and used this jar? Although certain object types would have been seen primarily in private settings by members of elite social status groups, this jar might well have been used in a public setting such as a tavern, where its scenes of inebriation might have enhanced the customers' enjoyment of their drinks.

Would this jar have been used in an upscale establishment, or a more modest one? It would have been relatively inexpensive. However, there is insufficient evidence to argue that such jars were never used in elite restaurants, and in any case, it seems likely that privileged people might have lowered their standards on occasion to patronize run-of-the mill taverns. The people who made and used such a jar did not exist in perfectly circumscribed social and cultural environments. Rather, while each Ming dynasty person would have brought different perspectives to the act of looking at this jar, each would have shared some of the same visual culture with most others of the same period. This principle would apply not only to the commercial decor of a tavern, but also to murals and icons in temples and monasteries. These and other situations created opportunities for partially overlapping cultural practices.

Before proceeding, we should consider how social status was determined in China. Very briefly, it should be noted that though status changed over time, elite status was long linked with holding an office in the government bureaucracy. By the period relevant to the jar analyzed here—the fourteenth through the sixteenth centuries—the examination system that was employed to select government officials was well-established and open not only to men whose families were land owners, but also to those with a mercantile background.[4] This evolving examination system contributed to social mobility and to a pool of educated men that exceeded the available number of government positions.

In this essay, the phrase "elite social status" is not limited to the families of men holding office, but includes people belonging to families of well-educated men working in a variety of professions. The other broad social status group to which I refer lies between this elite and the illiterate, poor masses; it constitutes a kind of middle class. The social status of women was determined primarily by that of their

fathers and husbands. During this period, in China as in Europe, women did not enjoy the rights and career options of more recent eras. Thus, their opportunities to see things in public places depended greatly on their respective social statuses. Elite women would not have circulated in taverns, but female entertainers would have worked there. Some elite women were quite well-educated, and a few were highly regarded as authors, artists, and religious mentors.

In using the expression *common culture* in the title of this essay, I do not mean to suggest that certain cultural practices at a given time were shared fully by all, despite significant social differences—status, gender, generation, and regional affiliation. Instead I mean to emphasize that there were partially shared aspects. These aspects merit scholarly attention because they provide pertinent clues regarding practices that might have promoted some degree of social cohesion. How did diverse cultural practices affirm some areas of commonality, while simultaneously articulating socially significant distinctions?

Pictorial decor is only one aspect of the visual and tactile experience of ceramics, but it is the feature most amenable to my interest in reconstructing how people in the past looked at ceramics and connected them to other cultural objects and practices. When looking at Chinese ceramics with figural subject matter displayed in museums or reproduced in books, one is often frustrated by the unsatisfactory but common descriptions—"figures and buildings" or "figures in landscapes." Some examples of such pottery decor combine images with texts; however, most do not. Instead, ceramic decor usually relied on visual codes that were commonly understood at the time and could communicate even to people who lacked textual literacy. Art historians continue to strive to reconstruct the gestures, sartorial clues, and visual indicators of popular stories that helped identify famous cultural icons.

Although identifying a theme or cluster of themes decorating a ceramic object can prove challenging, it is only part of the process of reconstructing the visual codes operating when the object was first made, viewed, and used. Other research strategies include looking at stylistic features in the execution of each detail and in the ways various elements are related within different segments of the overall decorative program. What might those visual traits have communicated at that time? What expectations were set up by the function of the object and the desires of those who originally would have purchased it? The following section demonstrates some strategies for seeking plausible answers to such questions, using a Ming dynasty Cizhou-type stoneware jar as a case study.

A Ming Dynasty Cizhou-type Stoneware Jar

The overall decorative program on this jar features three gentlemen, two of whom (Figs. 1a-1b) look less intoxicated than the third (Fig. 1c). A somewhat similar approach had been employed earlier in the decor for a Song dynasty stoneware vase (*meiping*); however, each figure here embodies an obviously different stage of inebriation.[5] I am not suggesting that the Ming jar was inspired by the Song vase, but rather that the practice of portraying different stages of intoxication was probably part of the popular visual culture associated with the consumption of wine and that this motif appears over many centuries in different parts of China.

In this Ming example, a noteworthy feature is that the three inebriates are identifiable historical figures. Li Bai (701-762) is depicted lounging on the ground near wine implements on a moonlit evening (Fig. 1a), Tao Yuanming (365-427) is indicated by the inclusion of his beloved chrysanthemums (Fig. 1b)**,** and Bi Zhuo (active ca. 320s) is shown sleeping near two huge jars of wine (Fig. 1c). Bi Zhuo is best known for anecdotes regarding his drunken behavior; he was an official who served in the government of the Eastern Jin dynasty (317-420).[6] Tao Yuanming, who lived later during this dynasty, left a far greater legacy. After sporadic government service in low-level positions, he chose to retire to the family farm, despite the resulting sharp reduction of income. His ability to articulate his personal feelings and values in plain poetic language gained him widespread admiration centuries after his death.[7] Like Tao, Li Bai achieved an enduring reputation as one of the most revered poets in the history of Chinese literature. A flamboyant figure, Li enjoyed a brief period of favor at court during the Tang dynasty (618-907), largely due to his poetic genius and unfettered behavior.[8]

For each scene on the jar, I shall first demonstrate how the primary subject can be identified, despite the absence of any text, by noting attributes typically associated with each man. I shall also discuss the decor in relation to relevant art objects made in diverse media for different social status groups and refer to pertinent literature written in vernacular as well as in classical Chinese. It is necessary to make use of all of these approaches in order to situate the pictorial decor on this jar within the broader culture to which it once belonged.

Li Bai's identity (Fig. 1a) is indicated by his scholar-official attire and by the moon, shown both as an orb backed by a cluster of auspicious clouds in the sky and as a circle against stripes, signifying rippled water. The renowned poet's relaxed pose as he leans back on one arm suggests a state of intoxication conducive to congenial companionship with the moon, for which he was renowned, and is in keeping with his self-proclaimed status as an Immortal in Wine.[9] Li's poetry laid the foundations

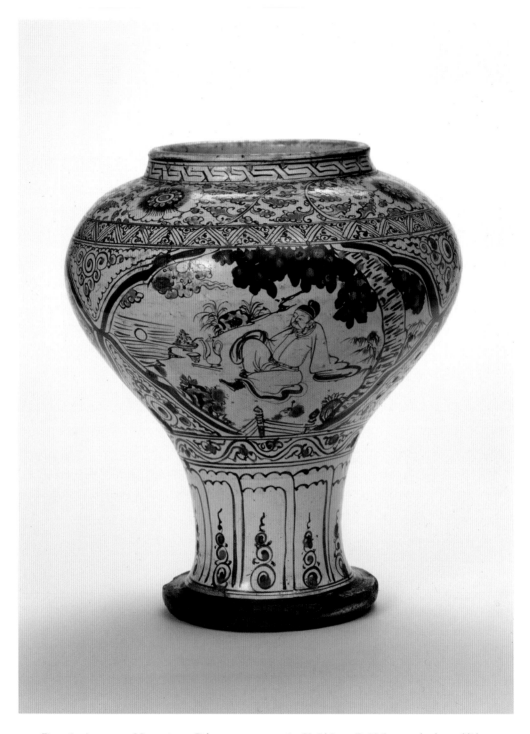

Figure 1a. Anonymous Ming artisans, Cizhou-type stoneware jar, H. 34.3 cm, D. 28.6 cm, underglaze reddish-brown and black on white slip, view of Li Bai. San Francisco, Asian Art Museum, B60P166.

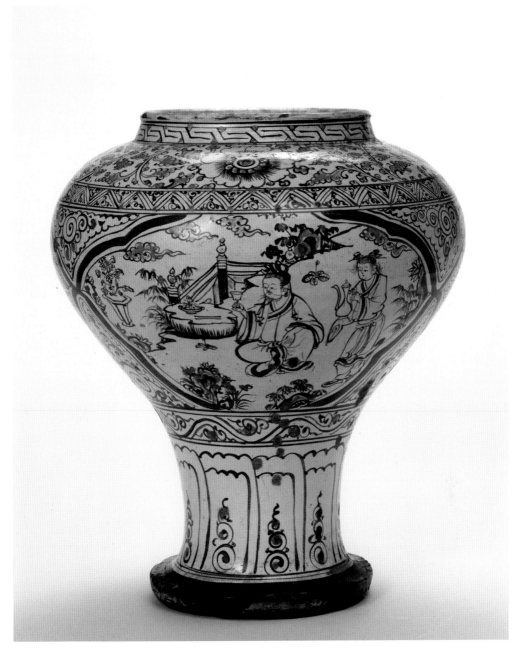

Figure 1b. Anonymous Ming artisans, Cizhou-type stoneware jar, H. 34.3 cm, D. 28.6 cm, underglaze reddish-brown and black on white slip, view of Tao Yuanming. San Francisco, Asian Art Museum, B60P166.

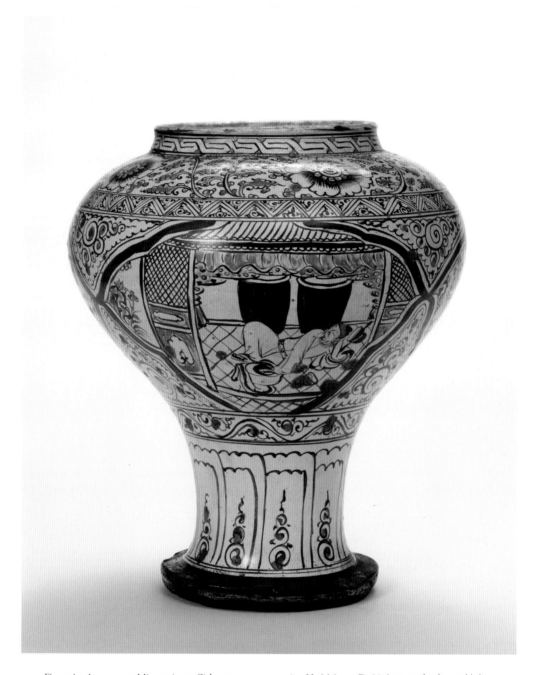

Figure 1c. Anonymous Ming artisans, Cizhou-type stoneware jar, H. 34.3 cm, D. 28.6 cm, underglaze reddish-brown and black on white slip, view of Bi Zhuo. San Francisco, Asian Art Museum, B60P166.

for many images of him toasting the moon, yet here he does not do so. There is a dynamic quality to the sketchy delineation of his clothing, especially in the swirling lines employed for his long sleeves, that reinforces his identity as a free spirit. A few lines for a railing in the foreground suffice to demarcate a private realm of natural beauty.

The potter-painter cleverly adapted features fostering the illusion of pictorial depth to the bulging shape of this section of the jar and to the picture's irregular frame by exaggerating the curving sweep of a tree trunk—a device which also focuses attention on the drunken poet. Amidst the clouds, the conventional schema denoting a constellation—a set of smaller circles connected by lines—provides a clear code indicating evening. Although this schema had long been used in various artistic media to specify night time and to identify Taoist stellar beings, it was rarely employed in elite Ming paintings.[10]

By the Ming dynasty, stories about Li Bai were widely known. These developed first in association with commemorative sites dedicated to him, but spread during the Yuan dynasty due to the development of versions popularized in the performing arts. In the same era a few surviving Cizhou-type stonewares portrayed him or featured his poems in their calligraphic decor.[11]

In the next figural scene (Fig. 1b), a gentleman wearing the cap of a recluse toasts a vase of chrysanthemums, which also grow in clumps nearby. The additional reddish-brown color enriching the palette for this jar accentuates these flowers, whose presence suffices to signal that this inebriant is Tao Yuanming, well known for his love of both chrysanthemums and wine. The same gesture occurs in a more elaborately detailed portrayal of this poet on a Yuan dynasty fan painting (Fig. 2).[12] Perhaps the choice to use this established gesture for identifying Tao influenced the decision to employ a different one for Li Bai, even though he was often shown toasting the moon. As depicted on the Ming jar, neither of these renowned poets manifests excessively drunken behavior. Rather, each appears to be in tune with his environment, especially the particular natural object with which he reputedly felt a strong kinship.

Three auspicious rust-red clouds hover in the garden sky as if pointing to Tao Yuanming, while a fourth draws attention to the boy holding the wine ewer, while simultaneously echoing the nearby ogival frame (Fig. 1b).[13] Here these clouds occur as distinct shapes rather than as part of a unified formation. This un-massed type had long been associated with portrayals of dragons, phoenixes, and other numinous beings in murals and decorative objects.[14] In Cizhou-type wares, the incorporation of this particular type of isolated cloud-form into figural compositions

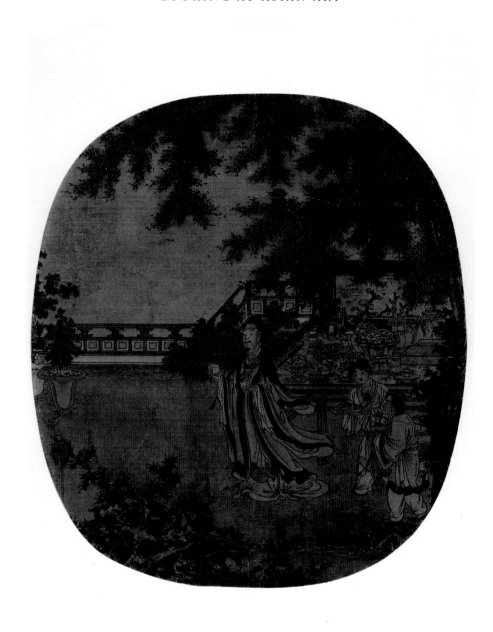

Figure 2. Anonymous Yuan, *Reciting Poetry*, fan, ink and colors on silk, Beijing, Palace Museum, reproduced from *Yuan ren hua ce* (Beijing: Wenwu Press, 1959), Vol. 1.

was more common during the Ming dynasty than in earlier periods, and is found on objects decorated with Confucian as well as Taoist themes.[15] Although the repetition of these special cloud forms does not enhance the illusionism of the painted scene on this jar, it does impart an auspicious aura to the portrayal of Tao, a multivalent poet-icon open to Confucian and Taoist interpretations.[16] In some contexts, the inclusion of auspicious clouds would have held serious religious or political significance. However, the appearance of such signs in two scenes on this jar probably conveyed felicitous wishes to enjoy drinking as much as Tao Yuanming and Li Bai and to achieve the contented, unfettered states of mind associated with each poet's persona.

By the Ming dynasty, even people of modest means and limited degrees of textual literacy would have been familiar with stories about Tao Yuanming. Back in the Yuan dynasty, vernacular lyrics and Northern musical dramas had helped to popularize the poet. For example, in a quartet of vernacular lyrics, Grand Guardian Liu employs four cultural figures as tropes for the proper enjoyment of the four seasons, with Tao exemplifying the appreciation of autumn.[17] Anonymous verses decorating Cizhou-type ware pillows during the Jin and Yuan dynasties referenced Tao in association with drinking, chrysanthemums, and the simple pleasures enjoyed by a recluse farming a modest family plot.[18]

Portrayals of renowned inebriates on objects used to create an ambiance for the consumption of wine were not confined to the social stratum that purchased Cizhou-type wares. For example, during the fifteenth century some wealthy people enjoyed drinking from cups with pictures illustrating Tao Yuanming's fondness for chrysanthemums and wine, as can be seen in an extremely fine porcelain cup adorned in underglaze blue joined with overglaze enamel colors (*doucai*), which has an imperial Chenghua (1465-1487) reign mark and date (Fig. 3).[19] In this instance, the underglaze blue is carefully coordinated with the overglaze yellow for the flowers in a manner evocative of minimally colored paintings. Pale blue tones were applied on areas of plain white porcelain to appear like an ink wash on paper. This subtle effect was reinforced by the potter-painter's judicious use of select blue lines for some bamboo, flowers in pots, and the boy presenting chrysanthemums to Tao. On this very small cup, the absence of the auspicious cloud forms employed on the stoneware jar (Fig. 1b) simultaneously humanizes Tao and enhances the illusion of space. The sparse subtlety of the porcelain cup's pictorial decor is quite different from the crowded composition favored by the artisan decorating the stoneware jar, yet both of these roughly contemporary vessels enabled the drinkers who used them to claim an affinity with the same renowned recluse.

Figure 3. Anonymous Ming artisans, porcelain cup painted in underglaze blue and overglaze enamel, with a Chenghua (1465-1487) mark and date, H. 4.5 cm, D. 7.5 cm. Taibei, National Palace Museum, Taiwan, Republic of China.

One more historical figure adorns the Ming stoneware jar (Fig. 1c). The image of the man dozing drunkenly in front of two huge wine jars recalls a story about Bi Zhuo, who was said to have helped himself to some liquor in a neighbor's storehouse one night. The watchman who caught and tied him up did not discover the distinguished identity of the thief until daylight. Upon awakening, Bi Zhuo was completely nonplused and further manifested his unconventional behavior by inviting the owner to join him in drinking more wine right there in the storehouse. The story was recounted by He Fasheng (fifth century) in a book covering the Eastern Jin dynasty.[20] It circulated more widely in Li Han's (eighth century) book, augmented by Xu Ziguang (twelfth century) in one of the pairs of accounts about various men and women selected for their educational value. Each person was encapsulated in a terse characterization such as: "Bi Zhuo beneath the wine-jars (*Bi Zhuo wengxia*)," precisely the scene selected for this Ming stoneware jar.[21] In a mid-thirteenth-century literary encyclopedia, this story was recounted under

the subtitle, "Drinking stolen wine beneath the jars (*daoyin wengxia*)" under the category "Extreme Drinking (*juyin*)" in the section on wine.[22] The cultural habit of terse verbal encapsulations of significant events associated with famous historical figures probably facilitated the decoding of depictions of them, in the absence of identifying texts. It is also possible that those creating such concise verbalizations had drawn inspiration from earlier abbreviated visual characterizations that have not survived.

In the portrayal on the Ming jar, Bi Zhuo appears alone, dozing in front of two large black wine jars. His outer scholar-official cap has fallen off and a wine cup has been knocked over. As with the terse four-character references to this story, the focus is entirely on him: no watchman ties him up, nor is the owner of the storehouse present. His pose and the brushwork rendering it convey a fluid, languid quality. Unlike the other two outdoor scenes decorating this jar, here the storehouse is the primary setting with only a glimpse of a garden to one side. In portraying the tiled storehouse with its latticed doorways, the potter-painter used an established convention which minimized the illusion of three-dimensional space.[23] Especially in the case of the tiling, the lack of any foreshortening makes the "floor" appear to be a flat surface comprised of interlocking diamond patterns directly beneath the blank "wall." The floor's lack of recession is thus at odds with the delineation of the dozing drunkard, whose bodily form actually suggests some solidity and depth.

In many elite paintings, there is no indication of floor tiling at all, although in some detailed court paintings and temple murals, this type of information is provided. In many but not all such paintings, the artists foreshortened the tile patterns to some degree and also endeavored to make the lines parallel to those of the foreshortened buildings and furnishings.[24] The very flat interlocked diamond pattern used for the flooring in the storehouse scene on the Ming jar was more common in contemporary book illustrations printed from carved wood blocks.[25] These comparisons establish the larger visual culture to which this pictorial image belongs. However, they do not provide close parallels for the way the potter-painter positioned the flattened architectural elements so close to the viewer of this jar. Other artisans decorating Cizhou-type wares during the fourteenth to sixteenth centuries also minimized pictorial depth in figural scenes, a tactic which creates a sense of close proximity to the portrayed subjects while simultaneously harmonizing well with the flatness of adjoining areas of decorative patterns.[26]

The potter-painter decorating this Ming jar with three figural scenes appears to have adapted visual "phrasing" commonly used in different media serving a wide array of functions. Areas of fluently modulated brush strokes along with some

features of the compositions evoke painting traditions, but other stylistic features and visual codes occur more commonly in the decorative arts and in printed book illustrations. Within painting traditions, the closest parallels to the stylistic repertoire of this Ming jar occur in extant murals for tombs and temples. Therefore, it would appear that this jar's decor was part of a common culture that valued a visual shorthand which was easily understood and readily rendered in different artistic media, including expensive ones.

The subtle conventions associated with elite paintings of the Song through the Ming dynasties stand in contrast to visual schemata commonly used for other pictures, at least until the end of the Ming period.[27] Viewers of this jar who lacked exposure to art works made for the elite would have recognized visual conventions frequently seen in art works open for public viewing. They would probably have learned anecdotes about its three featured inebriates from oral lore performed in public settings. Elite viewers would have had a wider range of visual and literary culture with which to compare the scenes on this jar. They would have recognized shared elements in the different versions, while also noting differences that connoted social distinctions.

I have been comparing specific visual codes present in the three figural scenes on the jar with similar features present in many media, including murals, in order to call attention to common visual conventions. Now I would like to propose a more direct relationship by suggesting that the potter-painter adapted imagery from Ming tavern murals to the smaller scale and curved surfaces of this jar, and that viewers probably associated its decor with such public art. It is difficult to envision such murals, because none have survived. However, the clear visual codes seen in extant religious murals and Ming Cizhou-type wares were presumably also employed in secular commercial establishments. Fictive accounts of tavern scenes suggest that famous drinkers were often mentioned in such contexts and that wine-shop decor utilized the cachet of renowned drinkers to boost business. For example, a short reference in a Yuan Northern musical drama implies that Li Bai, the Immortal in Wine, was well-known to tavern habitués. The reference occurs in a dialogue between the waiter and Lü Dongbin, one of the Eight Taoist Immortals, who was mingling with mortals incognito.[28] Some poems in the 120-chapter variorum edition of *Story of the Water Margin* (*Shuihu zhuan*) mention tavern murals portraying Li Bai, Liu Ling (d. ca. 265), Tao Yuanming, and other famous wine drinkers in various combinations.[29]

Famous historical figures were appropriated for depiction in taverns and occasionally grouped without regard to the fact that they lived at different times.

In such lost murals and on this Ming stoneware jar, what would have been the effect of such groupings? If each scene on the jar is considered in relation to what is known about the man, then it is evident that his drunken persona is only a part of what he came to mean to later generations. This is especially true in the cases of Tao Yuanming and Li Bai, who left influential literary works and who were portrayed and discussed by many later Chinese. Considering the three scenes decorating the jar in conjunction, the theme of inebriation is reinforced through both repetition and variation.

Roughly comparable examples from elite practices may shed some light on the significance of such groupings. For example, Lou Yue (1137-1213) once saw a handscroll belonging to Gao Wenhu (*jinshi* 1160, 1134-1212) entitled *Picture of the Six Unfettered Ones* (*Liuyi tu*) in which men from different eras were selected to embody six qualities associated with the over-arching theme of being unfettered. Su Shunqin (1008-1048) had written the Chinese words for these six qualities, which Lou recorded along with the short titles for the paintings of each exemplar. According to these titles, the six men's innate characters were not all epitomized by their drinking behavior. However, two of these figures were and they are both relevant to the decor of the Cizhou-type Ming jar. Straining wine with his kerchief, Tao Yuanming embodied delight (*le*), whereas Bi Zhuo, dozing beneath wine jars, exemplified an unfettered state of being (*yi*).[30] A grouping of people from different eras can create new meanings, because it makes quite clear that there are reasons other than a shared time frame for doing so. In the elite handscroll, the titles for each figural scene encapsulated some episode associated with each of the men, whose import was then reduced to a single quality conveyed by one word. Seemingly very abstract, this quality or character trait gains a vivid presence when embodied by a famous person, as visualized by an artist.

Without the written characters for these words, the qualities embodied in each figure would have been more open to various interpretations. For example, I have cited textual evidence indicating that Bi Zhuo could exemplify an unfettered state of being, but also extreme consumption of alcohol. When the Cizhou-type Ming jar was made and seen, most people would have recognized some, if not all, of the historical men portrayed in the figural scenes. However, there was not one fixed meaning attached to each man. The overall intention seems to have been to enable contemporary users to associate themselves with various styles of drinking as exemplified by the three famous men. The people who contributed to the earlier handscroll probably felt that their episodes of wine drinking had a spiritual dimension beyond the capacities of their social inferiors, whom they saw as

simply becoming drunk, whereas they attributed to themselves a nobler motive—fostering the unfettered freedom and spontaneity of talent so prized in Taoism. The fact remains, however, that elite cultural practices sanctioned the celebration of renowned tipplers and facilitated their appropriation by other social groups.

Conclusion

The Cizhou-type stoneware jar discussed in this essay was an ordinary object, but its decor provides visible traces of contemporary cultural practices that were shared to some extent with those who could afford and appreciate more exclusive things. A comparison of aspects of the pictorial decor of this jar with relevant texts and other images provides a means for exploring evidence of what Evelyn Rawski describes as "cultural integration and differentiation" among different social status groups.[31] However, analysis of these two interrelated social practices poses many challenges to conceptual frameworks, as she and others noted in a groundbreaking book of essays entitled *Popular Culture in Late Imperial China*. Although two decades have passed since the publication of this book, many of the authors' insights remain relevant. David Johnson noted that simple definitions of "popular" and "elite" culture are problematic due to the existence of many different social status groups, each inflected by gender roles and subject to upward and downward social mobility.[32] Yet as shorthand terms, they remain useful and are commonly employed. The intended market for Cizhou-type wares such as the jar examined here occupied an intermediary social position. It probably consisted primarily of farming and mercantile families of moderate means who could read simple texts in vernacular and classical Chinese, who could afford tombs and moderately priced ceramics, who attended dramas and heard vernacular lyrics sung at taverns, and who saw murals in various publicly accessible buildings.[33]

When historians of China examine the factors that foster social cohesion, they often stress the agendas and roles of the well-educated elite, as private persons and as government officials, in propagating cultural norms advantageous to their own privileged social group and to the state.[34] Yet as Rawski notes, these elite efforts to promote social norms succeeded in part by accommodating and incorporating diverse non-elite traditions.[35] Members of the highly educated elite were sometimes outraged by unauthorized appropriations of historical figures they claimed for their own cultural practices.[36] However, the authorities and self-appointed moralizers could not control all of the cultural practices of people belonging to lower social status groups. Other members of elite social status groups probably concluded that

appropriations of elite culture such as that seen in the pictorial decor of the Ming Cizhou-type stoneware jar were relatively harmless, and some probably even found them to be entertaining. Some members of the educated elite engaged with aspects of popular entertainment culture, both during the Yuan, when Mongol rule limited opportunities for well-educated Chinese men to serve in the government, and also during the late Ming, when the intensified pace of commercialization provided employment opportunities for the many educated men not incorporated into the bureaucracy.[37]

One result of these ongoing interactions among different social status groups is that many complex systems of thought existed in what Johnson has called "variations" or "different versions." In his opinion, "The principal beliefs and dominant ideas . . . were always formulated and transmitted in ranges of related texts (oral and written), from peasant proverbs and tales to learned treatises and sophisticated narratives."[38] Although it is helpful to recognize that the coexistence of these different "versions" manifests both cultural integration and differentiation, there is no valid reason to limit this insight to related texts.[39] Different versions in the visual arts—best exemplified here by the three portrayals of Tao Yuanming (Figs. 1b, 2, and 3)—affirm significant differences in terms of their stylistic features, while also revealing some shared aspects in terms of how this cultural icon was portrayed and utilized by people from different walks of life. In studying eras when many people had limited or no textual literacy, it is especially important to look for common aspects of culture in the visual arts. Relatively inexpensive ceramics merit greater attention, especially types manifesting links with religious practices and popular forms of literature.[40]

Cultural integration and differentiation were mutually implicated in human efforts to maintain social harmony in a hierarchical but socially mobile environment. Exploration of a broad cultural context potentially relevant to the three figural scenes depicted on the Ming dynasty Cizhou-type ware jar helps identify the three historical men and suggests a range of meanings possibly associated with their drinking activities. A comparison of stylistic features and visual conventions evident in these three scenes with ones utilized in a wide range of media helps viewers today to decode the visual clues and to discern their social status implications in Ming dynasty China. When wealthier, better educated viewers of that era applied relational looking to the decor of this jar, they would have noted it lacked characteristics signaling the exclusivity of elite taste. However, they would also have acknowledged that the decor's thematic and stylistic features bore some relation to their values and tastes. When viewers possessing more modest educations related

the figural scenes on this jar to other aspects of their cultural experiences, they would have found affirmations of their positions within a shared culture fostered through public visual culture including public murals, public performances, and relatively inexpensive objects such as this exuberantly decorated jar.

Endnotes

1. I wish to dedicate this essay to the memories of Father Harrie Vanderstappen, Ms. Mali Edmonds, and Dr. Geri Fuller. Father Vanderstappen inspired me to study Chinese art and trained me to look closely at art works. The two friends and fellow students taught me much about art history and life. I would also like to convey my gratitude to Professor David Roy, University of Chicago, who remains my valued mentor; and to the many curators and other staff at the National Palace Museum, Taibei, whose support over the years has assisted various research projects, not just this one. I am also indebted to Ms. He Li, associate curator of Chinese art at the Asian Art Museum, San Francisco, for her assistance.

2. These wares were made not only in kilns in Ci county (formerly Cizhou) in Hebei, but also in ones in Henan, Shanxi, Shaanxi, and Shandong provinces. For a discussion of different uses of the terms Cizhou wares and Cizhou-type wares, see Regina Krahl, "Famous Brands and Counterfeits: Problems of Terminology and Classification in Song Ceramics," in *Song Ceramics: Art History, Archaeology, and Terminology*, Colloquies on Art & Archaeology in Asia No. 22, ed. Stacey Pierson (London: Percival David Foundation of Chinese Art, School of Oriental and African Studies, University of London), 67-69.

3. He Li, *Chinese Ceramics: The New Standard Guide*, The Asian Art Museum of San Francisco, No. 390 (London: Thames & Hudson, 1996), 183, 144. She refers to the shape both as an inverted pyriform vase and as a jar, and dates this example to the fourteenth-fifteenth centuries because it was at this time that dense parallel friezes framing a series of figural scenes became conventional for this vessel shape. She also says that all three scenes portray Li Bai; however, here I re-identify two of them. Yutaka Mino, *Freedom of Clay and Brush Through Seven Centuries in Northern China: Tz'u-chou Type Wares, 960-1600 A.D.*, exh. cat. (Indianapolis, MN: Indianapolis Museum of Art, 1980), 192-193, publishes two *guan* with fairly similar shapes and systems of decor, one of which is dated 1541; he notes that this shape is unique to this period. A closer comparison is a jar (*tsubo*, in Japanese) with underglaze black and brown decor published in *Charm of Black and White Ware: Transition of Cizhou Type Wares*, exh. cat. (Osaka: Osaka Municipal Museum of Art, 2002), cat. no. 100, 110, 183 [hereafter, Osaka, *Charm*], where it is dated to the Ming dynasty (fourteenth-fifteenth century) Jessica Harrison-Hall, *Catalogue of Late Yuan and Ming Ceramics in the British Museum* (London: The British Museum Press, 2001), 437-438, dates a Cizhou-ware arrow vase with somewhat similar decor in underglaze brown and overglaze enamel on a cream slip to the Jiajing era (1522-1566) based on similarities of the figural decor with that seen on some underglaze blue porcelains of that era in the British Museum.

4. For an excellent introduction to the history of China, see Patricia Buckley Ebrey, *The Cambridge Illustrated History of China* (Cambridge: Cambridge University Press, 1996). Her discussion of the examination system begins with the Sui dynasty (581-617), p. 112; for its importance during the Ming dynasty, see pp. 198-201. She also discusses women's lives, for example, pp. 158-161. See also Kathlyn Liscomb, "Social Status and Art Collecting: The Collections of Shen Zhou and Wang Zhen,"

Art Bulletin 78, No. 1 (1996): 112-136, which considers changes in the fifteenth century.

5. Song Liangbi, ed., *Guangdong sheng bowuguan cang taoci xuan* (Beijing: Wenwu, 1992), plate 67, 13, 170. This *meiping* with underglaze brown figural decor is dated to the Song dynasty and was found in a tomb at Lanshi, Foshan, Guangdong; similar fragments have been found at the Qishi kilns at Foshan. Each figure appears with a few wine implements on a plain ground within an ogival frame set off against wave patterns; above and below are bands of dense floral motifs. On this Song example the four figural pictures represent four different stages of intoxication. It is less clear that this is the case for the Ming jar; however, it also ends with a slumbering inebriate. It should be noted that *meiping* probably served as jars for wine; however, the translation as vase is quite common and makes it easier here to differentiate this category in English from *guan*, usually translated as jar.

6. Zhongwen da cidian bianzuan weiyuanhui, comp., *Zhongwen da cidian*, Vol. 6 (Taibei: Zhongguo wenhua xueyuan chubanbu, 1980), 674-675, s.v. Bi Zhuo (citing Fang Xuanling (578-648), *Jin shu*, *juan* 49). His government position circa 320 was that of *libu lang*; that is, he served as the director of the Personnel Section of the Imperial Secretaries. See Charles O. Hucker, *A Dictionary of Official Titles in Imperial China* (Stanford: Stanford University Press, 1985), nos. 3563, 3565, 3630, 3632.

7. See William H. Nienhauser, Jr., ed. and comp., *The Indiana Companion to Traditional Chinese Literature*, second revised ed., Vol. 1 (Bloomington: Indiana University Press, 1986), 766-769, s.v. T'ao Ch'ien, for editions, translations, and studies of his poetry. See also Kang-i Sun Chang, "T'ao Ch'ien—Defining the Lyric Voice," in ed. Sun Chang, *Six Dynasties Poetry* (Princeton: Princeton University Press, 1986), 3-46. Tao's personal name originally was Yuanming, but was later changed to Ch'ien, also spelled as Qian. Both names are commonly used.

8. See Nienhauser, Jr., *The Indiana Companion,* 549-551, s.v. Li Po, for editions, translations, and studies of his poetry. See also Paula M. Varsano, *Tracking the Banished Immortal–The Poetry of Li Bo and Its Critical Reception* (Honolulu: University of Hawai'i Press, 2003). The variety of spellings for this poet's name is due to changes in pronunciation over time and also to different systems for spelling the sounds of Chinese characters. I have chosen to use the modern pronunciation for his personal name, Bai, and to use the pinyin romanization system.

9. Li Bai's self-appellation occurs in a song by Du Fu (712-770), "*Yin zhong baxian,*" in *Du shi xiangzhu*, annot. Qiu Zhao'ao (Qing dynasty), (Beijing: Guangwen shuju, 1955), Vol. 1, *juan* 2, 1a-4a (219-225). For Li's poetry about his congenial relationship with the moon, see for example Li Bai, "Yue xia du zhuo si shou," in *Li Bai ji jiaozhu*, Vol. 2, ed. and annot. Qu Tuiyuan and Zhu Jincheng (Shanghai: Guji chubanshe, 1980), 1331-1335. For translations, see Elling Eide in *Classical Chinese Literature: An Anthology of Translations*, Vol. 1: *From Antiquity to the Tang Dynasty*, ed. John Minford and Joseph S. M. Lau (New York: Columbia University Press and Hong Kong: Chinese University Press, 2000), 740-742; and Stephen Owen, *An Anthology of Chinese Literature: Beginnings to 1911* (New York: W. W. Norton & Company, 1996), 403.

10. The constellation schema was employed in Han dynasty tomb murals; see Yang Xin *et al.*, *Three Thousand Years of Chinese Painting* (New Haven: Yale University Press, 1997), pl. 19 (part of the celestial sphere). For its use on silver, see *Chinese Porcelain and Silver in the Song Dynasty*, J. J. Lally and Co., Oriental Art, March 18 to April 8, 2002, cat. no. 18, especially the detail inside the back cover. Such metalwork may have inspired ceramic examples. See S. J. Vainker, *Chinese Pottery and Porcelain, from Prehistory to the Present* (London: British Museum Press, 1991), fig. 72 (Song, Ding ware porcelain). For lacquer examples, see Nishida Hiroku et al., *Sō Gen no bi: Ten rai no shikki wo chūshin ni*, exh. cat. (Tokyo: Nezu Institute of Fine Arts, 2004), no. 82 (also on the cover), no. 130. Wen C. Fong and James C. Y. Watt, *Possessing the Past: Treasures from the National Palace*

Museum, Taipei, exh. cat. (New York: The Metropolitan Museum of Art and Taibei: The National Palace Museum, 1996), pl. 133 (for a Song portrayal of a textile), and fig. 121 (a constellation in an imperial insignia). For examples in Taoist ritual contexts, see Stephen Little with Sean Eichman, *Taoism and the Arts of China,* exh. cat. (Chicago: The Art Institute of Chicago, 2000), pls. 58, 60, 112. For examples in woodcut illustrations, see Julia Murray, *Mirror of Morality: Chinese Narrative Illustration and Confucian Ideology* (Honolulu: University of Hawaii Press, 2007), fig. 70 (sixteenth century, Confucian miracle); and Robert Hegel, *Reading Illustrated Fiction in Late Imperial China* (Stanford: Stanford University Press, 1998), fig. 4.5 (ca. 1250, temple charms) and fig. 4.9 (1498 edition of *Xixiang ji,* a Northern musical drama).

11. For the poems, see Wang Xing, *Cizhou yao shici* (Tianjin guji chubanshe), 7, 111, 128; and Mino, *Freedom of Clay and Brush,* 189, fig. 221. Some poems were by him, others were imitations of his poems. See also Kathlyn Liscomb, "Li Bai Drinks with the Moon: The Cultural Afterlife of a Poetic Conceit and Related Lore," *Artibus Asiae* 70, No. 2 (2010): 365-369, especially figs. 6a-b and the section entitled "The Moon-Grasping Poet as Portrayed in Arts of the Yuan Dynasty."

12. For a color reproduction, see *Yuan ren hua ce* (Beijing: Wenwu Press, 1959), vol. 1; see also Susan Nelson, "Revisiting the Eastern Fence: Tao Qian's Chrysanthemums," *Art Bulletin* 83, No. 3 (2001): 452.

13. Some scholars identify this particular cloud shape with reference to a fungus of immortality (*lingzhi*), while others describe it in terms of "as you wish" (*ruyi*) scepters. The two were roughly related in terms of their shapes and auspicious associations, although the fungus refers more specifically to longevity or immortality. See Guting shuwu, comp., *Zhongguo jixiang tu'an* (Taibei: Zhongwen tushu, 1987), Nos. 1, 2, 23, 53. See also C. A. S. Williams, *Outlines of Chinese Symbolism and Art Motives,* 3rd revised ed. (New York: Dover Publications, Inc., 1976), 238-239, 328-330, s.v. "Joo-i" and "Plant of Long Life," respectively.

14. For tomb murals, see, for example, Yang Xin *et al.*, pl. 34 (ca. 570, above zodiac animals); and *Zhongguo meishu quan ji bianji weiyuanhui,* comp., *Zhongguo meishu quan ji, Huihua bian,* Vol. 12: *Mushi bihua* (Beijing: Wenwu, 1995), pl. 139 (Song dynasty, near birds and a peony), pl. 171 (Liao dynasty, near dragons) and pl. 175 (Liao, near a phoenix and a woman). Fong and Watt, *Possessing the Past,* pls. 65, 127, 133 (for textiles and portrayals of them); and pls. 219, 225 (for ceramics).

15. The isolated auspicious cloud type occurs on the following Ming Cizhou-type wares: a pillow with filial piety scenes (Suzanne Wright, "Six Cizhou-type Ceramic Pillows," *Orientations,* No. 11 (November 1989), fig. 6a-b); an arrow vase with portrayals of the god of longevity and Eight Taoist immortals (Harrison-Hall, *Catalogue of Late Yuan and Ming Ceramics,* No. 14:6); and a *guan* with proportions similar to the one discussed here, decorated with a scene of a crane and one of a man standing near a shore (Osaka, *Charm,* fig. 99, and in *Tōkyō Kokuritsu Hakubutsukan zuhan mokuroku Chūgoku kotoji hen* (Kyoto: Benrido, 1965), 78, no. 322 (where it is dated as Yuan)). In earlier Cizhou-type wares, this type of cloud shape usually occurs near numinous animals with no setting, for example, in Mino, *Freedom of Clay and Brush,* pl. 15, figs. 65, 67, 196-197, 273. Less typically it occurs as an isolated sign as part of a developed pictorial setting. For examples on Jin dynasty pillows, see Zhang Ziying, comp., *Cizhou yao cizhen* (Beijing: Renmin meishu chubanshe, 2000), pl. 39 (from the mouth of a tortoise accompanying Zhao Bian), pl. 41 (one near a tiger in a landscape), and pl. 43 (above a leaf floating near a recluse/immortal). Special clouds and other auspicious signs also occur sometimes in more elite artistic media in connection with Confucian arts. See, for example, Murray, *Mirror of Morality,* pl. 21 (painting, probably early sixteenth century) and figs. 69, 70 (woodblock-printed album, sixteenth century)

16. For example, Susan Nelson, "What I Do Today Is Right," *Journal of Sung-Yuan Studies*, No. 28 (1998): 30-60 (for Confucian interpretations) and Susan Nelson, "Tao Yuanming's Sashes, or, the Gendering of Immortality," *Ars Orientalis* 29 (1999): 1-27 (for Taoist interpretations).

17. Yang Chaoying, comp., fourteenth century,, reprinted with collation by Sui Shusen as *Xinjiao jiu juan ben Yang chun bai xue* (Beijing: Zhonghua shuju, 1957), 17-18.

18. Wang Xing, *Cizhou yao shici*, 71 (a *yongwu* verse about chrysanthemums on a Jin-dynasty pillow), and 90 (a lyric on a Yuan-dynasty pillow). The poets are anonymous.

19. Fong and Watt, *Possessing the Past*, 443, pl. 239 (a color plate) and *Guoli gugong bowuyuan*, comp., *Ming Chenghua ciqi tezhan*, exh. cat. (Taibei: National Palace Museum, 1977), fig. 40 (which also reproduces the Chenghua reign mark).

20. He Fasheng, (*Jin*) *Zhongxing shu*, in *Guangya congshu*, comp. Tang Qiu, *tao* 82, *juan* 7, 10b.

21. Li Han, augmented with Xu Ziguang's notes, *Mengqiu ji zhu* in *Xuejin taoyuan*, *Baibu congshu jicheng*, comp. Yan Yiping, Vol. 103 (Taibei: Yiwen yinshuguan, 1965), *juan* 1, 46b-47a; the relevant passage has been translated elsewhere by Burton Watson in *Meng Ch'iu: Famous Episodes from Chinese History and Legend* (Tokyo: Kodansha International Ltd., 1979), 125-126.

22. Xie Weixin, comp., *Gujin hebi shi lei beiyao*, ca. 1257, facs. of a 1556 ed. (Taibei: Xinxing shuju, 1969), 1995 (*juan* 44, 11a-12a).

23. For portrayals of similar-looking buildings, see Hegel, *Reading Illustrated Fiction*, fig. 4.9 (a 1498 woodcut print); and Murray, *Mirror of Morality*, pl. 21 (a sixteenth-century painting), and fig. 69 (a sixteenth-century woodcut print).

24. For some examples of portable-format paintings where tiling is portrayed, see Zhongguo gudai shuhua jianding zu, comp., *Zhongguo huihua quan ji* (Beijing: Wenwu, 1997-), Vol. 4: pls. 27-29 ; Vol. 5: pls. 80-85 [S. Song]; and Vol. 10, pl. 163 [fifteenth century]. For examples of this in Ming temple murals, see Zhongguo meishu quan ji bianji weiyuanhui comp., *Huihua bian*, Vol. 13: *Siguan bihua*, pls. 150, 173, 176, 178.

25. For examples in printed books of the bird's-eye view of interlocked diamond shapes, see Hegel, *Reading Illustrated Fiction*, fig. 4.3 (1215) and 4.14 (1472), but see also figs. 4.31 (Yuan) and 4.9 (1498) for more foreshortened portrayals of tiling.

26. See for example Wright, "Ceramic Pillows." fig 6a-b; Harrison-Hall, *Catalogue of Late Yuan and Ming Ceramics*, fig. 14.6; Mino, *Freedom of Clay and Brush*, pl. 84, fig. 231; Suzanne Valenstein, *A Handbook of Chinese Ceramics* 2nd ed. (New York: The Metropolitan Museum, 1989), fig. 140; and John A. Pope et al., *World's Great Collections of Oriental Ceramics: Freer Gallery of Art, Washington, D.C.* (New York: Kodansha, 1981), fig. 85. Some of these Cizhou stonewares employ overglaze colors to enrich the decorative effect.

27. By the late Ming, this would change, and it would be much more common for printed book illustrations and pictorial decor on porcelains to emulate elite, non-mural painting conventions.

28. Ma Zhiyuan, "*Yueyang lou*," in *Ma Zhiyuan ji,* Xiao Shanyin et al., ed. (Taiyuan: Shanxi guji chubanshe, 1993), 50.

29. Shi Naian and Luo Guanzhong, trad. attribs., *Shuihu zhuan*, collated ed. Zheng Zhenduo et al. (Beijing: Renmin wenxue press, 1954), ch. 9, 137 (for Li Bai and Liu Ling); ch. 29, 451 (for Liu Ling and Li Bai; with further references to Tao Yuanming and Wang Hong, who sent him wine; and Abbot Foyin and his friend Su Shi); and ch. 82, 493 (a rustic portrayal of the *Jiuxian shike* [Wine Immortal poetry guest], probably Li Bai). I am grateful to David Roy who informed me about these poems. The dating of the *Story of the Water Margin* is a complex matter due to different versions, but some extant printed editions date to the early sixteenth century, and its evolution seems to have stopped by the

mid-seventeenth century. Nienhauser, *The Indiana Companion*, 712-716, s.v. *Shui-hu chuan*.

30. Lou Yue, *Gongkui ji, Sibu congkan chubian* (Shanghai: Shangwu yinshuguan, 1929), *ce* 20, *juan* 77, 12a-b. Paintings of Tao straining wine through his kerchief are known from poems responding to them, and from some extant examples. For example, Yang Weizhen (1296-1370) "Inscribed on a Picture of Tao Yuanming Straining Wine," in *Yuan shi xuan xinji*, comp. Gu Sili (*jinshi* 1712), (Beijing: Zhonghua shuju/Xinhua shudian, 1987-2001), Vol. 1, pt. 3, 2037; and Susan Nelson, "The Thing in the Cup: Pictures and Tales of a Drunken Poet," *Oriental Art* 46, 4 (September 2000): figs. 12, 16, and 17.

31. David Johnson, Andrew J. Nathan, and Evelyn S. Rawski, eds., *Popular Culture in Late Imperial China* (Berkeley: University of California Press, 1985), 404 (Rawski).

32. Johnson et al., *Popular Culture*, 67-68 (Johnson). See also Stephen F. Teiser, "Introduction," in *Religions of China in Practice*, ed. Donald Lopez, Jr. (Princeton: Princeton University Press, 1996), especially 21-25, for additional problems with these terms.

33. For the target market for Cizhou-type wares, see Mino, *Freedom of Clay and Brush*, 9-14. For analyses of textual and pictorial themes that shed light on this market, see Wang Xing, *Cizhou yao shici*, 1-22; Ma Xiaoqing and Li Liucun, *Cizhou yao sixi ping* (Tianjin: Tianjin guji chubanshe, 2004), 8-9, 16-20.

34. Johnson et al., *Popular Culture*, 406-407 (Rawski) and 46 (Johnson); Anne E. McLaren, *Chinese Popular Culture and Ming Chantefables* (Leiden: Brill, 1998), 288-291 (although she notes modifications of elite orthodox Confucian values in Chinese chapbook culture); and Anne E. McLaren, "Constructing New Reading Publics in Late Ming China," in *Printing and Book Culture in Late Imperial China*, ed. Cynthia J. Brokaw and Kai-wing Chow (Berkeley: University of California Press, 2005), 152-183.

35. Johnson et al., *Popular Culture*, 407 (Rawski).

36. For example, Ye Sheng (1420-1474), *Shuidong riji*, in Wu Xiangxiang, chief ed., *Zhongguo shi xue congshu* (Taibei: Xuesheng shuju, 1965), *juan* 21, 11b-13a.

37. See for example Stephen West, "Mongol Influence on the Development of Northern Drama," in *China under Mongol Rule*, ed. John D. Langlois Jr. (Princeton: Princeton University Press, 1981), 465; and Chow Kai-wing, *Publishing, Culture, and Power in Early Modern China* (Stanford: Stanford University Press, 2004).

38. Johnson et al., *Popular Culture*, 71 (Johnson).

39. Johnson was clearly biased against nonverbal forms of communication, as can be seen in Johnson et al, *Popular Culture*, 34. Indeed the disciplines represented in this book of essays did not include art history or archaeology. However, social historians are increasingly paying attention to visual culture, as exemplified in his own later publications: Po Sung-nien and David Johnson, *Domesticated Deities and Auspicious Emblems: The Iconography of Everyday Life in Village China*, (Berkeley: Publications of the Chinese Popular Culture Project 2, 1992).

40. In addition to Cizhou-type wares, an important type as yet barely explored is a kind of celadon bowl made during the Ming which was decorated with figural decor inspired by various sources, including Gao Ming's *chuanqi*-type drama *Pipa ji*. See Zhejiang sheng qinggongye ting, Zhejiang sheng wenwu guanli weiyuan hui, and Gugong bowuyuan, comps., *Longquan qingci* (Beijing: Wenwu chubanshe, 1966), fig. 69, 4, 132. Some examples can be studied in relation to evidence about their owners. For example, Jiangsu sheng Huaian xian bowuguan, "Huaian xian Ming dai Wang Zhen fufu hezang mu qingli jianbao," *Wenwu*, No. 3 (1987): fig. 27, 1-15; and Kathlyn Liscomb, "A Collection of Painting and Calligraphy Discovered in the Inner Coffin of Wang Zhen (d. 1495 C.E.)," *Archives of Asian Art* 47 (1994): 6-34.

Amdo Rebdong *see under* Tibetan painting, landscape elements in early
Andersson, J.G. 27

Ban Dainagon ekotoba see Illustrated Scroll of Major Counselor Ban
Banpo 半坡 site
　basin with design of human face 24–6, *24*
　firing station 28
　pottery bottle (*ping* 瓶) 19–22, *20*, 32
Banshan 半山 site
　firing station 29
　funerary storage jar *26*, 27–8, *27*
Bi Zhuo 181, *184*, 188–9, 191
Binyon, Laurence 76–7
bodhisattva *see* Chinese bodhisattva
Book of Master Huainan 49

calligraphy *see* Chinese calligraphy
Carnegie Museum of Art, *Yoshitsune and Benkei see under* Japanese prints
ceramics, looking at early 16, 18–23
　Banpo 半坡 site *see* Banpo 半坡 site
　Banshan 半山 site *see* Banshan 半山 site
　Jomon Period 縄文時代 pottery 22–4, *23*
　Neolithic ceramics *see* Neolithic ceramics
　Proto-Geometric pottery, Ancient Greece 21–2
Chen Kaige 陳凱哥 (film director) 127–30, *128*, *129*
Chen Xiaoning 陳孝寧 69–72
China, linguistic and ethnic diversity map *55*
Chinese bodhisattva 15, 134–58
　Amitābha (Amituo 阿彌陀, Amitayus, Wuliangguang 無量光 or Wuliangshou 無量壽), Buddha of Measureless Light and Lord of the Western Paradise 140, 147, *148*, 151, 152–4
　Avalokiteśvara (Guanyin 觀音or Guanshiyin 觀世音), bodhisattva of compassion *137*, 138, 141–3, *148*, 149, 151
　Buddha Nature 151
　Buddhism as official religion, social effects of 150–51
　Cave 1, altar in central pillar 143, *143*, 145
　Cave 1, carved relief frieze 145–7, *146*
　Cave 1, Western Paradise depiction 152–4
　Cave 2, altar in central pillar 143, 144–5,

144, 146
　Cave 2, altar in central pillar with restored images 144, *145*
　Cave 2, carved relief frieze 147–9, *147*, *148*
　Cave 2, Western Paradise depiction 152–4
　cave temple site 141–9, *141*
　cave temple site, history of 141–2
　cultural and religious contexts 149–54
　Dunhuang 敦煌 caves, comparison with murals in 152
　Eastern Wei dynasty (Dong Wei 東魏) 150
　as enlightenment being 135–6, 151
　Freer-Sackler Gallery 140, *140*, 142, 147, *147*, *148*, 151, 152
　Gao Anagong 高阿那肱 141
　and Houzhu 後主, emperor (Gao Wei 高緯) 141
　and Indian Buddhist art 149
　and lay practitioners 151
　locations and groupings 138–49
　Longer Sukhāvatīvyūha sūtra 無量壽經 152
　Longmen 龍門 caves 140
　and Loo, Ch'ing-tsai 盧芹齋 (C.T. Loo) *136*, 138–40
　lotus flower *137*, 138, 140, 147, *147*, *148*, 151, 152, 153–4
　lotus ponds 152
　Mahāsthāmaprāpta (Dashizhi 大勢至) bodhisattva (achievement of Great Power) *139*, 140, 142–3, *148*, 151
　Meditation Sūtra (*Guan Wuliangshou jing* 觀無量壽經) 153–4
　museum setting 138–40
　musical instruments 152
　North Cave, head of demon 142, *142*
　Northern Qi (Bei Qi 北齊), formation of 150
　Northern Wei (Bei Wei 北魏) dynasty 150
　Northern Zhou (Bei Zhou 北周), formation of 150
　physical description 135–8, *136–7*, 142, 145–9, *146–8*
　as *pusa* 菩薩 (enlightenment being) 135–6, 151
　rebirth in Western Paradise 152–3
　Sukhāvatī, Land of Bliss 152
　Western Paradise depiction 152–4
　Xianbei 鮮卑, descendants of horse-riding

nomads 150
Xu Xianxiu 徐顯秀 tomb paintings, comparison with 149, *149*, *150*
Chinese calligraphy 53–74
 aesthetic appreciation of 53
 Binyon, Laurence, on rhythmic character of brushstroke 76–7
 clerical script (Han dynasty) 57
 Cuan Baozi Stele 爨寶子碑 *see Cuan Baozi Stele* 爨寶子碑
 Cuan Longyan Stele 爨龍顔碑 64, 66, 68
 Cuan Man 爨蠻 ethnic group 66
 epigraphy movement 66–9
 Epitaph for Tang Yao 唐耀墓誌 59, *59*, 62, *63*
 Epitaph for Xi Zhen 奚真墓誌 59–62, *60*
 Epitaph for Yuan Zhen 元楨墓誌 *61*, 62
 Fu Hao 婦好 bronze ritual vessel 53, *54*
 and graphology 53–4
 ink rubbings, use of 56, 69
 mirror symmetry 53
 miswritten characters 62–3
 and orthography 62–3, 70
 Ouyang Xun 歐陽詢 style 70
 proportions of characters 59–62, 70
 pyramidal stability 53
 regular script features 57–8, 59–62, 70
 round brushwork 63, 64
 Shi Chen Stele 史臣 *61*, 62
 size of characters 58–62
 square writing 63–4
 style 63–4
 variant characters 62, 67, 70–71
 visual analysis and interpretation 13
 Wang Xizhi 王羲之 style 64, *65*, 66, 67, 70, 72
Chu State
 bronze *bianhu* wine vessel *40*, 44
 Mawangdui, red lacquered coffin *see* Mawangdui, red lacquered coffin
 procedural design rules 44
cinema
 anime films and debt to traditional art 77, 89
 first lines, last scenes *see* first lines, final scenes
Cizhou-type stoneware jar *see* Ming Cizhou-type stoneware jar
Cuan Baozi Stele 爨寶子碑 54, *54*, 56–7, *57*
 aesthetic qualities 67–72
 ban character 70, *71*
 bin character 70, *71*

biographical background, absence of 56–7
cai character 70, *71*
calligrapy style 63–4
cang character 62–3, *63*, *71*, 72
Chen Xiaoning 陳孝寧 on 69–72
clerical script (Han dynasty) 57, 62
criticism of 68, 69
Cuan clan ethnicity 66, 67, 69–72
Cuan clan, history of 64–6
and Deng Erheng 鄧爾恆 56, *57*
Eastern Jin dynasty date 67, 72
epitaph details 65
fa character 59, *59*, 70–72, *71*
fang character 58, *58*
gan character 59, *60*, 70–72, *71*
Hibino Takeo 日比野丈夫 on 64, 66, 70
ink rubbings 56, *57*
Jiang Kui's character descriptions 69, 72
jun character 58, *58*
Kang Youwei on 康有為 57, 67, 68, 69
and Kunming 昆明 56
le character 59, *60*
ma character 70, *71*
Ma Guoquan 馬國權 on 57, 62, 68–9
miao character 59, *59*
miswritten characters 62–3
proportions of characters 59–62, 70
and Qujing 曲靖 56
regular script features 57–8, 59–62
rustic style 64, 66, 69–70
Sha Menghai 沙孟海 on 68–9
she character 58, *58*
size of characters 58–9
su character 59, *60*
variant characters 62, 67, 70–71
wei character 70, *71*
Western Jin dynasty style 64
xing character *61*, 62, 70
yin character 62, *63*, 70, *71*
yong character *61*, 62
yuan character *61*, 62
zhi character 58–9, *59*
zi character 58–9, *59*
see also Chinese calligraphy

Dai, Marquess of *see* Mawangdui, red lacquered coffin
Deng Erheng 鄧爾恆 56, *57*
Dungkar, Cave 2 163–5, *164*, 166
Dunhuang 敦煌 cave murals 152, 165

emakimono see Illustrated Scroll of Major

Counselor Ban

first lines, final scenes 14–15, 114–33
 A Tale of Two Cities 114
 Absalom, Absalom! 115
 Apocalypse Now 115
 Camus, Albert 116
 Carrie 117
 Chen Kaige 陳凱哥 (film director) 127–
 30, *128, 129*
 Chinatown 115
 Chinese cinema, best closing scenes
 125–31
 Chinese cinema, best opening scenes
 120–25, 128–31
 Chinese handscroll painting 118–20
 Conrad, Joseph 115
 The Day the Sun Turned Cold 天國逆子
 123–4, *124*
 Dickens, Charles 114, 116
 *Dreaming of Immortality in a Thatched
 Hut* 119–20
 Fan Kuai 樊噲 119
 Fan Kuan 范寬 120
 Farewell My Concubine 霸王別姬 128–
 30, *129*
 Faulkner, William 115
 The Feast at Hongmen 鴻門宴 118–19,
 118–19
 fen jiu bi he, he jiu bi fen 分久必合，
 合久必分 (*The Romance of the Three
 Kingdoms* 三國志演義) 114
 Fishing in a Mountain Stream 119
 Fitzgerald, F. Scott 115
 Gazing at the Mid-Autumn Moon 120
 Good Men, Good Women 好男好女
 125–6, *126*
 The Great Gatsby 115
 Hamlet 115, 116, 118
 Heart of Darkness 115
 Hitchcock, Alfred 130
 Hou Hsiao-hsien 侯孝賢 (film director)
 125–6, *126*
 In the Heat of the Sun 陽光燦爛的日子
 126–7, *127*
 Jiang Wen 蔣文 (film director) 126–7,
 127
 kai he 開合 (spatial composition) 118
 Ladies Playing Double-Sixes 119
 Lee, Lilian (Li Pik-Wah) 133
 The Lin Family Shop 林家鋪子 123, *123*
 Liu Bang 劉邦 118–19

 Liu Sanjie 劉三姐 122, *122*
 Lou Ye 婁燁 (film director) 130–31, *131*
 Mao Dun 矛盾 123
 Mars Attacks 117
 Mo Yan 莫言 116–17
 Old Well 老井 120–22, *121*
 Proust, Marcel 116, 120
 qi fu 起伏 (rise and fall of landscape
 form) 118
 Qingming Festival scroll 清明上河圖 *117,*
 118
 Rear Window 130
 The Red Cliff 前赤壁賦圖卷 119, *120*
 Red Sorghum 紅高粱 116–17
 Richard III 114–15, 116
 The Romance of the Three Kingdoms 三國
 志演義 114
 Shakespeare, William 114–15, 116, 118
 Shen Zhou 沈周 120
 Shui Hua 水畫 (film director) 123, *123*
 Sima Qian 司馬遷 119
 The Stranger 116
 Street Angel ⬛⬛⬛⬛ 124–5, *125*
 Su Li 蘇里 122–3, *122*
 Su Shi 蘇軾 119
 Suzhou River 蘇州河 130–31, *131*
 Third Sister Liu 劉三姐 122–3, *122*
 Vertigo 130
 Water Village 119
 Wu Tianming 吳天明 (film director)
 120–22, *121*
 Wu Yuanzhi 吳元直 119, *120*
 Xiang Yu 項羽 118, 128, 129
 *Xiao Yi Seizes the Orchid Pavilion
 Manuscript* 119
 Xu Daoning 許道寧 119
 Yan Liben 閻立本 119
 Yellow Earth 黃土地 127–8, *128*
 Yim Ho 顏浩 (film director) 123–4, *124*
 Yu Ji 虞姬 128, 129–30
 Yuan Muzhi 袁牧之 (film director)
 124–5, *125*
 Zhang Yimou 張藝謀 120, *121, 128*
 Zhang Zeduan 張擇端 *117,* 118
 Zhao Mengfu 趙孟頫 119
 Zhou Chen 周臣 119–20
 Zhou Fang 周昉 119
Freer-Sackler Gallery
 bronze *bianhu* wine vessel *40,* 44
 Chinese bodhisattva 140, *140,* 142, 147,
 147, 148, 151, 152

Guge Kingdom 162, 163–5
Gyantse, Kumbum, chapels 170–72, *170, 171*

Han Dynasty
 clerical script 57, 62
 Mawangdui, red lacquered coffin *see* Mawangdui, red lacquered coffin
handscroll
 Chinese handscroll painting 118–20
 Gao Wenhu 191
 Illustrated Scroll of Major Counselor Ban see Illustrated Scroll of Major Counselor Ban
Harunobu, Suzuki 105
He Fasheng 188
Heian Period 96, 99, 104
 court culture and art 75–7
Hibino Takeo 日比野丈夫 64, 66, 70
Hou Hsiao-hsien 侯孝賢 (film director) 125–6, *126*
Hunan Provincial Museum, Mawangdui *see* Mawangdui, red lacquered coffin

Idemitsu Museum of Arts, illustrated scroll *see Illustrated Scroll of Major Counselor Ban*
Illustrated Scroll of Major Counselor Ban 75–93
 anime films and debt to traditional art 77, 89
 architectural framing 90
 artistic expression 90–91
 artistic practices employed in scrolls 76
 black caps of male figures, staccato effect of 84–5
 black caps, and sense of progression 85
 black caps, significance of 84
 Chōju giga (frolicking animals and people) 77
 comportment, differentiated manners of 85
 Emperor Seiwa 78, *81*, 82, 83, 87, 90
 framing technique 86
 Fujiwara no Tokihira and 78, 79
 Fujiwara no Yoshifusa and 78, 79, *81*, 82, 83, 90, 91
 Fujiwara no Yoshisuke and 79, 82–3
 gendered modes 87–8
 Heian court culture and art 75–7
 historical background 78–9
 Kose no Kanaoka and 79

 measured movements and the boys' fight *82*, 83, 85–7, *86*, 88–9, 91
 Minamoto no Makoto and 78, 79, 82, 83, 87, 90, 91
 musical analogies in 76
 Nihon sandai jitsuroku reference source 78
 onna-e (female-gendered paintings) 87
 Oten Gate Fire 78–9, *79–82*, *80–81*, 84–5, 86–7, 88, *88*, 89, 91
 otoko-e (male-gendered paintings) 87–8, *88*
 psychological moments, framing of 90
 qi yun sheng dong first principle (spirit resonance and animation) 77
 rhythmic artistry in 76, 84–5
 and Sadanari (Fushimi), Prince 79
 scroll 1 79–82, *80–81*, 85, 88, *88*, 89, 90
 scroll 1, contemporaneous literary text 82
 scroll 2 *82*, 83, 85, *86*, 88–9, 90, 91
 scroll 3 83–4, *83*, 85, 89–90, *89*
 scroll 3, text accompanying 90
 seasonal landscapes reflecting human emotion 91
 Shigemi, Komatsu on 78, 79
 and *Six Laws of Chinese Painting* (Xie He) 77
 story of Counselor Ban 79–84
 and Takatori, Oyake 78
 The Tale of Genji, and art appreciation 75–6, 87, 88, 90, 91
 Tanaka, Ichimatsu on Japanese ink painting tradition 77
 Tomo no Yoshio and 78–9, 82, 83–4, 85, 86, 87, 89–90, *89*, 91
 as triple set of handscrolls 79
 Uji shūi monogatari (Collection of Tales from Uji) 78
 and visual art appreciation 75–6
 visual framing and viewing angles 88–90
 wind direction effect 84–5

Japanese prints 13–14, 94–113
 actor prints 99
 Benkei, Saitō Musashibō 西塔武藏坊 弁慶 (Musashi no bō Benkei 武藏坊弁慶) *see below* in *Yoshitsune and Benkei*
 chōnin 町人 (townsmen) 95
 and Dark Valley of Japanese history 106–7, 108
 Flowers and Leaves (Kōrin) 101–2, *102*
 Harunobu, Suzuki and 105
 Heian Period 96, 99, 104

historiographical considerations 106–8
ko-jōruri 古上瑠璃 (music and puppetry) 103
Koryūsai, Isoda and 105
and Kuniyoshi, Utagawa 宇多国芳 (Ichiyūsai 勇斎国芳) 94, 95, *95*, 100
Lane, Richard, and criticism of View 1 96, 97–8, 99, 100, 105
Matabei, Iwasa Katsumochi 岩佐勝以又兵衞 and 97, 103, 107–8
Moronobu, Hishikawa 菱川師宣 and 96
Nara Period, Buddhist images 96
Rimpa School 101–2, 103
Shin hanga 新版画 (New Print School) 96, 100
Sōjōbō, Kurama 鞍馬僧正坊 101
Sōtatsu, Tawaraya 俵屋宗達 101–2, 103
Sōsaku hanga 創作版画 (Creative Print School) 96, 100
tarashikomi 滴込 (dripping onto) technique 101–2, 112–13
tengu 天狗 (demons) 95, 96
Three Great Brushes of Tosa school of artists 107
Tokugawa Period class divisions 94–5, 98–9, 100, 103, 104–5, 108
ukiyo-e definition 94–5
ukiyo-e, and Kabuki theaters and brothel district of Edo 94–5, 98, 99–100, 103, 105
ukiyo-e and landscapes 100
ukiyo-e, main themes in 96
ukiyo-e, philosophical and religious concept of 98–9
ukiyo-e production, artisans involved in 95
ukiyo-e, relationship to modern developments in 100
ukiyo-e as tradition of painting 97, 100–106
ukiyo-e and *yamato-e*, connections between 102–4, 107–8
Ushiwakamaru, Onzōshi 御曹子 牛若丸 (Minamoto Yoshitsune 源義経) 95–6
and Utagawa School 100
View 1 of *ukiyo-e* 96–100
View 1 of *ukiyo-e*, as floating 浮世 or sorrowful world 憂世 98–9
View 2 of *ukiyo-e* 97, 100–106
warriors, depiction of 99–100, 103, 104, 108
woodblock prints as scholarly investigation, value of 97–8

yamato-e painting tradition 101, 102–4, 107–8
Yoshitsune and Benkei 94, *95*
Yoshitsune and Benkei, central panel detail *101*
Yoshitsune and Benkei, story of 95–6, 103
Yoshitsune and Benkei, tonal changes *95*, 101, *101*
Java sculptural narratives 165
Jiang Kui 姜夔 69, 72
Jiang Wen 蔣文 (film director) 126–7, *127*
Jomon Period 縄文時代 pottery 22–4, *23*

Kaminishi, Ikumi 75–93
Kang Youwei 康有為 57, 67, 68, 69
Kita, Sandy 94–113
Kōrin, Ogata 尾形光琳 101–2, *102*
Koryūsai, Isoda 105
Kuniyoshi, Utagawa 宇多国芳 (Ichiyūsai 勇斎国芳), *Yoshitsune and Benkei see under* Japanese prints

landscape elements *see* Tibetan painting, landscape elements in early
Lane, Richard 96, 97–8, 99, 100, 105
Le Comte, Louis 35–7
Lee, Lilian (Li Pik-Wah) 133
Lhasa, wooden lintels, Jokhang 165–6
Li Bai 181–5, *182*, 190, 191
Li Han 188
Licchavi artists, Kathmandu 165–6
Linrothe, Rob 159–77
Liscomb, Kathlyn 178–98
Liu Sanjie 劉三姐 122, *122*
Longmen 龍門 caves 140
Longshan 龍山 culture, black ware stem cup 29–32, *30*
Loo, Ch'ing-tsai 盧芹齋 (C.T. Loo) *136*, 138–40
Lou Ye 婁燁 (film director) 130–31, *131*

Ma Guoquan 馬國權 57, 62, 68–9
McNair, Amy 53–74
Mao Dun 矛盾 123
Martinez, Maria, black pottery 29
Matabei, Iwasa Katsumochi 岩佐勝以又兵衞 97, 103, 107–8
Mawangdui, red lacquered coffin 12, 35–52, *36*
animal designs *39*, 47–8, *47–8*, 49, 50–52, *50–51*
artisan workshops 39

atmospheric motion, curvilinear nature of 49–50

border design and procedural design rules *36*, 44, 45

cloud design *39*, 46, 49–50, *50*, 51–2

design intricacy and artisan skill 38

head panel *38–9*

immortality, depiction of 48–9

innermost coffins 37–8

lacquerware, cost and rich appearance of 37–9

procedural design rules 44, 45, 46

scroll and volute motif, design derivation *39*, 46, *47*, 48

Shaofu (Privy Treasury) workshops 39

and social status 41

techniques used 37–8, 49, 50–51

three-dimensional effect of design 50, *50*

see also ornament

Ming Cizhou-type stoneware jar 178–98

Bi Zhuo figure 181, *184*, 188–9, 191

character groupings from different eras 190–91

Chenghua period comparison 187, *188*

chrysanthemums and wine, depiction of 181, 185, 187

common culture 180, 190, 192

cultural environment and art interpretation 178–9, 192–4

decoration methods 178

design overview 181

elite social status 179–80, 189, 190, 191, 192–3

evening and night time, depiction of 185

Gao Wenhu handscroll, comparison with 191

He Fasheng (author) 188

imagery from Ming tavern murals, adaptation of 190

Li Bai figure 181–5, *182*, 190, 191

Li Han (author) 188

pictorial decor 180

pictorial depth 185, 189

qualities embodied in each figure, representation of 191–2

Reciting Poetry, fan *186*

repetition and variation, use of 191

and social status, determination of 179–80, 181–5, 192–3

Song dynasty stoneware vase (*meiping*) 181

special cloud forms, interpretation of 181, 185–7

stylistic features, contemporary meaning of 179, 193–4

and Su Shunqin 191

Tao Yuanming figure 181, *183*, 185–7, 190, 191

visual phrasing 189–90

Xu Ziguang (author) 188

and Yuan dynasty design 185

Ming dynasty, Wang Xizhi-style calligraphy 64, *65*, 66, 67, 70, 72

Minneapolis Institute of the Arts

funerary storage jar, Banshan 半山 site 26, 27–8, *27*

Jomon Period 縄文時代 pottery 22–4, *23*

Longshan 龍山 culture, black ware stem cup 29–32, *30*

Mitsunaga, Tokiwa

illustrated scroll *see Illustrated Scroll of Major Counselor Ban*

Minister Kibi's Adventures in China 87

Mo Yan 莫言 116–17

Moronobu, Hishikawa 菱川師宣 96

Mozi 42–3

Nara Period, Buddhist images 96

National Academy of Social Sciences, *Fu Hao* 婦好 bronze ritual vessel 53, *54*

National Library of China, *Cuan Baozi Stele* 爨寶子碑 *see Cuan Baozi Stele* 爨寶子碑

Neolithic ceramics

basin with design of human face, Chinese 24–6, *24*

ceramic utility and symbolic function 32–3

continuity of ceramic tradition in bronze casting 31–2

cun 寸 measurement and rule of thumb 21

decoration 22, 24–8

Eight Trigram symbols 25

fire flame pattern, Japanese 22

funerary storage jar, Banshan 半山 site 26, 27–8, *27*

Jomon Period 縄文時代 pottery, Japan 22–4, *23*

kiln processes 28–32

Longshan 龍山 culture black ware stem cup 29–32, *30*

mask imagery 24–5

potter's wheel 28, 31

pottery bottle, Banpo 半坡 site 19–22, *20*, 32

proportion, use of, and "rule of thumb" 21

scroll and volute motif, design derivation 46, *47, 48*

sectional construction 21, 31

shamanism and sympathetic inducement 25–6

shape of object 19–24, 27–8, 31

symmetrical design 25

visual analysis and interpretation 11–12, 18–34

Newari painting, Kathmandu Valley 168, 169

Northern Qi dynasty

Chinese bodhisattva *see* Chinese bodhisattva

Xu Xianxiu tomb 149, *149, 150*

Northern Wei dynasty, calligraphy inscriptions 62

ornament 12, 35–52

bixiang (resembling recognizable image) 47

bronze inlaid belt buckle 35, *36*, 42–3

design properties and meaning 45

diagonal grid design 44

European attitudes towards 41–2, 44

and fantasy 46–52

figure and ground interchange design 44

and group identity 37

and identity 44

Mawangdui, red lacquered coffin *see* Mawangdui, red lacquered coffin

Mozi on 42–3

non-mimetic qualities 37, 45

politics of 41–3

procedural design rules 44, 45, 46

scroll and volute motif *39, 40*, 46, *47, 48*

and social values 37, 41–3, 45, 47

as unnecessary adjunct 42–3

uses and significance of 35–7

Oten Gate Fire 78–9, *79*–82, *80–81*, 84–5, 86–7, 88, *88*, 89, 91

Ouyang Xun 歐陽詢 style 70

Pennsylvania University Museum, bodhisattva *see* Chinese bodhisattva

Poor, Robert 18–34

Powers, Martin J. 35–52

Rimpa School 101–2, 103

Sangdak Tsering 174

Sha Menghai 沙孟海 68–9

Shalu monastery *see under* Tibetan painting, landscape elements in early

Shen Zhou 沈周 120

Shigemi, Komatsu 78, 79

Shui Hua 水畫 (film director) 123, *123*

Silbergeld, Jerome 114–33

Sima Qian 司馬遷 119

Sōtatsu, Tawaraya 俵屋宗達 101–2, 103

Song dynasty stoneware vase (*meiping*) 181

Su Li 蘇里 122–3, *122*

Su Shi 蘇軾 119

Su Shunqin 191

Tabo monastery *see under* Tibetan painting, landscape elements in early

Tanaka, Ichimatsu 77

Tao Yuanming 181, *183*, 185–7, 190, 191

Tholing, Gyatsa Lhakhang *161*, 162

Three Great Brushes of Tosa school of artists 107

Tibetan painting, landscape elements in early 159–77

Ajanta mural paintings 165

Amdo Rebdong 173

Amdo Rebdong, Galdan Gyatso shrine *173*

Amdo Rebdong, Lokapāla Dhritarāstra 173–4, *173*

Amdo Rebdong, Sengge Shong Mango 174

Arhats 172

blue-and-green landscape painting 171–3, *171*, 174, 175

Bodhisattvas contained in round nimbi 165

and Borobudur, Java sculptural narratives 165

and Buddhism revival 162

Cakrasamvara mandala 162, *163*

Chemre monastery, Lama Lhakhang *172*

cubic rock forms 166, 168–9, *168*

Dhritarāstra, Lokapāla mural 173, *173*

Drukpa Kagyu teachers *172*

Dungkar, Cave 2 163–5, *164*, 166

Dunhuang 敦煌 cave murals 165

Dunhuang 敦煌 cave murals, Southern Xiangtangshan 響堂山 cave site comparison 152

Gandavyūhasūtra, Sudhana narrative
 159–62, *160*, 162
Guge Kingdom 162, 163–5
Gyantse, Kumbum, Mañjughosa chapel
 170–71, *170*
Gyantse, Kumbum, Sadaksara
 Avalokitesvara chapel 171–2, *171*
Indian (Magadha) influence 165, 166
Indo-Newari style 166
Java sculptural narratives 165
Jokhang, Lhasa, wooden lintels 165–6
Kashmiri painting, influence of 162, 165,
 166
Kathmandu 165–6, 168
Ladakh, Lama Lhakhang of Chemre
 monastery *172*
Lhasa, wooden lintels, Jokhang 165–6
Licchavi artists, Kathmandu 165–6
Mahāsiddha 162
Mt. Sugrīvā 159–61, *160*
Mt. Sulabhā 161–2
Nepalese influence 165, 166
Newari painting, Kathmandu Valley,
 influence of 168, 169
rocky landscape, different ways of
 indicating 163–5
Sangdak Tsering 174
sculptural forms 165–6
Shalu monastery 166, *166*
Shalu monastery, Gonkhang 169–70, *169*
Shalu monastery, Sadaksara Avalokitesvara
 Lhakhang 166–8, *167*
Shalu monastery, Sadaksara
 Avalokitesvara Lhakhang *khorlam*
 (circumambulationcorridor) 166, *166*
Shalu monastery, Yumchenmo Lhakhang
 168–9, *168*
Spiti *see below* in Tabo monastery
Sudhana narrative 159–62, *160*, 162
Tārā mural, Tabo 163, *164*
Tabo monastery, Dukhang 159–62, *160*,
 162, 163
Tabo monastery, Serkhang 163, *164*
Tholing, Gyatsa Lhakhang *161*, 162
Tsaparang, Demchok Lhakhang 162–3,
 163
Tokugawa Period 94–5, 98–9, 100, 103,
 104–5, 108
Tsaparang, Demchok Lhakhang 162–3, *163*
Tsiang, Katherine R. 134–58

Utagawa School 100

visual properties of art, challenges in study
 of 9–11

Wang Xizhi 王羲之 style 64, *65*, 66, 67,
 70, 72
Warring States Period
 bronze belt buckle 35, *36*, 42–3
 bronze *bianhu* wine vessel *40*, 44
Wu Tianming 吳天明 (film director) 120–
 22, *121*

Xiang Yu 項羽 118, 128, 129
Xiangtangshan 響堂山 Caves, Chinese
 bodhisattva *see* Chinese bodhisattva
Xie He, *Six Laws of Chinese Painting* 77
Xu Daoning 許道寧 119
Xu Xianxiu 徐顯秀 tomb paintings 149,
 149, *150*
Xu Ziguang 188

Yan Liben 閻立本 119
Yangshao culture
 basin with design of human face,
 Chinese 24–6, *24*
 pottery bottle, Banpo 半坡 site 19–22,
 20, 32
Yim Ho 顏浩 (film director) 123–4, *124*
Yu Ji 虞姬 128, 129–30
Yuan Muzhi 袁牧之 (film director) 124–5,
 125
Yunnan Province
 Cuan Baozi Stele 爨寶子碑 *see Cuan
 Baozi Stele* 爨寶子碑
 Cuan Longyan Stele 爨龍颜碑 64, 66,
 68

Zhang Yimou 張藝謀 120, *121*, 128
Zhang Zeduan 張擇端 *117*, 118
Zhao Mengfu 趙孟頫 119
Zhou Chen 周臣 119–20
Zhou Fang 周昉 119

Ikumi Kaminishi is Associate Professor in the Department of Art History at Tufts University. Her 2006 book, *Explaining Pictures: Buddhist Propaganda and Etoki Storytelling in Japan* (University of Hawai'I Press), investigated Japanese use of religious paintings as a didactic method of disseminating Buddhism. Her current research explores the affect of Buddhist concept of "skillful means (*hoben* in Japanese, or *upaya* in Sanskrit)" in illustrated scrolls (*emaki-mono*) from medieval Japan. Her essay, "Dead Beautiful: Visualizing the Decaying Corpse in Nine Stages as Skillful Means of Buddhism" in *A Companion to Asian Art and Architecture* (Blackwell Companions to Art History, 2011), examines the shifting meanings of Buddhist teachings. She also pursues her interest in Japanese tea ceremony, which helped her create an art history course in Zen and tea aesthetics.

Sandy Kita is Professor and Senior Scholar at Chatham University, Pittsburgh, PA. He is the author of *The Last Tosa: Iwasa Katsumochi Matabei, Bridge to Ukiyo-e* (Honolulu: University of Hawaii Press, 1999); *The Floating World: Shadows, Dreams, and Substance* (New York: Harry N. Abrams, Inc., Publishers, in Association with the Library of Congress, 2001); *The Moon has No Home, Japanese Color Woodblock Prints from the University of Virginia Museum of Art* (Charlottesville: University of Virginia Museum of Art, 2004); and *A Hidden Treasure: Japanese Prints in the James Austin Collection* (Pittsburgh: The Carnegie Museum of Art, 1996). He published numerous articles and curated more than 50 exhibitions. In 1993, Dr. Kita was inducted into the Freshman Honor Society Phi Eta Sigma for the Distinguished Teaching of Undergraduates at the University of Pittsburgh, Pittsburgh, PA and in 2001, was A Lily Center for Teaching Excellence Teaching Fellow at the University of Maryland, College Park, MD.

Rob Linrothe is Associate Professor in the Department of Art History, Northwestern University. He is a specialist in the Buddhist art of the Himalayas, conducting extensive field work on pre-modern mural painting of Ladakh and Zangskar (Indian Himalayas) and the contemporary revival of monastic painting in Amdo (China, northeastern cultural Tibet). From 2002 – 2004, Prof. Linrothe served as the inaugural curator of Himalayan art at the Rubin Museum of Art. He authored two catalogs to coincide with the museum's opening exhibitions in October 2004—*Paradise & Plumage: Chinese Connections in Tibetan Arhat Painting*; and, with Jeff Watt, *Demonic Divine: Himalayan Art and Beyond*. A third catalog, *Holy Madness: Portraits of Tantric Siddhas,* was published in 2006. He is also the author of *Ruthless Compassion: Wrathful Deities in Early Indo-Tibetan Esoteric Buddhist Art* (London: Serindia, 1999). In 2008-2009 he was a Scholar-in-Residence at the Getty Research Institute in Los Angeles.

Kathlyn Liscomb taught for many years in the Department of History in Art at the University of Victoria, Canada. Her publications include *Learning from Mount Hua: A Chinese Physician's Illustrated Travel Record and Painting Theory* (Cambridge University Press 1993); an exhibition catalogue, *China & Beyond: The Legacy of a Culture* (University of Victoria 2002); numerous articles in such journals as *Artibus Asiae*, *Art Bulletin*, and *Monumenta Serica*; and book essays.

Amy McNair is Professor of Chinese Art History at the University of Kansas and Editor-in-chief of *Artibus Asiae*. Her research interests include patronage and political uses of medieval Chinese Buddhist sculpture and issues of reception in Chinese calligraphy. She is the author of *Donors of Longmen: Faith, Politics, and Patronage in Medieval Chinese Buddhist Sculpture,* published by University of Hawai'i Press in 2007, and *The Upright Brush: Yan Zhenqing's Calligraphy and Song Literati Politics,* University of Hawai'i Press, 1998. She is currently working on a translation of *Xuanhe huapu*, the catalogue of paintings in the imperial collection circa 1120.

Robert J. Poor is currently Professor Emeritus in the University of Minnesota's Department of Art History. During his forty-five years at the University, Dr. Poor taught classes in Chinese and Japanese painting, Japanese prints, Asian ceramics, Indian art, connoisseurship of art and also courses in theories, methods and history of world art. His area of specialization was ancient Chinese bronzes. His initial interest in Asian art was sparked by frequent childhood visits to the Museum of Fine Arts in Boston and then confirmed during a year spent living in the Kyoto-Nara area in Japan while in the military. Upon returning from Japan he received a Master's Degree in Art History from Boston University and then completed the Ph.D. program at the University of Chicago. His published works include catalogs of the Arthur M. Sackler collection of Chinese bronzes, of the Asian antiquities in the Honolulu Academy of Fine Arts, ancient Chinese bronzes in the collection of the University of Chicago, and several exhibition catalogs of modern Japanese prints, Chinese jade, Indian sculpture, and East Asian art in Minnesota collections.

Martin Powers is the Sally Michelson Davidson Professor of Chinese Arts and Cultures at the University of Michigan, and former Director of the Center for Chinese Studies. His research focuses on the role of the arts in the history of human relations in China, with an emphasis on issues of personal agency and social justice. In 1993 his *Art and Political Expression in Early China*, Yale University Press, received the Levenson Prize for the best book in pre-twentieth century Chinese Studies. His *Pattern and Person: Ornament, Society, and Self in Classical China*, was published by Harvard University Press East Asian Series in 2006 and was awarded the Levenson Prize for 2008. In 2009 he was resident at the Institute for Advanced Study in Princeton writing a book on the role of "China" in the cultural politics of the English Enlightenment. Together with Dr. Katherine Tsiang, he is co-editing the *Blackwell Companion to Chinese Art*.

Jerome Silbergeld is the P. Y. and Kinmay W. Tang Professor of Chinese Art History at Princeton University and director of Princeton's Tang Center for East Asian Art. He has published more than sixty books, edited volumes, exhibition catalogues, articles and book chapters on topics in traditional and contemporary Chinese painting, architecture and gardens, cinema and photography.

Katherine Tsiang is Associate Director of the Center for the Art of East Asia in the Department of Art History at the University of Chicago. She oversees research materials and coordinates research projects and collaborative activities to promote and encourage new approaches to the growing field of East Asian art. The Center collects research materials, coordinates projects for digital archiving, supports graduate student research, hosts conferences, and invites visiting scholars and post doctoral fellows to work in affiliation with it. Her recent research and publication has been largely in the art and visual culture of the early medieval period of China. She curated an exhibition with the Smart Museum of Art of the University of Chicago and the Freer-Sackler Gallery in Washington D.C., entitled "Echoes of the Past: The Buddhist Cave Temples of Xiangtangshan," that incorporates stone sculptures from the caves with 3D digital installations and is traveling to four American museums from 2010-2012.